travel **+** PHOTOGRAPHY

Off the Charts

to robert
thanks for all
the questions
you guys

3/2007

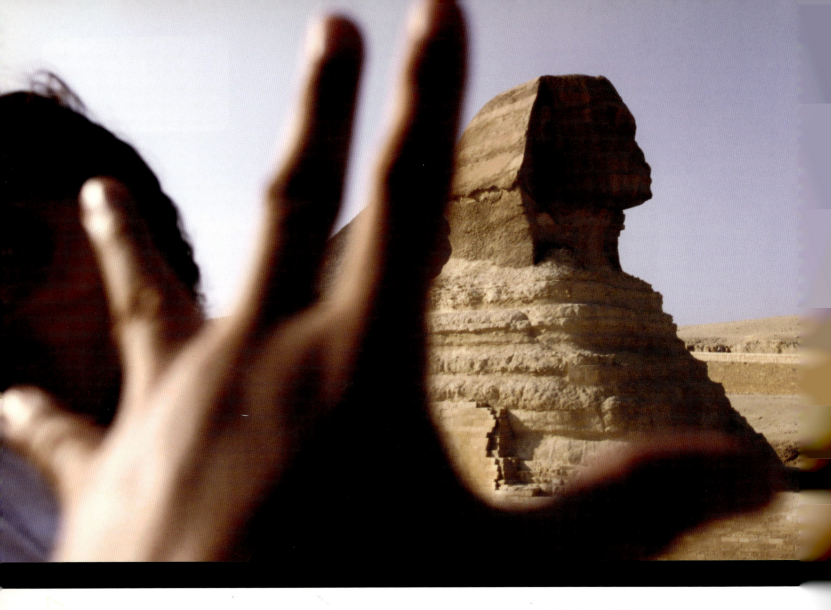

Sphinx, Cairo, Egypt.

travel + PHOTOGRAPHY

Off the Charts

Lou Jones

ELSEVIER

AMSTERDAM • BOSTON • HEIDELBERG • LONDON
NEW YORK • OXFORD • PARIS • SAN DIEGO
SAN FRANCISCO • SINGAPORE • SYDNEY • TOKYO
Focal Press is an imprint of Elsevier

Acquisitions Editor: Diane Heppner
Project Manager: Paul Gottehrer
Assistant Editor: Cara Anderson
Marketing Manager: Christine Degon Veroulis
Cover Design: Heidi Ziskind
Interior Design: Yellow, Inc.
Layout: Shawn Girsberger

Focal Press is an imprint of Elsevier
30 Corporate Drive, Suite 400, Burlington, MA 01803, USA
Linacre House, Jordan Hill, Oxford OX2 8DP, UK

Library of Congress Cataloging-in-Publication Data
Application submitted

British Library Cataloguing-in-Publication Data
A catalogue record for this book is available from the British Library.

ISBN 13: 978-0-240-80815-4
ISBN 10: 0-240-80815-0

For information on all Focal Press publications
visit our website at www.books.elsevier.com

06 07 08 09 10 10 9 8 7 6 5 4 3 2 1

Printed in China

CONTENTS

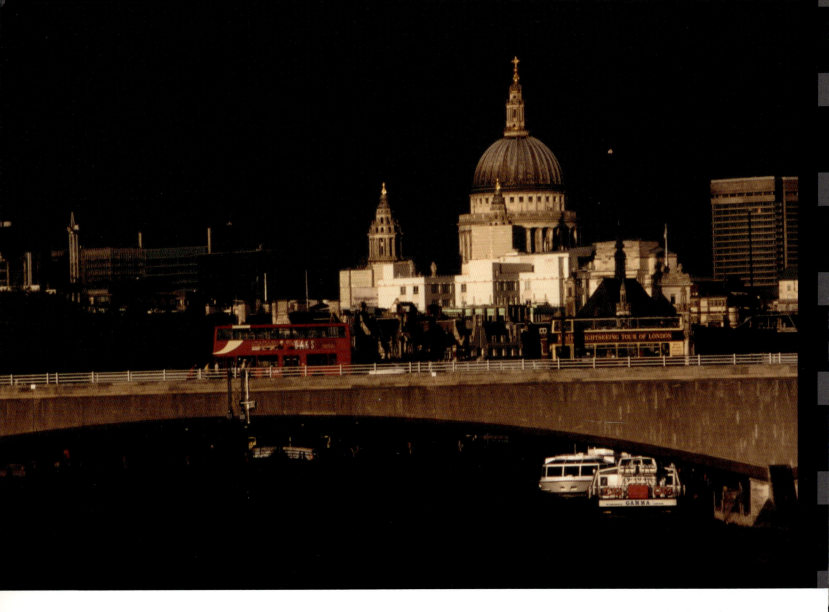

Notre Dame, Ile de la Cité, Paris, France

INTRODUCTION

For all recorded time, explorers such as Marco Polo, Magellan, and Lewis and Clark have been celebrated for their exploits. Since the invention of photography 150 years ago, travelers have used the medium to record their journeys. The promise of exotic foreign adventures has enticed all manner of people to investigate new cultures and locales. The allure of the unknown attracts the curious.

Stories are ephemeral. Memories fade. Photographs do not. Photographers bring back permanent proof of things never before seen. Images help the uninitiated experience unusual places. And history is established.

Today's practitioners of travel photography combine imagination, personal vision, and technology to elevate the profession to unprecedented levels. The camera is a passport to new worlds. This book illustrates the up-to-date art and science of taking creative pictures under familiar circumstances or while halfway around the world, whether you are taking your camera on vacation or are completing editorial assignments.

Herein you will find examples that reveal secrets, debunk myths, and explore the romance of traveling with a camera. By providing anecdotes that demonstrate how to solve both typical and unique problems regarding camera equipment, lighting, and language barriers, this ambitious book addresses extremes in subject matter, extreme conditions photographers have to endure, and the personal toll those extremes can take on a career.

The joyous emotions experienced upon cresting a hill and actually seeing a landmark for the first time or experiencing an event previously only heard about complete the best education that can be had. In addition, photography allows each of us to share our new knowledge with everyone else using the universal language. This book builds on that premise and demonstrates methods for bringing back successful and marketable photographs.

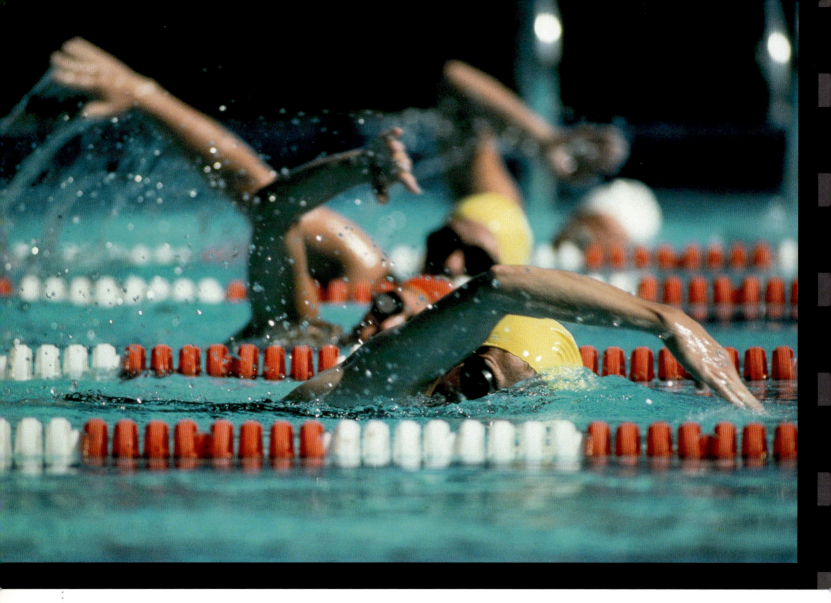

Swimming competition. *Shooting a 600mm lens on a tripod low to the water got me closer to the action, filled the frame with these female swimmers, and compressed the distance between them.*

"Gene Smith once said, 'The real feature is going to be when there's a chip imbedded in my head and all I have to do is look at something and want it to be imbedded on the chip.' That's the camera he was waiting for; he just died too soon."

—DANIEL KRAMER, ASMP

Chapter One: EQUIPMENT

The increasing popularity of photography has created "camera wars." Technology is the weapon. New space-age materials (plastics and lightweight metals), miniaturization of electronics, and new ground-breaking designs allow manufacturers to build cameras that are smaller, lighter, faster, better, and, in some cases, cheaper. Consumers are getting more for their money than ever before. With so many options, it is an exciting time to be a photographer. Whether you choose digital or silver-based equipment, you cannot make a mistake.

Men's 400-meter hurdles, Summer Olympics, Atlanta, Georgia. *Today's 35mm cameras are marvels of technology. With such a small, portable package we can perform amazing photographic feats. During this once-in-a-lifetime race, I was able to automatically focus on a fast-moving subject, use a motor drive to advance the film quickly enough for the action, expose properly for the changing light, and program in just enough blur for aesthetic reasons.*

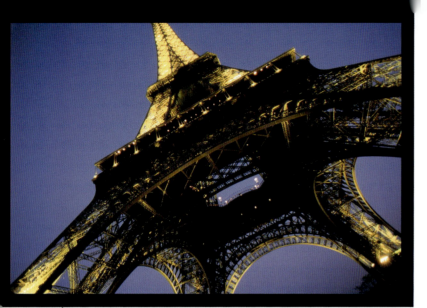

Eiffel Tower, Paris, France. *The first time I was in Paris as a photographer, I was hosted by my mentor who was born in France. After several days of him showing me all the back alleys of the City of Lights and the back roads of his childhood in France, he questioned me as to why I hadn't photographed the Eiffel Tower. With total disdain and hubris, I said I was a real photographer, not a tourist. He begged me to reconsider. Back home, every request I received for France included the Eiffel Tower. I kept promising myself the next time I was in France I would remedy that oversight. Assignments took me all over the world and Europe but not back to Paris. One day with a free ticket I got on a plane, stepped into a cab, dropped my bags at the pension, and went directly to the landmark. I took a series of pictures I had been dreaming about for twenty years. I had dinner with a friend and the next morning boarded a plane and came home.*

CAMERAS

SLRs

There are myriad choices, but the primary camera for travel photography is the 35mm single-lens reflex (**SLR**). It offers the most versatility combined with the best portability. And, because the biggest excuse among nondedicated photographers is inconvenience, it solves much of that problem. SLRs are designed to let you see exactly what you record, so you can crop the picture "in camera" and compose precisely for more exact creative control. You can see how each lens will optically alter the picture.

In order to have the most options, a camera that has fully **automatic** or **programmed** capabilities with the ability to also be completely **manual** is the most obvious compromise. Automatic exposure mode is the first feature that substantially increases the cost of the camera. The real value in automatic cameras is their ability to extend human capabilities, to "out-think" the photographer and perform functions more accurately and faster than you can. When the light is changing quickly, modern hardware can adjust instantly, even at the moment the exposure is actually being made. This results in a higher percentage of usable photographs. If the action is too fast, **autofocus** can track it and focus better than you can.

With digital SLRs (DSLRs), you can also get immediate feedback on your progress. The liquid crystal display (**LCD**) monitor and the histogram ensure that you get what you wanted. As you become more familiar with your DSLR equipment you can react more quickly to your environment and be more spontaneous about seizing every unique opportunity you encounter.

Many SLR models come with built-in motor drives or they can be added as accessories. Motor drives automatically advance the film in the camera and relieve you of that repetitive task. They increase the weight and the cost but make the act of taking pictures more fluid. They can also make louder noises and are somewhat intrusive.

Rangefinder

There are other types of 35mm cameras. The one most worthy of serious attention here is the **rangefinder camera**. Rangefinder cameras, prede-

cessor of the SLR and more popular a couple of decades ago, are excellent alternatives. They have tremendous advantages, too. By and large, they are usually smaller and much quieter. This can be important in dramatic, sensitive situations (e.g., churches, theaters, concerts) where noise is a factor. When you need to be unobtrusive, they are a great option. Rangefinder cameras are excellent in crowded places. They can be wielded in close quarters without drawing attention to yourself. Focusing is manual but tends to be simpler in very low light, and, because you are always looking through the same viewfinder, it is easier to focus when using wide-angle lenses. The downside is that the off-center viewfinder is subject to **parallax**. Unfortunately, rangefinder cameras are becoming rare in the digital age.

Point and Shoot

Point and shoot type cameras have their own place in travel work. Their low price is attractive. They are less intimidating for both the photographer and the subject. They are quiet and convenient. Many take excellent pictures and compare favorably to good consumer products, and their compact size makes it easier to always carry one on your person and be on the ready for snapshooting. Both digital and traditional film models can be purchased almost anywhere. Some are inexpensive enough to be disposable.

Medium Format

Medium format and panoramic cameras are especially suited to travel work. They come in a variety of shapes and film sizes. There are models for waist-level viewing, eye-level viewing or SLR types, leaf or focal plane shutters, fixed or interchangeable film backs, and square or rectangular film shapes. They yield a negative area that often is much more than three times that of a 35mm. Image quality increases and exquisite enlargements can be made. But they should be considered carefully. They are specialty items and are limited for photojournalism or documentary work. Using medium format tends to slow the process down but is perfect for a more contemplative approach—that is, developing a style that makes you think more about composition and prepare each picture formally. A lot can be said for how much more seriously your subjects take you when you bring

"**The secret** to making a good photograph **is the ability** to see in terms of photography, **to see like a camera,** to be familiar with the camera's advantages and disadvantages, to utilize the first and avoid the latter."

—ANDREAS FEININGER

Time (Watches) Time is bigger than life when you travel. As soon as I get to a new region, I check to get the correct time. When I was just starting my career I was full of hubris. I thought I didn't need to wear a watch. It was a hang-up of average people to always be conscious of the time. I could "guesstimate" the time by my familiarity with the sun and seasons. In Crete, I lost two days. I could not remember or recreate in my mind my activities for the week and nothing gave me clues—not newspapers (couldn't read Greek), not the sun (it was alien light), nothing. Ever since that misadventure, I've learned that not only is it imperative to know the time but you also have to get used to interpolating the time back home, too. Ever since then, I've worn only watches that give me at least two time zones.

in bigger equipment. Digital medium format cameras remain very expensive and require a lot of accessories and technical support for optimum use.

LENSES

After you have selected the kind of camera that fits your personality, you can turn your attention to lenses. A normal lens usually comes with the original purchase of your camera. Science tells us it most closely approximates the way you see with your naked eye. It is a simple piece of equipment, easy to use, and all some people ever need.

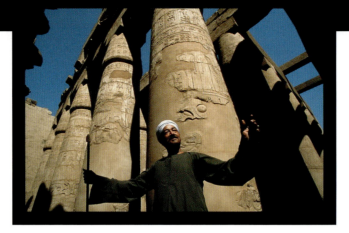

Karnak Hypostyle Hall, Luxor, Egypt. *Employing an 18mm wide-angle lens both integrates the animated guide to this historical environment and exaggerates the perspective and colossal size of the monument.*

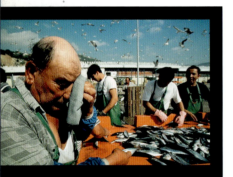

Worker scaling fish, Portugal. *After running for a long time, I sought these workers surrounded by seagulls and fish. A wide-angle lens allowed me to wade in close and become part of the process.*

Often a second lens is the first major addition. Consider carefully.

With many high-end DSLR cameras there is a subject magnification factor caused by the electronic sensor when compared to traditional 35mm cameras. It is not unusual to encounter a 1.5× increase. You have to factor that in when selecting another lens. A 50mm lens for a film camera acts as a 75mm on a digital camera, and a 300mm lens on an SLR would look like a 450mm lens on a DSLR.

Adding additional "glass" affords you more options and often solves a number of creative problems. You should be burdened with only as much equipment as you or your personality can shoulder for an extended period of time. Too little limits your chances for experimentation; too much, you tire and cannot create due to fatigue. Carry a minimum of two lenses: a wide-angle lens and a moderate telephoto. The average photographer's most sensitive, most interesting and well thought

out photographs tend to be taken at focal lengths between 35 mm and 105 mm. That means you need only simple equipment, not exotic, expensive paraphernalia.

The main reason for changing lenses is to isolate the necessary amount of information in the picture without having to move drastically or crop the final photograph. There are also more artistic reasons, but we will address them later.

Wide-Angle

For 35mm cameras, wide-angle lenses are those with focal lengths less than 50 mm. A "short" lens increases your angle of view so, without changing position, you can take in more of a scene than with a longer lens. You may not be able to move but want to include a larger vista. The shorter the lens, the greater the inherent depth of field it exhibits; therefore, these lenses are favored for landscape photography. With this

Apply the right tool to the right job.

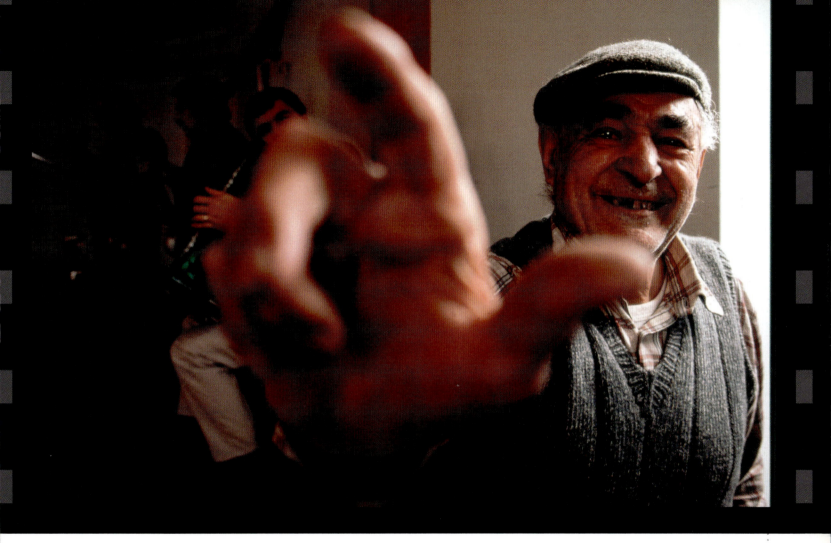

Wedding guest, Comegliano, Italy. *Working in tight is easiest with a wide-angle lens. You don't have to be as exact with focusing and you can maneuver around in small spaces. It allows you to work fast and to move right along with your subject's actions.*

Three of us flew to
Santo Domingo for a
project. After three
days we decided we had
time to make a side
trip to the other side
of the island, Haiti.
We knew nothing about
the place except the
rumors and had no idea
what to expect. For
two days we enjoyed
Haitian hospitality
except for the fact that
everyone was habitual-
ly late. It wasn't until
later that we realized
that from one side of
the island to the other
there was an hour time
change. It taught me an
invaluable lesson.

8

extra depth of field, the lens allows you to keep more of the image in focus. This results in objects appearing sharp despite being far apart. Optically, wide-angle lenses also increase the apparent distance between foreground and background.

When you cannot back up in cramped quarters, a wide-angle is the answer. They are perfect for shooting interiors or when you have to insinuate yourself into a crowd. Because they are often smaller they are less obvious, and because they have a greater depth of field, focusing is less critical, and you should be able to work faster. Short lenses are ideal in low light because you can handhold them at slower shutter speeds.

Telephoto Lenses
At the other end of the scale are telephoto lenses. Long lenses provide greater image magnification and a narrower angle of view. They bring you closer to your subject if you cannot or do not want to move. They are tools of the trade for sports and news photographers.

Telephotos are ideal for people pictures. Portraits welcome involvement. They allow you to shoot close up. Focal lengths in the range of 85 mm to as much as 135 mm put you about 2 meters from your subject for a head/shoulders shot. Long lenses compress distance and bring objects into better scale with their backgrounds. Objects appear closer to each other than they actually are. This is an important relationship to understand and exploit.

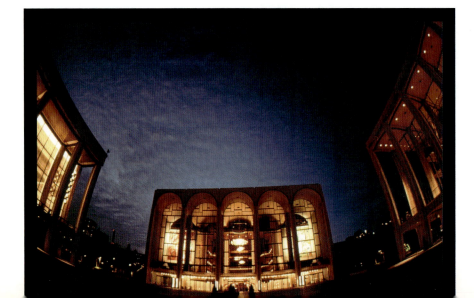

Lincoln Center, New York. *Fisheyes are specialty lenses. Because of the obvious distortion they cause at the edges of the frame, they are difficult to use, but, if you emphasize these defects, you can make interesting pictures.*

> ## "If you can't use a 24mm, back up and use a 500."
> —BERNIE BOSTON

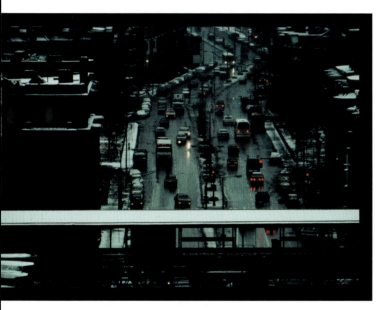

MBTA elevated railways station over Massachusetts Avenue, Boston, Massachusetts. *Shot with a 600mm lens, this photograph covers several blocks on one of the city's most famous streets. The lens compressed the traffic to add to the dark mood caused by the weather.*

The longer the lens, the more the depth of field is reduced. Because of that physics principle, telephotos are used to throw distracting backgrounds out of focus. Besides magnifying the object, long lenses accentuate camera movement. So, if you are handholding the camera, you need to pay more attention to shutter speed. The rule of thumb is that the shutter speed used should be equal to or faster than the reciprocal of the focal length (1/focal length ≥ shutter speed); that is, with a 200mm lens, 1/200 seconds is the slowest shutter speed that is reliable for sharp pictures.

Another rule of thumb for long lenses is to remember that, if you want to emphasize the sun or moon, you get approximately 1 mm of sun or moon for every 100 mm of focal length. So, a 500mm lens will render 5 mm of stellar object. On a 24×36-mm negative, that is more than 20% of the width of the image.

Telephotos can be big and cumbersome. They "separate you from what you are photographing. They can be intimidating and obtrusive.

Long lenses force the subject closer to you; with short lenses, you are closer to the subject. A wide-angle lens puts things in context; a long lens separates them from their environment. Switching back and forth is one of the creative techniques available today with improved "glass." Extreme wide-angles or telephotos can produce even more dramatic results.

Zoom Lenses
Instead of thinking separately of wide-angle, normal, and telephoto lenses, you can now envision all of them bundled together at one time. Using complex computer designs, manufacturers have been working tirelessly to

> **Kleenex®** or **Facial Tissue** I carry a couple pocket packs of facial tissue no matter where I go. You can use them to blow your nose, clean your glasses or lenses, or wipe your butt in the bathrooms and outhouses or woods that have no toilet paper.

Fishing boat, Port Antonio, Jamaica. *Local fishermen coming home at the end of the day were reluctant to be photographed. The wide-angle zoom allowed me to follow their movements fluidly and include foreground, the human element, and the inviting, azure background in one picture.*

fill the gaps and make zoom lenses the quality equivalent of fixed focal length lenses. Zooms provide an infinite variety of focal lengths in one compact package.

Their biggest asset is expediency. One zoom can cover a broad range, is easier to carry than several fixed focal length lenses, and often is less expensive, too. But you also have more options with image size and framing. Without physically moving, you can exactly compose and crop in camera just by using the appropriate zoom lens. Working distance and perspective can be precisely controlled, and it is certainly faster than having to constantly change lenses. Although you can learn to focus, compose, and zoom almost as quickly as with a single focal length, zooms are usually bulkier and slower (i.e., their maximum aperture is smaller).

TRIPODS

A good **tripod** is the first important piece of non-camera equipment. Its purpose is to keep your camera steady during an exposure. Tripods come in all shapes and sizes. A tripod used when traveling differs from one you might purchase for outdoor, scenic, portrait, or other commercial photography. With travel work, if you have to constantly debate whether to carry your tripod or not, then it is the wrong kind. The tripod has to be very sturdy but small and compact. To get a vibration-free tripod that is inexpensive and meets the above criterion takes some investigation.

Bourne Bridge, Bourne, Massachusetts. *A client who was repairing the bridge needed photographs. I set up with a 500mm lens far up the hill. I wanted the sun to be as large as possible. The orb measures 5 mm across. Rule of thumb: 1 mm (sun/moon) for each 100 mm of telephoto lens.*

"Where light is not welcome, a photographer's greatest ally is his tripod."

—WILBUR E. GARRETT, *NATIONAL GEOGRAPHIC*

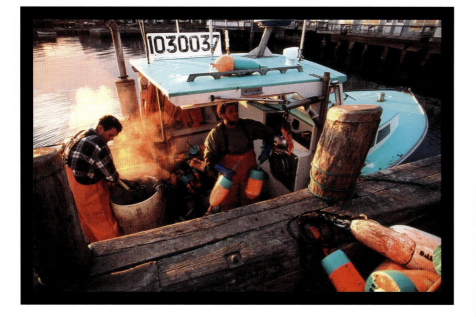

Lobster boat, Carver's Harbor, Vinalhaven, Maine. *We were off-season for this story about a quaint tourist destination. I waited for the lobstermen who were due in at the end of the day. Because they put up at sunset I had to carry a tripod around all afternoon. It was cold, but by using a stable platform I was able to get in tight and increase the chances for sharp images while shooting into the low backlighting.*

A 35mm camera with a motor drive and moderate telephoto lens can exceed 2 kg in weight, which is quite a strain when the tripod legs and center column are fully extended. Larger formats make the job even more difficult. You never want to entrust a precious piece of hardware to inadequate support. Cheap tripods do not have the mass to dampen wind vibration or mirror slap, and they are difficult to set up and maneuver.

Out of the vast selection has emerged the carbon-fiber tripod. They absorb vibration better than metal and are a good percentage lighter than aluminum. These high-tech composite materials exhibit tremendous tensile strength. They save on weight but not on price. Aluminum or black anodized tripods still make up the majority of choices, and there are even some camouflage-decorated ones.

Flashlight On assignment in Havana, Cuba, I heard music. It was across the street and far away. I couldn't track down the source. As I got closer, I could hear the echo bouncing off the tall buildings. It was amazing. Running back and forth to find the source, I eventually got someone's attention. He led me on a dead run into one of Old Havana's famous condemned historical landmarks. I thought it was abandoned. Upon entering the lobby, I found it totally dark in the middle of the day. No light at all. My "guide" ran up the stairs with me in close pursuit. The circular staircase wound round and round. But soon I hit something. Hard. Because it was so black I had no idea the staircase was full of people. I couldn't see a thing. I panicked. But, I always carry a small flashlight on my key chain, so I was able to stumble safely the several flights up to the band rehearsing on the top floor. Great photographs.

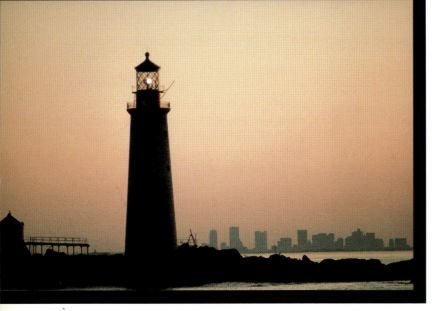

Graves Lighthouse, Boston Harbor. *This shot was "engineered." A great deal of planning went into this photograph intended for a calendar. We had to shoot from a special boat. Because the boat was rocking, I constructed a harness that went over my shoulders and held my 35mm camera with a 300mm f/2.8 lens. My legs acted as the shock absorber/stabilizer. Because we were shooting at dusk, I had to use slightly faster film and the aperture was wide open to ensure adequate shutter speeds. My assistant used a stopwatch to tell me precisely every 8 seconds when the light would be directly in the lens. The telephoto reduced the distance between the lighthouse and the distant city.*

Most tripods can be equipped with a three-way pan head or a universal ball head. It is a matter of personal preference, but the head should provide effortless movement and handle the weight without drift or sag. Movements should allow you to rotate your camera from horizontal *past* vertical. Smooth horizontal movement is a necessity in case you want to attempt panning during a long exposure. The fewer bells and whistles, the better.

There are many situations where a tripod is not practical. Many institutions will not permit their use. Stadiums and field officials will often confiscate them. But, they are excellent creative implements that enhance our capabilities. They facilitate long exposure times and the technique of panning. They let you capture events that are virtually invisible (i.e., too slow or too fast for the naked eye). The downside is that they reduce your mobility.

Quick-release systems cut down on the frustrations of getting cameras on and off the support systems rapidly. On the one hand, they are convenient; on the other, they add pounds and are extra, complicated,

moving parts. To your setup add a good cable release in order to eliminate shaking the camera when releasing the shutter. Use a strap or buy a tripod bag to carry the tripod around conveniently.

MONOPODS

Another kind of camera support that provides limited support but has a great deal more portability is the **monopod**: a single leg substituted for three. Of course, they are nowhere near as sturdy as a full tripod, but they eliminate one degree of freedom, make you steadier, and therefore increase the range of usable shutter speeds. Using a monopod, you can shoot as much as two extra stops slower than the hand-held minimum shutter speed.

It is an excellent way to support the extreme weight of long, fast telephoto lenses for sports and wildlife photography. The monopod can easily be used with equal effectiveness in a horizontal position or at an angle, such as when wedged against a wall or tree.

Traffic in Financial District, Boston, Massachusetts. *I staked out the location on a pedestrian bridge over the highway that went right through the financial district of Boston. The streaked headlights/taillights indicate that it was a long exposure of approximately 2 to 3 seconds. The shot would have been impossible without the sturdy tripod I brought along.*

Accessories

Small alarm clock
Portable AM/FM radio
Calculator
Rubberbands
Gaffer's tape
Needle and thread
ZIPLOCK® bags
Mailing tube
Safety pins
Sunglasses

Camera Bag

2 CC30M 75mm × 75mm filters
Voss spring-loaded filter holder
Model releases
2 Lintless lens cloths
Nikon® Speedlight
Gepe Card Safe memory card case
LensPen camera brush
Butane lighter
Folding 5x loupe
Maglite® mini flashlight
2 Compasses
Sharpie® permanent markers
Grease pencil
Leitz ball head
3 Polarizing filters (77mm, 62mm, 52mm)
15 AA alkaline batteries
Swiss Army knife
Gitzo "shorty" monopod

Both tripods and monopods are much sturdier when kept as low as possible. The further they are extended, the shakier they become. In lieu of a monopod or tripod, for greater stability lean yourself or the camera against a tree or building. Brace your elbows on the ground, roof of a car, or other solid object. Use your camera bag as a sandbag type of support.

FILTERS

The purpose of **filters** is to modify light. You can go through life without ever having to screw one onto your camera, but, if you are at all technical and want to put as much information as you realistically can onto film, mastering filters will make achieving that objective easier. Small things often have large effects. Most filters reduce or block certain wavelengths of light. So for black/white, when a filter is placed in the optical path there is a reduction in the quantity and quality of light reaching the recording medium. Objects of the affected wavelength appear on the print in *lighter* shades of gray, and vice versa. After generations of "blown out" skies in landscape photographs, Ansel Adams popularized dramatic dark skies by his use of a red filter. A colored filter absorbs its complimentary color.

The compensation in exposure is indicated by a number accompanying the filter which is called the **filter factor**. The number tells the meticulous photographer how much to increase exposure. The primary materials used in filter manufacture are optical glass, optical plastic, and gelatin. Filters have equivalent applications in black-and-white and in color. Deciding how and where to use them can become very intricate.

Even though filters are small, carrying lots of them on a travel assignment becomes a prodigious undertaking. Different lenses require different filter sizes which increases duplication. Relying on a big assortment makes for a very heavy camera bag. Keeping your choices simple and to a minimum will reduce that load.

Polarizing Filters

Polarizing filters are used to cut the glare from nonmetallic objects and reflections in glass. As you turn the movable section on a *polarizer*, you can observe through the lens how it enhances the overall appearance of a scene. Because you are blocking certain light waves, orientation in relation to the sun is important. Optimum is 90 degrees to the light source. A second application for a polarizing filter is to increase color saturation. By reducing reflections in the atmosphere, the filter has an effect on the color of the sky. It darkens clear blue skies and enhances the contrast between less than clear skies and white clouds. The results can be quite dramatic and help an otherwise flat scene.

An often-overlooked application for the polarizer is as a neutral density filter. Because it does not affect the color cast of the image, it can be used merely to cut down on the total amount of light reaching the film. This helps if you want to employ a wider aperture or longer shutter speed. Most polarizing filters require 1.5 to 2 f/stops of additional exposure.

For reliable results with the newer autofocus, autoexposure cameras, you may need a circular polarizer. With manual cameras, a linear polarizer is sufficient.

Color Compensating Filters

The true color of an object is affected by the color of the light source. When attempting to photograph inside or outside, on cloudy days, or at sunrise or sunset, the color of the light is different in each case. You may barely detect it, because your brain very efficiently compensates for these vast differences. Unlike our eyes, the mediums used for image capture (film or digital) are extremely sensitive to these differences. Because color negative films can be somewhat corrected in the printing process, color compensating (CC) filters are more useful for transparency films where color balance is critical. CC filters are supplied in squares of gelatin. They are very delicate and susceptible to moisture and handling. They are used when incremental changes are necessary to correct for various light sources: tungsten (standard light bulbs) or halogen and "noncontinuous" lights, such as fluorescent, metal halide, sodium vapor, etc. CC filters usually come in magenta, cyan, yellow, red, blue, and green. There are additional CC filters that will convert daylight to tungsten and *vice versa*. Some help to eliminate infrared or ultraviolet. Still others are intended to warm a cool scene or otherwise make a picture acceptable. Filters come in all sorts of colors for various creative and unorthodox reasons. More importantly, several of them can be stacked in combinations to achieve the desired results.

Digital cameras often eliminate the need for color compensating filters, as they can be adjusted for the particular light. This is called **white balance**. White balance can be set automatically, as a preset, or manually. It frees you up from having to always pay attention to how lights are influencing or corrupting your photograph. Today it is also easy to balance or fine-tune color correction in postproduction.

Diffusion Filters

Diffusion or "soft-focus" filters are used to degrade the overall sharpness of an image. They are mostly called upon to render a portrait more flattering and to make unflattering facial features less distinct. They reduce the contrast significantly, and more pronounced results are achieved at wider apertures. Diffusion can introduce a feeling of softness to a scene that can

Canoe, Haggett's Pond, Andover, Massachusetts. *On a very gray day, we had to make a story where the conservationist who owned this canoe was central. So, I put a graduated filter over the top portion of the lens and gave an otherwise dull day a little life.*

be interpreted as romantic or nostalgic or wistful. To produce similar results, photographers used to smear petroleum jelly strategically on select areas of an inexpensive glass filter or stretch a mesh material across the front of the lens. Black stockings achieve an almost neutral affect on color balance. Any other color introduces its own color cast over the final picture.

Special Effect Filters

The overwhelming number of interesting filters available on the market these days encourages a lot of experimentation. Testing what they do to film can be fun, but, by and large, such uses are gimmicks. Seek what works for you but be judicious. Computer software continually introduces new filter plug-ins. Some of them are amazing. Many are overused. Tricks with filters can sometimes make mediocre pictures usable but rarely improve good pictures.

One of the more useful categories of special-effect filters is the **graduated filter**. Made in a variety of colors that either warm or cool a scene, half of the filter has a gradually fading neutral density or color and the other half is clear. You can move the filter around in front of your lens to adjust where the division intersects the scene. Its application can dress up a rather flat, overcast, colorless shot or introduce density where the sky is washed out. It is difficult to place the line of demarcation just right and make it appear natural. To better predict the final effect, stop the lens down to see how it will look with the chosen f/stop.

COMPUTERS

Computers have traversed every longitude and latitude, and they have permeated all aspects of our daily lives. For the serious travel photographer, they are almost as ubiquitous as cameras. If you are on the road a lot or for extended periods of time, they become an essential part of your arsenal. Of course, in most cases, the discussion is limited to laptops, as size and weight remain major consider-ations. Computers provide the globetrotter with communications, word processing, bookkeeping, enter-tainment, research, and companionship—like a high-tech Swiss Army knife with a television screen.

On the other hand, the care and feeding of computers creates its own set of problems. Besides the usual foreign nuisances of having to recharge batteries on unknown electricity and matching up with alien phone equipment, laptops are finicky about logging onto the Internet. It may be necessary to purchase an Internet Service Provider (ISP) that has adequate international coverage. **Wi-Fi** can be found in many establishments, airports, and first-rate hotels, but, if you are reduced to using dial-up service, it should be a local call as often as possible so you do not amass enormous long-distance charges. Going through complex hotel operators and then draconian telephone systems is frustrating, expensive, and time consuming enough.

As a diary, the laptop can organize your calendar, record captions, and broadcast details of your entire trip. If you are using digital capture, you have the technology to download and backup the images of the day. You can begin the editing process, send pictures off to your agent or studio back home, and broadcast your trip's progress in real time.

If you would rather not be burdened with the weight and hassle of transporting a laptop all over the world, Internet cafés are a prolific alternative. Amazingly, they have wired the develop-ing world. These establishments are good substitutes in case you have difficulty logging on your own computer. You can go in and check you e-mail, socialize, and sample indigenous cuisine, and you avoid the threat of spam and viruses. In addition to the business office in better hotels, you can often find colleges, travel agents, and airports where you can pay to go online. Access to the Internet is free at many libraries in the United States.

MOBILE PHONES

Have you ever been to a restaurant and observed a table full of people all talking separately on cell phones? Obnoxious? Ironic? However you rate its influence on society, the cellphone is no longer considered an accessory. It has had the most profound effect on the twenty-first century—bringing both halves together. The promise of being able to talk to anyone anywhere at any time increases

your potential exponentially. Today's mobile phones and personal digital assistants (PDAs) are minicomputers. Their address books, voice mail features, Internet service, and calendar replace the traditional office. Small and compact, this powerful instrument is, at the same time, the biggest scam in modern history. With expensive ring tones, text messaging, designer colors, and notoriously bad service, the cellphone companies have pulled the wool over government regulators' and customers' eyes. They promise you the world and deliver a good deal less. When your ventures are only domestic, your options are relatively simple, but as soon as you have to navigate borders and oceans, cellphones fail miserably.

Most of the world utilizes the Global System for Mobile Communication (GSM). Notable exceptions are the United States and Canada; therefore, cellphone systems can often be incompatible when you roam from one nation to another. The many mobile services advise you to purchase dual-, tri-, and quad-band phones that theoretically close the gap but present their own challenges. Frequent travelers somehow play games of juggling multiple phones and phone numbers, and trying to maintain a single phone number to make yourself available to clients and associates all over the world is nearly impossible. Attempting to have call-forwarding transfer calls from your landline to your cellphone is even less reliable.

Satellite phones may be your only choice if you absolutely have to be connected. Business personnel, journalists, and explorers swear by them in remote areas. Just be aware that they are expensive, can be hampered by bad weather, are generally too slow to transmit data, and are restricted to line-of-sight with the satellite (i.e., you must be outdoors).

Despite its shortcomings, however, the cellphone is here to stay. It is convenient. It is essential in emergencies. It often carries less expensive tariffs than the telephones in your hotel. And, many come with their own built-in cameras. Just remember to pack the charger.

If you learn to pack all of the products that have been discussed here into a small carry-on bag you are a true "road warrior." Of course, all

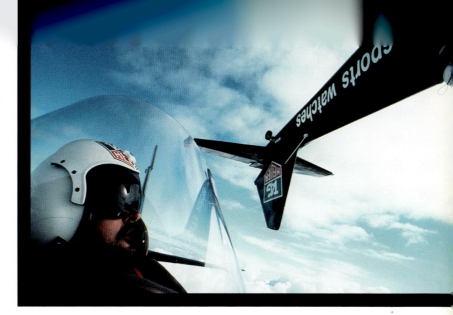

Aerobatic planes during airshow. *Barnstorming and documenting airshows all over the Eastern seaboard, we had bolted all manner of cameras to the wings and struts of high-performance aerobatic planes. The pilots triggered the cameras using remotes as they were doing their hammerheads and death spiral tricks. The assignment, however, called for "participatory journalism." Up until then I had been a disciple of external light meters. I trusted them with uncanny results. But, flying upside down and sideways, my subjects were not stationary for the long contemplative process. At such high speeds, I never even knew where the sun was most of the time. I could not have completed the job without automatic exposure functions on my camera, and I have relied on it whenever called for ever since.*

of this equipment is no better than the operator. Before taking anything out into the field, you should test it thoroughly. You need to familiarize yourself with its operation and make sure it does what it is supposed to do. Discovering a faulty product in the field is the worst possible mistake. Leave nothing to chance. Be so comfortable with your equipment that it is all second nature. As a matter of fact, the more Zen-like you treat your stuff, the more you can concentrate on important things. 🔘

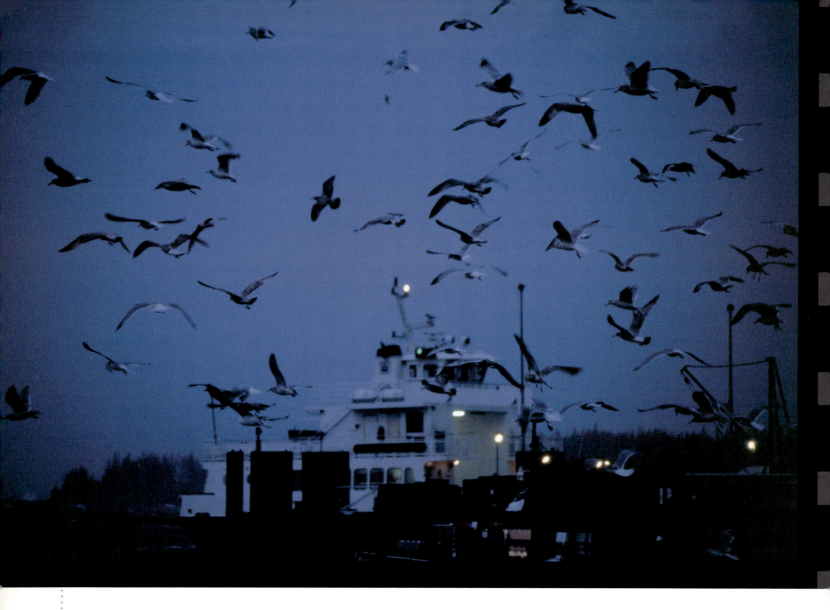

Seagulls, Vinalhaven, Maine. *I got up before sunrise and walked down to one of the harbors in Vinalhaven. I shot the already fast film two stops faster than the recommended speed, then I had my lab "push" process it accordingly by extending the developing time. The early hour light levels were so low but I needed a faster shutter speed to freeze the motion of the seagulls.*

Chapter Two: FILM VERSUS DIGITAL

Photography is a constant assortment of choices. Hundreds, thousands of them go into every picture you take. Equipment choices: big and small. Creative choices: concrete and elusive. Ethical and environmental. From what lens you buy to the f/stop you select, dozens of decisions make up each and every image. Many are instantaneous, made just as we compress the shutter release at 1/125th of a second, but today the method of capture is more malleable. The biggest change since the advent of photography is the medium upon which the image is permanently imprinted for the rest of time. It is both resilient and delicate and is most important because it is where the magic resides.

The **capture** medium can be many things but for the sake of this book, **film** is defined as a light-sensitive material in the form of an emulsion coating on a flexible base, such as plastic or celluloid. The coating undergoes a chemical reaction when exposed to the visual spectrum of light. That physical change permanently imprints an image on the medium. For all practical purposes and, despite what camera format you choose, the three types of film to be seriously considered are color negative, color reversal (transparency), or black and white. All others are special purpose: high contrast, infrared, chromogenic, etc.

19

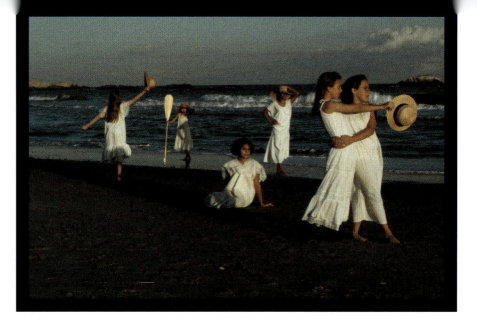

Eleven-year-old girls on the beach, Narragansett, Rhode Island. *The girls were all models and friends. In order to enhance the romantic nature of the setting, I used a film at 1000 ASA that is noted for its beautiful grain structure. All things being equal, the faster the film, the larger the grain or, if using digital, the greater the noise.*

Film speed is irrelevant. You're going to take the picture anyway.

Digital capture is recording on charge-coupled device (**CCD**) chips. They are comprised of millions of light-sensitive cells arranged in a grid pattern. Each position on the grid is termed a **pixel** (picture element). These pixels are reassembled by computer software on a monitor or computer screen to make up a conventional picture.

The many choices on the market has created some anxiety over whether there is a right or wrong medium for any given situation. Nothing could be further from the truth. It all comes down to individual preference or personal vision. Film is an established, mature technology and is unprecedented in quality; it is archival and accessible, while the industry is fast moving toward a constantly evolving electronic standard.

The pitched battle for the millions of photographic souls is in its infancy. Amazing developments in the quality of light-sensitive materials have propelled photography forward faster than at any other time in its history, and the resulting control we have over image content and speed of delivery makes progress in this business especially exciting.

Regardless of your choice—film or digital—the prevailing wisdom is to use the lowest ISO/highest resolution possible for the existing conditions (e.g., light level, weather, lens, aperture). For example, in bright sunlight, in the snow, on the beach, if you are concerned about optimum resolution and grain then a slow ISO (100) is appropriate. If it is overcast or you are shooting in shade or with

a telephoto lens, you might want a moderate ISO (200). High-speed films and greater sensitivity are required for shooting at night or in inclement weather, for stopping fast action, or when using really long lenses; these situations might call for ISO 400 or higher. It is not unusual for photo-journalists to use 1600, 3200 ASA film or faster when the content of the picture outweighs its quality. Scientists have kept the measurements for both film and digital analogous, so there is an equivalent loss of quality for both media as the ASA increases. This is called grain with silver and noise for electronic sensors .

COLOR TEMPERATURE

In order to make intelligent exposures, there are a few concepts that are useful, although they tend to be badly defined in most discussions. It is easy to understand the importance of matching the capture medium to a par-

There is no such thing as white light.

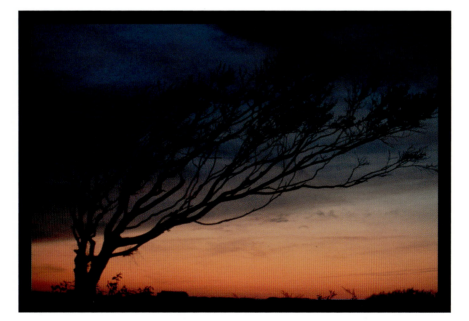

Newport, Rhode Island. *You can see a portion of the spectrum behind the tree. Note the difference in color temperature, ranging from the warm colors near the horizon to the cool tones of the light diffracted by the storm clouds.*

21

ticular type of light. It is not so easy to know what that light is. Our eyes and imaginations are not reliable for differentiating light sources, a drawback that is especially critical with color.

The decision to make a color photograph adds complexity. The introduction of color adds a new dimension to the creative process. Color balance is an objective as well as subjective issue. **Color temperature** is a scientific abstraction. It is a theoretical measurement. In nature, the human brain works instinctively to "see" a wide variety of lights as "white." Inside or out, even under exaggerated, artificial colors, the mind makes involuntary adjustments so that people with normal eyesight interpret colors basically the same under varying conditions. But true *white* light occurs only when all the colors in the rainbow (the spectrum) are combined in equal amounts. This rarely happens in nature, so our vision adjusts and makes the light of the environment appear close to white in spite of an actual tint. The average person can recognize sunrises and sunsets as being much warmer (orange/yellow) than light during the middle of the day. When it is overcast, clouds refract the longer red and yellow wavelengths of light and the shorter, cooler wavelengths at the end of the spectrum (blue and ultraviolet) penetrate the atmosphere. This variation in color is somewhat detectable by trained eyes but is especially apparent on color films. Depending upon your intent, it can be either a good thing or a bad thing. Many experi-

enced photographers use this color shift to their artistic benefit but recognize that it can become very problematic if the result is exaggerated, unpleasant, or unexpected.

Light-sensitive media are designed to be used within relatively narrow spectral ranges. It is essential to understand what natural and artificial light sources do to different emulsions so we can control the final outcome. The biggest demarcation is between films or CCDs engineered for outside use during daylight and those meant to be used indoors or under incandescent illumination. We filter for everything else.

Color temperature is measured in degrees Kelvin (K). Film designated "daylight" has a rating that is optimum at 5500 K. Most flash is also rated to imitate daylight at noon (approximately 6000 K). Household light bulbs are continuous light sources that emit wavelengths nearer the red end of the visible spectrum (approximately 2800 K). Professional tungsten lamps give off a temperature of 3200 K (type B) or 3400 K (type A). Sources that give off light well outside the capabilities of these two film types may require filtration to render a realistic-looking image. Shooting film under conditions for which it was not designed can produce unusual results. Daylight film can be intentionally used with tungsten light, but it will render the scene artificially orange. Shooting tungsten film with a strobe or outside during the day will result in a very blue color balance.

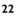

POSITIVE *VERSUS* NEGATIVE

Color reversal films, also known as "positives," make transparencies (slides) and color negatives produce prints. Your choice can be as simple as that. Traditionally, most commercial applications for photography have used transparencies. Magazines, graphic designers, and advertising agencies usually insisted on "chromes," but with today's technology (e.g., computers and scanners) they are proving less important.

Reversal films must be more precisely exposed and developed. They are very unforgiving, whereas negative film has much more **latitude.** Latitude is defined as the range of brightness a film can render. It is the variation in exposure that will still produce an acceptable image without noticeable loss of shadow or highlight tone gradation. Instead of the photographer having to be 100% accurate in judging the exposure, there is some latitude. This is another significant difference between positive and negative films. The additional latitude gives negative films several stops' advantage over positive films. Acceptable prints can be made from negatives that have been somewhat over- or underexposed.

Because relatively large adjustments in color can be made during printing, negative films are well suited to all sorts of difficult and unfamiliar lighting conditions. Gray or inclement weather is the most obvious situation, but you often encounter other lights that are not matched to any film. More complex scenes may combine daylight with incandescent lights, neon lights, candles, fluorescent lights, etc. If you load your camera with negative film, you can make compromises to the color in the darkroom, but with more experience and by employing filters, color temperature meters, and Polaroids to preview before the final exposures, you can render any scene acceptable and pleasing with either transparencies or negatives.

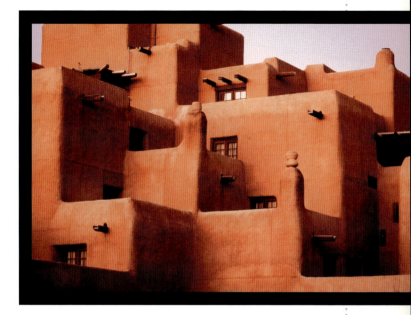

Adobe structure, Santa Fe, New Mexico. *In order to take advantage of the sunset, I had to return twice to this spot, but I wanted the golden light that occurs when the sun is near the horizon.*

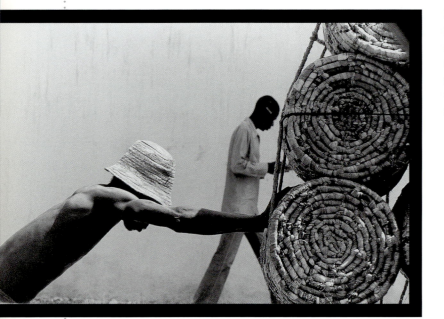

Laborer, Port-au-Prince,
Haiti. *Some subjects call for black and white.*
I saw this man pushing his wares up a small
side street. While I waited for him to reach me I
prefocused and framed by guessing. The graphic
nature of the subject matter enhances the
drama of the toil.

> "Black and white are the colors of
> photography.
> To me, they symbolize
> the alternatives of hope and despair
> to which mankind is forever subjected."
> —ROBERT FRANK

BLACK AND WHITE

Most people see in color. Some photographers "see" in black and white. In black and white are the origins of photography. Much of history has been documented in black and white, and creatively it will always be a compelling component of a photographer's arsenal. Photojournalism continues to nurture the uniqueness of black and white. Galleries and museums elevate black and white to fine art. In the right hands, it can be graphic and dramatic. And it remains a wonderful introduction to the mysteries of the medium. Also, the absence of color can obscure a lot of the problems discussed on these pages. Color temperature is far less important when using monochromatic films. These films offer exceptional processing and exposure latitude. Stylistically, you can be a little more cavalier about shooting black and white.

Some photographers say that color film is too real for their art. Black and white images force the viewer to concentrate on content, composition, or abstraction. Some subject matter is so compelling that reality is secondary. It takes a trained eye to interpret the different facets of the world around us in shades of gray. The emotional impact of color complicates some subjects. Black and white simplifies.

Black and white preserves my past. Contact sheets are my diary. They are my ideas traveling at the speed of light. It is almost mythological.

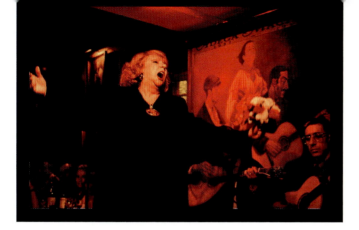

Fado singer, Lisbon, Portugal. *It is impossible to carry all the films that might be necessary for the different lighting conditions you might encounter in a day. We got permission to photograph in a club in Portugal. It was a quaint, traditional, badly lit environment. All I had was daylight film, but I took pictures anyway. I pushed it a few stops and hoped the power of the moment and content of the photograph would outweigh the warmth in color and gain in grain.*

DIGITAL

Digital capture media are taking over a larger share of the photographic market. From small, pop-culture cameras to fully functioning professional models, they are rapidly displacing film. Charge-coupled devices and complimentary metal oxide semiconductors (CMOSs) are light-sensitive computers. Proprietary software interprets the analog image that comes through the lens and converts it into numerical form. The instantaneous gratification of seeing an image on the LCD on the back of the camera or bringing it up on a computer monitor make the possibilities limitless.

This kind of immediacy and flexibility from digital capture can put unprecedented control into the photographer's hands. The size of the electronic sensor and the make and model of the chosen camera will determine the size of the eventual file and the resolution of the digital image. Maximum resolution of any camera is largely a matter of cost; that is, the more money you spend, the sharper your pictures will be. By allowing you to turn up the electronic gain the memory cards let you select a different ISO or sensitivity for each individual shot. Similar to film, when you increase the sensitivity (grain), you increase the "noise" or unwanted electronic information.

PUSH/PULL

There is no perfect film, no perfect film speed. And nowhere is the adage "for everything you gain, you give up something" more apt. For example, along with a gain in film speed comes a loss of sharpness, a decrease in contrast, and an increase in grain. With color film, there is also a loss of color accuracy and saturation. Usually we try to reduce these effects but we can opt to emphasize any of them for effect as well as practical reasons.

Some artists like the "textured" appearance that the clumping of silver halide crystals produces. It is termed **grain** and is more apparent with high-speed films or when extending the recommended

25

development time, which is called **pushing.** Pushing is a great tool for the clever photographer. Not only can you increase the apparent ASA when encountering dim light or using faster shutter speeds, but you can also rescue film that has been improperly underexposed. If you are careful, you can process just a portion of a roll of film or one roll out of several shot at a critical scene. This is a "clip test." After you analyze the results, you incrementally "push" the rest of your film or even "pull" it (reduce the development) to produce optimum images. Many professionals rely on this technique for exacting commercial assignments.

BRACKETING

"Film is cheap." That is one of the most popular clichés that you hear in professional circles. You travel too far not to bring back decent photographs. It is imperative to carry enough film to ensure ample coverage. Nothing can be more expensive than to come home empty-handed. And, if a shot is worth taking, it is worth taking twice.

No matter how hard you try, there are photographs whose execution defies measurement. Light meters can be fooled, and the exposure range of the scene can exceed your ability to make an intelligent calculation. **Bracketing** is a way of buying a little insurance. Once you make your "best guess" exposures, you take additional ones both over and under the recommended reading. Depending on the critical nature of the shot, after taking the first shot you can overexpose a second frame 1/2 or 2/3 stop and then underexpose a third shot by the same amount, if it is a simple setup. With experience you will learn to expand the bracketing (i.e., wider range and more frames). With really tricky shots it is not unheard of to run through rolls of film and several stops to ensure achieving just one ideal frame. Because there is no one perfect exposure, an extreme setting may result in a better picture even though large parts of the image are obscured by "blownout" high-

lights or "blocked up" shadows. With changing light or lots of subject movement, judicious bracketing is essential. In fact, it is so important that camera manufacturers have designed automatic bracketing into some of their professional models.

With digital, the immediate feedback can reduce the necessity for so much bracketing but it does not eliminate it. You can view the photograph on the LCD and determine if you have what you want. The histogram assists in determining whether or not the shot is overexposed. But some situations defy simple capture. There are applications for merging two or three images to take advantage of the best exposed parts of each. Some professionals even bracket white balance to ensure that they have a color rendition that is most appealing or, at least, more easily correctable.

X-RAYS

So many of the places we wish to document are public. Today more of these spaces are guarded by security systems. Photographers are targets for inspection and confiscation. In the modern world, we find ourselves frequently passing our equipment through check-ins and check-outs. Increased airport security has made it difficult for travelers to protect their film. All film should be considered as carry-on luggage. Separating yourself from this delicate commodity is ill advised. If it is underneath the plane, there is no way to protect it from heat, cold, or moisture, especially if the plane is delayed or cancelled. In addition, new machines have been installed everywhere for scanning checked baggage. This high-powered computed tomography (CT) scan technology, similar to the medical equipment, is very dangerous to light-sensitive materials. Avoid at all costs.

Although hotly debated, x-rays do have an affect on film. How much is the real issue. Photographers encounter x-ray machines at

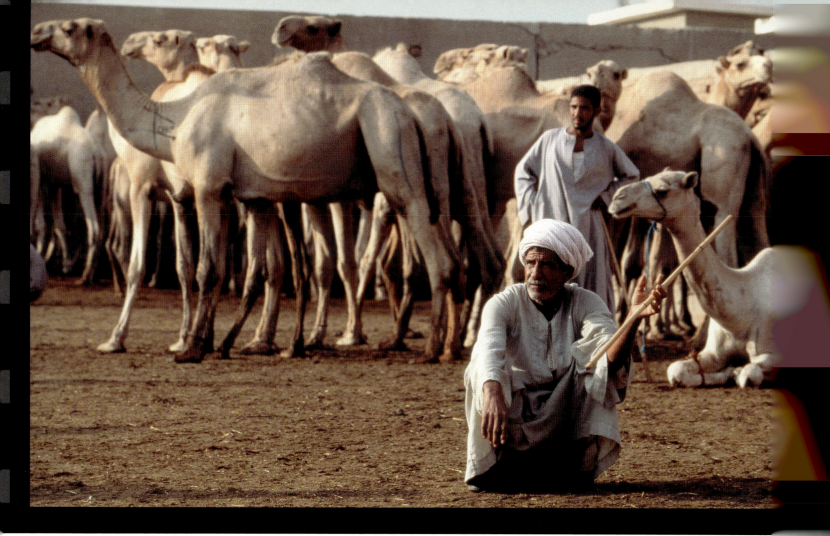

Camel market, Birqash, Egypt. *Over time, technology changes, tastes change, palettes change. Some films have a subtle palette, some use bold colors. Some render skin tones pleasantly, and some try to reproduce colors accurately. Test a few and stick with the ones you prefer. Learn how they react in various situations rather than risk using an untried film. In digital, use various software to expand the reproduction possibilities.*

security checkpoints everywhere, but the biggest problems occur at airports worldwide. Tests have been performed by manufacturers and security authorities in order to shed light on the problem, and their conclusions are that repeated scanning does not significantly damage most moderately rated films; however, the effect of x-rays is cumulative. Well-maintained machines do not leave discernible impressions, but a small change happens every time a roll goes through a machine. Multiple passes of film through x-ray machines, or with high speed film can show lower saturation or color shifts or, in extreme cases, shadows that look like Rorschach tests imprinted on layers of the film emulsion.

Ask for hand inspection whenever possible. By federal law and FAA rules, you are entitled to hand inspections within the United States.[1] You can request that a guard look through your sensitive belongings. Remember, though, that airport security is a low-paying, tedious, thankless job. Treat the people who perform these tasks with respect. Their jobs are difficult enough, and you are introducing a major interruption to their routine. If you make a conscientious effort to facilitate their jobs, the whole process can become more efficient. You can keep unexposed film in the original, sealed boxes and carry shot film in clear plastic bags. The inspectors can then observe exactly what is inside. Nonetheless, many overzealous personnel will still force you to take every roll out of its packaging. This is usually meant just to intimidate. Ask if you can help with the task.

Download your cameras and send all the hardware through the machines. Afterwards, airport personnel often still want to inspect cameras, bodies, or lenses. Offer to open anything. Be absolutely charming with the attendants and they may have mercy on you. Having careless people paw through your expensive, delicate equipment can be very stressful. Keep your wits about you and never overreact. You may have certain safeguards in your home territory, but once you are on foreign turf, life is not so democratic. In some countries, whether emerging or first world, hand inspections may not be possible, but the same advice applies: A calm demeanor usually goes a long way. Some travelers swear by lead-lined containers. They provide excellent protection but are not so easy to use and require additional handling at the airport checkpoints. Several companies market film shield bags in various sizes and weights.[2]

The inconvenience posed by security may be another compelling reason to switch to digital. Without rolls of film, you may be able to avoid some of the security humiliations, and there is so much anxiety and confusion regarding x-ray security that you may not want to deal with the hassle. But, take note. The effect on memory cards is no different than on laptops, PDAs, etc. The dosage of x-rays is extremely small, but, as for film, x-rays still can be harmful to digital media.

[1] www.faa.gov/avr/AFS/FARS/far-108.txt

[2] SIMA (film shield bags), www.simacorp.com

FILM You spend thousands of dollars on the best camera gear. You pay even more to travel halfway around the world. And then you entrust the most important, sensitive aspect of your photographic adventure to a one-hour kiosk lab? These film-processing places are fast and cheap. You may be lucky enough to find a conscientious craftsman working at one of them, but generally it is someone collecting minimum wage. It is potentially the most dangerous thing you can do to your film.

STORAGE

Film is an unstable commodity. Its active chemistry causes the material to constantly evolve, and it changes more quickly after exposure than before. Also, film ages and becomes outdated. So, special care must be taken with this precious product.

Heat is film's natural enemy. It should be stored in a dry, cool place. The aging process can be slowed down drastically if you refrigerate or freeze it. If you also protect it from long-term condensation, it will last longer than the recommended expiration date. In the comfort of your home, you can store both shot and unshot film under these ideal conditions, but on the road you must be careful about where you leave every roll in your possession. If you are lucky enough to have air conditioning in your hotel room or in the car, not only can the film be kept cool, but the air conditioning reduces the humidity.

In very hot or wet climates, packing all film in food/beverage coolers provides better control over climate and the coolers are reasonably portable. You can store film *underneath* refreezable gel packs; the new, soft kind can be compressed and packed away until needed. Never leave film in a car on a hot day. An automobile acts just like a greenhouse in the sun, and the temperatures inside can exceed those outside. In extreme situations, photographers have been known to bury their film in the ground.

Some manufacturers make memory cards that can withstand extreme temperatures, so, theoretically, you can be a little more relaxed about maintaining your digital capture media. Just be sure to take good care of the storage devices that you transfer your data onto. 🔘

Gospel choir leader, First Emmanuel Baptist Church, New Orleans, Louisiana. *The church pastor is in silhouette because the film had been exposed for the stained glass window. The latitude of the film was not capable of rendering the bright sun coming in through the window and the figure in front of it at the same time. A decision was made to take advantage of the iconic image and its colors.*

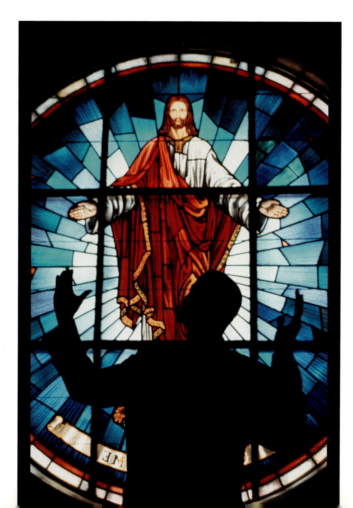

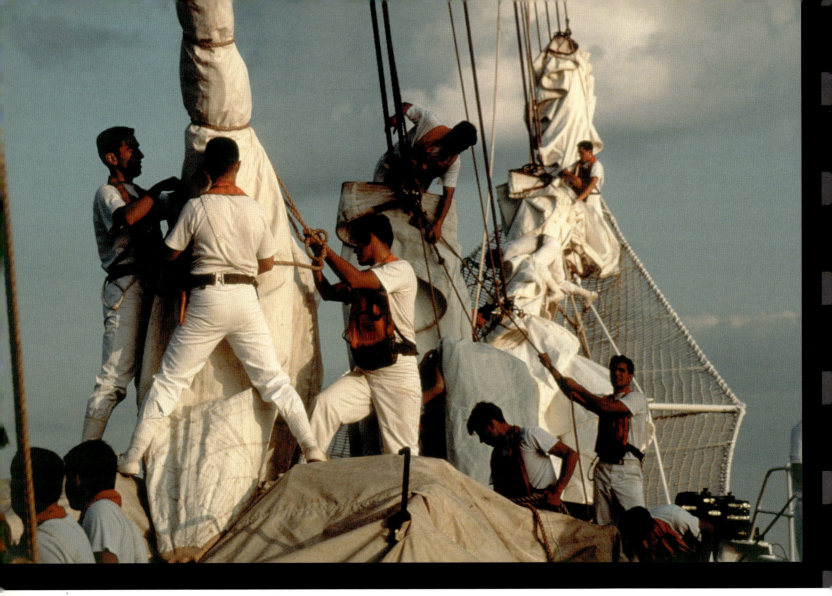

Crew on Chilean tall ship *Esmeralda*. *Daylight was abundant, and it was the only light source I had aboard this amazing boat. I convinced the Embassy of Chile to let me take the 3-day sail on the flagship Esmeralda from New York City to Boston. I had to travel light but still be ready for every contingency. All the important activity went on outside, so all of my pictures were taken using the available light.*

> "Light is my inspiration, my paint and brush. It is as vital as the model herself. Profoundly significant, it caresses the essential superlative curves and lines. Light I acknowledge as the energy upon which all life on this planet depends."
> —RUTH BERNHARD

LIGHT AND LIGHTING

LIGHTS! CAMERA! ACTION!

The word *photography* means "writing with light." The adventure we embark on as photographers requires that we make peace with light, or the lack of it. No matter what kind of camera we use—film or digital, large format or compact—and whether we shoot black and white or color, light is the main ingredient in any photograph. In photography, every characteristic of light can be used, controlled, altered, and recreated. Creatively mastering light and dark is the trademark of a good photographer. The better we are at recognizing and modifying light, the better our pictures will be.

Whether you are committed to editorial photography and small-format cameras or landscape photography with large-format equipment, you may never need to supplement your vision with artificial lighting. The travel photographer, however, cannot wait for perfect weather or ideal natural light and may have to take over occasionally for Mother Nature.

Vendor in the Iron Market, Port-au-Prince, Haiti. *The extremes of the day (sunrise/sunset) can produce the most beautiful, soft light. With the sun over my left shoulder, it bathed the merchant with an easy-to-measure golden light. The brown and yellow colors of the chairs and the skin tones just added to the monochromatic market scene.*

EXPOSURE

For decades, photographers have been trying to harness light, mold it in artificial ways, and invent creative, albeit unusual, techniques to improve their pictures. Any discussion about light must begin with exposure. To fully comprehend the physics and aesthetics of light is to measure it. Exposure on film is very important. Perhaps exposure for digital is even more so. For all practical purposes, the dynamic range of transparency film is about five stops and the useful range with digital is about the same. Outside of this range lie overexposure and underexposure, so proper metering is always critical. Whatever format you use—small, medium, or large; film or digital—careful metering prevents lost information.

Advanced through the lens (TTL) and evaluative meters in SLR cameras have improved over the years and are crafted for optimal results. The in-camera light meters segment a scene in a myriad of ways and the algorithms make their recommendations. Typically, an SLR camera will have evaluative, partial, and center-weighted average metering that can be relied on in most situations. With a little practice, sighting, reacting, composing, and shooting can be accomplished in almost one fluid motion, paying little regard to the mechanics of the camera, so you hardly ever disturb a scene. Although the automatic systems make the task of proper exposure easier, great caution must be taken to interpret the information properly.

HISTOGRAM

The most inventive and useful new tool that digital photography has introduced to help us perfect exposure evaluation is the **histogram**. The histogram is a graph with brightness along the horizontal axis (x-axis) and the number of pixels at each brightness level on the vertical axis (y-axis). It is basically a mapping of the colors in an image, and it allows the photographer to evaluate the accuracy and spread of the exposure over the camera's dynamic range. A histogram gives a good indication of whether the choice of aperture and shutter speed is overexposing or underexposing and whether exposure compensation can improve the scene. In bright sunlight, camera meters measure average subjects and scenes well and require no compensation. In shaded areas or on overcast days, most TTL meters are biased to underexpose, so you need to add light. Learning to read the data is essential.

Modern metering systems have been improved so much that they outperform handheld meters in many situations. They work exceptionally well during very long exposures and interpolate when you are mixing different light sources, doing it instantaneously, but they are not foolproof. Experience and the histogram will dictate whether or not to override the automatic readings.

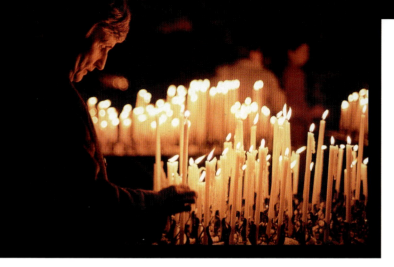

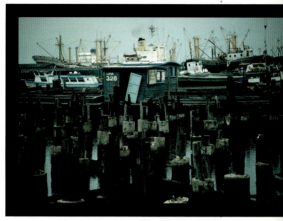

Waterfront, Cienfuegos, Cuba. *I knew I might never return to Cuba so I had to take pictures despite the rainy weather. The ultraviolet radiation penetrating the clouds tinted this waterfront scene blue but that made the rundown, cluttered setting even more dramatic.*

Votive lights and parishioner in Il Duomo, Milan, Italy. *The church was pitch black inside. The only light was near the huge areas of votive lights, so I staked out a spot near one that was giving off the most light and waited for the right subject. Il Duomo was so crowded with tourists that I don't think anyone noticed me off to the side. I steadied my camera with a monopod, which allowed me to use very slow shutter speeds. I expected the color temperature of candles to give me reddish tones but for this scene they are appropriate.*

AVAILABLE LIGHT

The most common light source is daylight. Because the sun is the first source we encounter, we often take it for granted. If you are a photojournalist or a travel or nature photographer, it may be the only light source you ever need. It is simple and abundant but unreliable. Besides being unpredictable, available light can have color temperature inconsistencies. With transparency film this is a major problem that may require filtration to correct, but it can be overcome with presets on most high-end consumer and professional digital cameras. Before you set out on any journey, there are certain things you need to know besides where you are going. Because photography is your intent, you need to develop the skills that enable you to "see" light. These can be learned, but you must be able to almost instinctively recognize the many qualities of light.

Feuerwehr Wagner restaurant, Vienna, Austria. *There are at least three kinds of light in this picture. The yellow color next to the men in the bar is tungsten. The light on the wall outside of the bar is green fluorescent. The cyan ultraviolet effect of the evening light is daylight. And, again, the tungsten light from the lanterns is warm. The extreme contrast and mixed light sources made setting the exposure very difficult.*

33

Light has *direction*.

Besides knowing whether it is coming from the north, south, east or west, you should train yourself to "feel" how the hemisphere or time of year affects the light. Carrying a watch and compass can give you the information you will need for the next few minutes, hours or days in order to predict where the light will be. How a scene is struck by light can make all the difference as to whether it is a good picture or just an average one. You may need to return at another time. This is called "chasing the light."

Light has *color*.

Most professional photographers acknowledge that some of the best light is usually at dawn and dusk. This is no secret. The sweet golden rays at those hours enhance almost any scenery. If your photography is intended for public relations, the nurturing effects of a sunrise or sunset cannot be ignored. But, almost all light is good if you know how to handle it. Cloudy days, fog, rain, and snow are weather conditions that establish a mood. They are all beautiful when beheld by the right eye. Recognizing the amount of ultraviolet light contained in bad weather or the amount of infrared found in candlelight and how it will influence your composition is part of the art of making pictures. Colors can be more vivid on overcast days. Muted tones and pastels are passive and romanticize foggy landscapes and force you to wake up earlier every day. It does not have to be sunny all the time.

Light has *shape and texture*.

Daylight may be plentiful but often it is "contrasty." Hard light yields deep shadows, while diffused light makes for soft, airy shadows. A light source raking across any object gives it shape and volume. A sharp, oblique light will bring out the texture in objects, so they appear more three dimensional, and a flat light will make things blend together.

Light defines space. It is your weatherman. It is your compass. Revel in its complexity and savor its personalities.

Schooners, Bartlett Harbor, Maine.

I thought my career was over. I had spent a lot of time and money to rent this boat, and the day began with beautiful weather but quickly deteriorated. As I stood on the deck alone, this ship emerged out of the fog. I had the presence of mind to realize this could be a good shot. I included part of my schooner in the foreground; its image is sharper and contrasts with the ghost ship obscured by the weather.

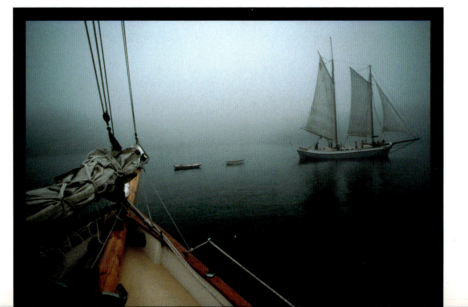

"Photographing in direct sunshine is like drinking from a firehose."

—JOHN SACHS

Preservation Hall Jazz Band, French Quarter, New Orleans, Louisiana. *I returned to this club three or four times before I was able to take the picture I had dreamed about. Even for interiors with mixed light sources (tungsten, fluorescent, neon), my default is daylight films. I positioned myself so I could include the band and the people waiting outside to get in. I used a fast, short telephoto with the camera on a monopod. I pushed the film, the lens was wide open, and the shutter speeds were still slow. I bracketed like crazy.*

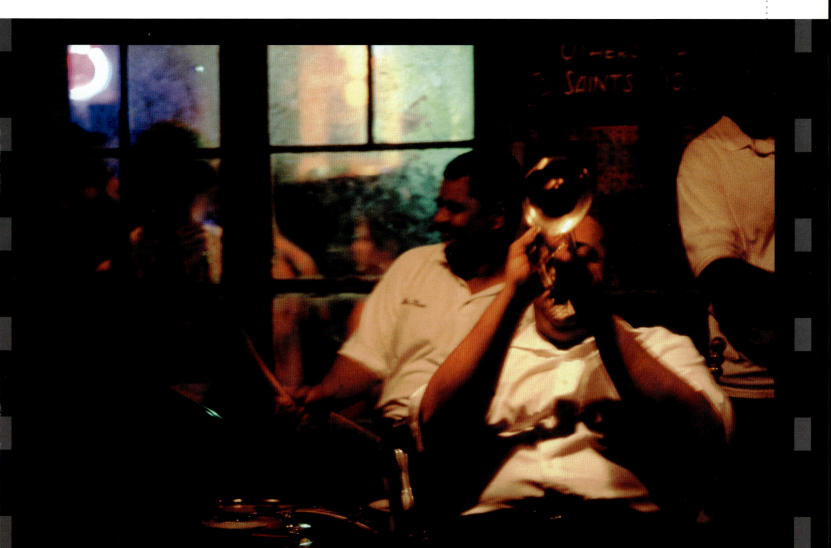

NONCONTINUOUS LIGHT

The bane of a photographer's existence is noncontinuous light sources: fluorescent, sodium vapor, mercury vapor, metal halide, etc. You will find fluorescents being used for illumination in more and more places—residential, industrial, and commercial. The other types of lights are extremely efficient ones that are used in industrial facilities for maximum illumination with the least expense. In these locations, color balance is not the major concern. These lights are engineered to produce a "spike" in their spectrum; that is, they emit a light deficient in certain wavelengths. The resultant illumination gives an undesirable cast to color film.

Fluorescent lights photograph green, mercury vapor emits predominantly a bluish light, and sodium vapor is orange. All of them are difficult to filter. Even color temperature meters turn out to be inadequate in some cases. It takes a lot of practice to photograph under these conditions. You have to learn to detect odd colors. With enough time, you can shoot a test with different filtrations and process it before shooting the final film. As discussed before, negative film may be a reasonable compromise. Digital has automatic white balance and it adjusts for most slight variations in lighting, but a wider range of preset conditions is built into most expensive digital SLRs. They may compensate for the above light sources, but custom white balancing may be the only solution.

God made daylight.

The devil made fluorescent.

Darling Harbor, Sydney, Australia. *Twice a day, rain or shine, you can experience this kind of light. For only about 45 minutes, just before the sun comes up or just as it is going down, the ambient light matches the city lights. The combination of reciprocity failure caused by the long exposures and the prevalent ultraviolet resulted in vibrant "magic blue" pictures.*

Women in butterfly park, Kuala Lumpur, Malaysia. *I was rushing from one side of the butterfly park to the other when I spotted these women inside the fluorescent-lit pavilion. Because I was chasing butterflies outside, my cameras had daylight film. I was reluctant to take this picture because I knew it would turn out green but it was too good to pass up. I have never color corrected the image because I think the eerie tint contributes to the surreal nature of the image.*

Motorcycle manufacturing plant, Lincoln, Nebraska. *I lit the plant all day for an annual report, but one section had huge skylights overhead. I thought it might be interesting to try to filter the mixed lighting. The interior lights were almost all fluorescent and the ambient was daylight. I measured the light with a color meter and used the recommended color-compensating filter pack of magenta and yellow to compensate for the green in the noncontinuous lights. I straddled the production line with my tripod and made several exposures as the motorcycles rolled between my legs.*

FLASH

We have come a long way since the introduction of magnesium powder as a substitute for the sun. The movie industry continues to wrestle with large, heavy, hot tungsten klieg lights to brighten their sets, but artificial illumination for travel photography has become almost exclusively the realm of electronic flash. In critical situations, where there is little or no light in evidence, the mastery of some form of light-assist is imperative. Strict reliance on available light means that you often have to walk away from interesting photo ops or settle for inferior pictures.

The use of small flashes is hotly debated. On-camera flash solves the contrast dilemma by front lighting everything, but the final product tends to be rather static and unnatural. On-camera flash is rarely seen in commercial photography. It is mostly an amateur's crutch. Most serious photographers solve lighting problems by using faster lenses, faster films, tripods, and their imagination. But the flash is an invaluable tool in the hands of a capable expert. The new breed of **speedlights** that are automatic and TTL (through the lens) are almost foolproof and require just a little understanding and practice.

Glass manufacturing plant, State College, Pennsylvania. *To shoot inside a large television manufacturing plant I lit the entire area. My assistant and I brought large studio strobes and spent hours relighting the assembly line. We used at least three flash heads, soft boxes, and umbrellas to light the television picture tubes, the female worker, and the background. Polaroids were used to establish the correct f/stop and shutter speed.*

"Using strobe is like taking your pistol to the opera."

—HENRI CARTIER-BRESSON

Basketball and tuxedo. *I took this dancer, who had arrived dressed in a tuxedo, a couple of blocks from my studio to photograph him in front of the urban graffiti. I had him jumping on a small, portable trampoline. I attached my speedlight to a lightstand and hardwired it to my camera, which was set to "programmed" mode. I tried to catch him at the apex. He jumped until he couldn't anymore, and we got these dynamic photographs for the magazine.*

Ballroom, Beechwood Mansion (home of the Astors), Newport, Rhode Island. *We set up a couple of small strobes on stands to light these gowned models. We moved a lot of furniture, then balanced the strobes to the ambient light coming in from outside.*

Location shot to illustrate variety in wines. *I used a strobe light with a blue gel on the background. A red neon tube was rigged directly behind the glasses. Incorporating flash with these primary colors created great contrast and drama.*

When used as fill, on-camera flash enhances and supplements nature. This system cannot be faulted for either convenience or portability. **Fill flash** is another byproduct of the modern electronic strobe. It is very useful for reducing shadows in harsh light and providing additional subject illumination while maintaining the ambient light as the main source. Experiment with the override buttons on both the flash and on the camera in order to arrive at the most pleasing combinations for your style. Often –1/2EV to –2EV will allow the fill to put detail in the shadows areas or on backlit scenes without being at all obvious. Even fill flash can be improved by holding the unit off camera to obtain more definition and contrast.

The use of extension PC cords that allow photographers to keep the speedlight off the camera or out to the side produces more natural results. They eliminate "red eye" and improve modeling by emphasizing subject shape, texture, and shadows. You can also apply diffusion to the flash tube to soften the light. These more advanced TTL strobes are not cheap, and the cheap ones are not capable. Perfecting technique with minimum power is recommended to both those photographers for whom buying ample light is not a problem and those whose pocketbooks cannot yet handle such an energy crisis.

Speedlights can be used to control your depth of field or to prevent ambient light from being overpowered by different sources (e.g., background fill, televisions or monitors, windows).

The single most important precaution for flash use is to use shutter speeds at or slower than the recommended **synchronization speed**. Synchronization is the mechanism that fully opens the shutter of a camera before the flash or speedlight can fire. Most of the more expensive cameras take care of that mode automatically. Every camera manufacturer produces a dedicated speedlight designed for use with their specific brand, but aftermarket brands get the job done too.

Because flash does not emit light continuously, it is difficult to estimate exposure. With speedlights it is measured automatically. The TTL metering accounts for not only the flash but also ambient sources of light. With DSLRs you can review the image on the LCD immediately to confirm results. The histogram ensures usable exposures. You can increase the number of strobes and eventually light bigger and bigger sets. You can control everything under your purview and have the security of knowing that you are getting what you intended.

Another technique that has gained favor since dedicated speedlights have come into fashion, is **slow** or **rear curtain sync**. Using the camera also in slow or rear curtain sync mode blends existing light and the speedlight output and integrates these multiple sources into the overall exposure. Special effects and stylized blurs can be incorporated into very low light because of "dragging the shutter" (i.e., long shutter speeds). Again the camera manages all these calculations automatically. With such long shutter speeds, make sure you use a tripod whenever possible.

BOUNCE

Flash aimed straight at a subject is a harsh light. The theory behind bouncing light is to spread out the concentrated "hard" light from handheld flashes or strobe heads. Bouncing the light off a white ceiling or wall or reflector will soften the result and create a more three-dimensional appearance. PC extension cords let you improve the efficiency of small units because the flash can be placed close to the subject while maintaining the camera/subject distance. The TTL circuitry allows you to make perfect exposures despite the use of long or short lenses. As you gain skill and confidence you can bounce your lights into additional types of light modifiers, such as umbrellas or portable bank lights (called *softboxes*).

It is difficult to master lighting. Breaking rules that were inviolable a few years ago is fashionable today. What passes for good technique is largely a matter of personal preference. But, armed with all the requisite equipment, metering systems, and sampling processes, you are ready to actually take pictures. If you are a truly versatile photographer, you will let your subject matter and its mood (e.g., comical, somber) dictate how you proceed. You have creative control because you decide what to illuminate and what to leave in the shadow. You can emphasize what is important in your image by making it brighter. Conversely, what you choose to hide remains in the dark. ◉

> **"Light is an active, aggressive force."**
> —JAY MAISEL (2000)

Young couple at outdoor café, Boston Harbor, Massachusetts. *For a large production for my stock agency, I put together models, props, and locations. All the images were shot digitally in RAW format. The large 13.5-megapixel files allowed me to do a lot of postproduction to manipulate color balance and correct other defects.*

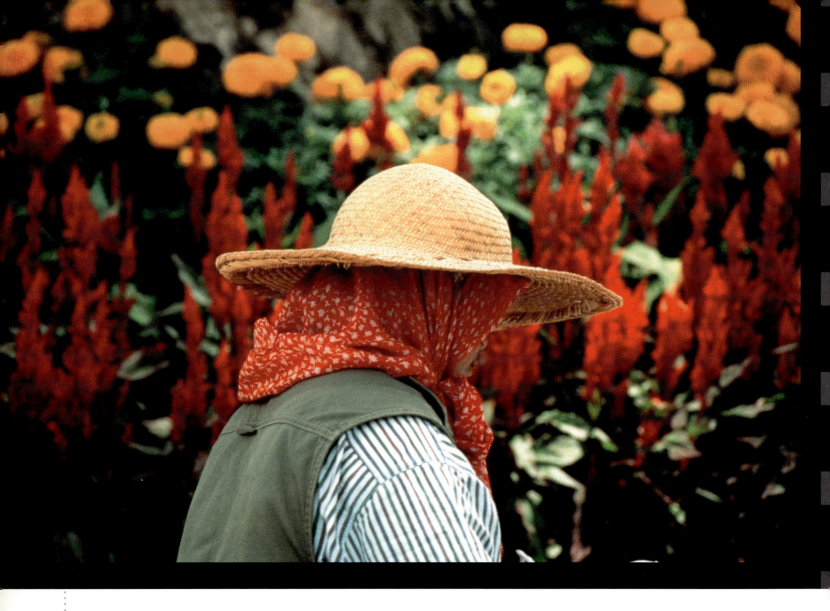

Kuala Lumpur, Malaysia. *Malaysia is near the equator, so the primary concern year-round is heat. Dressing in lightweight clothing, wearing a head covering, and drinking sufficient water make it easier to see abstract photographs, like this artist painting in downtown Kuala Lumpur.*

Chapter Four: **CLOTHING**

Down through history clothing has been an expression of individuality; it is your plumage. It can be conservative or trendy, bland or blatant, innocuous or outrageous, but it is all yours. You can dress comfortably. You can dress fashionably. You can dress for success. You can dress a mess. How you dress has little to do with photography, but your outward appearance can certainly affect the pictures you get.

For some reason, tourists outfit themselves in the most bizarre clothing once they get very far from home—they wear things they would not be caught dead wearing any other time. An entire industry has flourished around this compulsion to play the ugly traveler: umbrella hats, pith helmets, thick crepe-soled shoes, and even thicker mail-order catalogs are all conspicuous examples. The allure of foreign adventure makes people think they need to adopt new personas. Travel clothing does not make traveling easier, although the right clothing can. Success is often as much a function of packaging and image as content is.

On the other hand, nothing will compel you to put on clothes you do not want to wear, even when you should. Comfort may trump practicality, or *vice versa*. It is ultimately a matter of personal preference. Your only responsibility, as a photographer, is to be sensitive to local traditions. Modesty, religious customs, and fashion often determine your acceptability. It is rare that you will be forced to

wear native costumes. Some locals may even be insulted if you do because inevitably you will go about it incorrectly (e.g., wrong style, wrong accessory, a knot twisted the wrong way). Indigenous dress codes can take a lifetime to master.

Short pants and head coverings can be troublesome apparel for men. Short hemlines, pants, and bare shoulders can be taboo for women. In some cultures, certain colors raise "red flags" and should be avoided. If you have an agenda and cannot play by the local rules, then just stay home or visit the plenty of other places where your sensibilities will be tolerated.

If your style of photography is slow and deliberate (e.g., if you shoot four sheets of 8" × 10" black-and-white negatives per day) or if you mount huge productions with multiple assistants, models, and tons of lighting equipment, then how flamboyant your apparel might be does not matter. In these cases, you are manufacturing your own environment. But, if you attempt serious photojournalism or street photography and want to move amongst the locals, you may want to tone down the clashing neon ensemble.

SHIRTS

Exotic, expensive fabrics may be fashionable, but besides being susceptible to climate and terrain they may be difficult to wash on longer trips. Not every place you visit will have dry-cleaning facilities. So, keep it simple. Purchase natural fibers or natural/synthetic blends. Pure synthetics can get sweaty and retain odors even after laundering, and wrinkle-free rayon or polyester is suffocating. Be aware that most hotels will be able to help with basic washing and drying. In fact, many of the poorest countries have the best laundries.

When you encounter groups of people you hope to photograph, you want to give yourself the best chances of success. The prevailing wisdom among more experienced photographers is to try to blend in. Besides being culturally volatile, certain colors can be loud and draw attention to yourself. In most cases, avoid bright hues and shiny accessories. Remember that there is nothing you can do to make yourself inconspicuous. Disappearing is largely a state of mind that comes with feeling safe and confidant and projecting that to the people around you. Consider earth tones. They blend into most backgrounds and act as a sort of camouflage. Stay away from apparel bearing obvious trademarks or insignias or patterns. It can reveal your financial standing, nationality, or politics. Think natural and neutral.

Field test everything before you take it on a trip. On location is too late to find out that something is uncomfortable or just does not fit. Also, your clothes should not be brand new. Shirts should be generously cut for roominess. Depending on the climate, try to get used to long sleeves. They are multipurpose. Long sleeves protect you from the rays of the sun, insulate you if the weather takes a turn for the worse, and keep insects away from your skin. If it is hot, roll up the cuffs.

If you have a demanding schedule, pack at least a couple of shirts with collars. They can do double duty with a tie. Women need more formal blouses for the same reasons. If business attire is expected, make sure the entire ensemble complements the matching sport coat, pants, long skirts, and footwear.

COATS

Specialized jackets, safari jackets, and fishing vests are ubiquitous accessories. They are designed to be convenient; their big pockets, and lots of them, allow you to carry extra gear and distribute the weight more evenly. But, they can be extremely unflattering, and they mark you as a tourist. If you are on and off planes, you may not have the time to find out how people dress at your destination. Sport coats, suits, dresses, or other business attire may be necessary. And their upkeep has to be considered, too. If you expect to be very social and entertain a lot, you have to put more thought into your wardrobe. Search for very forgiving fabrics that resist wrinkles and are appropriate under various conditions. The most important concept is flexibility. Trench coats and blue blazers for men and women are nearly universal but they are not very interesting. Remember you will be noticed for your good as well as your bad taste. Pack light— the more you take, the heavier your luggage.

One caveat. In war-torn countries, stay away from military, army surplus, camouflage, or khaki clothing—that is, anything that will cause confusion about your appearance. Carrying long lenses in bad light and dressing in such a way that you can be mistaken for a combatant is very dangerous.

Resort, Little Palm Island, Florida Keys. *It is very difficult to always be prepared and have the appropriate clothes for various social situations. When traveling, it is not always possible to pack a jacket and tie or dress and jewelry for special occasions. In order to reduce the number of embarrassing moments, you have to travel a lot to find out what you absolutely need and what you can leave behind.*

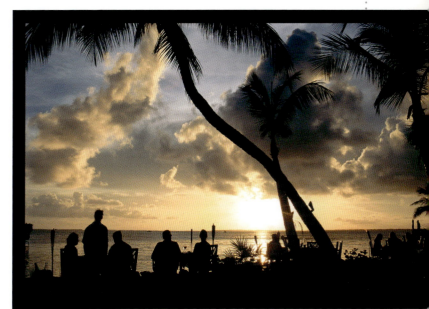

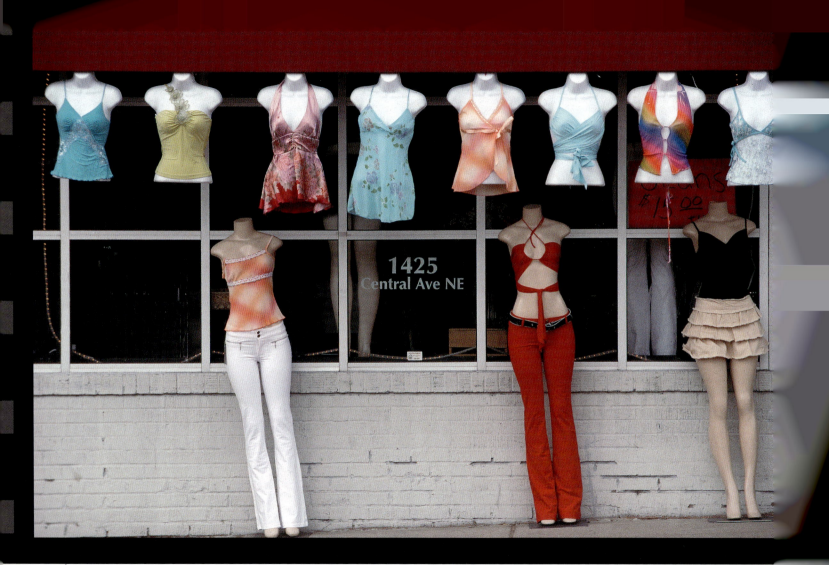

Clothing store on Central Avenue, Albuquerque, New Mexico. *Clothing is probably your most obvious identification. Clothes, like language, change with region or race. Clothes can be too new or too old. You need to be conscious of what you wear not only for modesty's sake but also for expediency.*

PANTS

Gone are the days when gentlemen would never appear in public without tie and proper hat. Today, casual attire is much more universally accepted. Even jeans are fairly common. Denim is a fashion statement that has permeated much of the world. You can wear it almost anywhere without standing out. Jeans, though, are somewhat heavy and take forever to dry. Shorts are controversial. Some societies and climates cannot exist without them. In many countries, they are *de rigueur,* but in other places of the world they are forbidden, especially on women. During the week, most locals are likely to be wearing working clothes, but if you encounter no grown men or women wearing shorts on the weekend then you can assume they are not appropriate.

Cotton trousers can be tailored with or without cuffs. They can be lightweight enough for the tropics or dense enough to keep you warm. They wear well in both dressy and relaxed situations, hold a crease, and shed wrinkles but look all right when rumpled. Cotton launders easily in water or chemicals. Linen breathes best in extreme heat, but it wrinkles easily. Stick with darker colors. They hide dirt and stains better.

Any number of miracle materials are used today for manufacturing clothing. When traveling, comfort should trump fashion, but be contemporary. If you are conscientious about buying clothes that work well together and mix and match easily, then your wardrobe will be more versatile. You can also pack just one color scheme or stick to solids in order to simplify your choices. Women might want to alternate between two complementary color schemes for more variety.

SHOES

For all of your childhood your mother tried to get you into a pair of sensible shoes but you wanted the patent leather pair with six-inch heels and knee-high laces. As a photographer, you will be consumed with the eternal pursuit for the perfect shoe. It has to be comfortable (enough to allow you to walk or stand all day), have a little style (enough not to expose you as

> **"To see well is to have a free mind, and good legs and good shoes. Photography is walking down muddy streets."**
>
> —MARC RIBOUD, *MAGNUM*

47

a geek in polite company), and still not be so foreign as to make people notice. There are people who can tell your nationality simply by looking at your feet. Look for yourself. Shoes are a dead giveaway. Footwear is seldom a priority for most of us, but, because shoes have such potential for exposing our personality, more attention should be paid to them.

Much modern research has been put into athletic shoes. Adidas, Puma, Reebok, and others have spent billions trying to outdo each other for the sake of your feet. The worldwide advertising campaigns have been so successful that you can wear today's sneakers without fear of exposure. It may take a little time to find the most innocuous looking pair but you can expect relief if you have foot or back problems. With some effort you can find styles that have little or no decoration or loud, contrasting colors. Black is good. You may have to search awhile, but black shoes are easier to conceal and wear under different clothes.

Unfortunately, there is more to the perfect shoe than color and style. Besides avoiding corporate logos, there are other criteria to watch for. Be wary of footwear material that has a tooth. Cloth or suede-like uppers are impossible to clean if they get dusty or muddy. Better to have leather shoes or a good facsimile. That way, they can be polished by you or your concierge overnight. To better keep your feet dry in rain or snow or when fording streams, shoes should have rubber or composite soles which make them more water resistant. For real backcountry treks, you may have to carry big heavy shoes or boots but they are strictly casual wear and should not be mistaken for everyday attire.

To complicate matters, many cultures require you to remove your shoes when entering residences, temples, or restaurants. If you find yourself tying and untying shoelaces each time you enter a room you will learn to hate laces. Loafers or slip-ons are an absolute must in vast parts of Asia or Islamic regions. Some places allow sandals; some do not. Do the research. A rule of thumb: Only wear shoes that you can run in. Your life may depend on it.

HATS

From Easter bonnets to beanies, hats make or break your aura. It is the finishing touch to your outfit and a real statement of who you are. Hats can create some sense of anonymity and, at the same time, protect you from the conditions: sun, rain, or snow. Simple fedoras or baseball caps, because of their brims, are only slightly out of place. They should not get in the way when you turn your camera to take vertical shots. Women have even more choices. Both sexes should try to avoid big, floppy, tourist wear. It is unflattering and it is unwieldy. If you make a habit of wearing headgear, you will eventually discover a hat that matches your personality, but wear it often enough at home to work out the kinks and break it in.

EXTREME WEATHER

When the climate is relatively benign, you might be able to wear whatever you please, but a real photographer has to make pictures under the worst conditions. Adverse, inhospitable weather limits your clothing options. Basically, you have to protect yourself against three conditions: hot, cold, or wet. These extremes always test your mettle even with ample planning and preparation, but if they are unexpected and occur during tight schedules, they can wreck havoc. As a photographer, it is your responsibility to be prepared. If you

are fighting the elements you cannot do your best thinking. Design your wardrobe to function in a multitude of situations and you will be ready to comfortably travel anywhere.

Heat

The only real caution in hot weather is modesty. Find lightweight, open-weave clothing that protects your arms and legs. Keep in mind that black and dark colors absorb heat and make you feel warmer if you spend time in the sun. Head coverings are a must.

In sunny weather, your primary cover may be more chemical than textile. If you are susceptible to sunburn, you need to apply sunscreen. A bad sunburn can slow you down as much as bad food. Be sure to apply a minimum of SPF 15, depending on your complexion. The SPF is a rating that indicates the effectiveness of a sunscreen against UVA and UVB radiation. The better products resist sweat and are waterproof, so they will last for long periods and under adverse conditions, but reapply them every couple of hours or as directed.

If you are photographing in terrain that has an insect problem, you may want to get appropriate medical treatments beforehand (see HEALTH) and plan on carrying insect repellent with you. The experts claim that the most effective insect repellents contain the ingredient DEET. Those that have plant oils and natural components may be more ecologically responsible but are rather ineffective.

Offroad traveling with SUV, Maine. *My location scout found a granite quarry so I could get a perfect reflection in the water. We brought in generators to power the lights, people to polish the car and models. I thought I had thought of everything. Then at dawn the mosquitoes came out with a vengeance. Billions of them. I always wear a pullover with a hood and carry gloves. I covered up completely. The only thing that saved us was our insect repellent. Nothing's perfect.*

Bicycle in snow, Boston, Massachusetts. *Many situations are time sensitive; therefore, you have to carry your camera with you everywhere. Even cold, dull weather can surrender exciting pictures. Mundane juxtapositions become iconographic with the addition of temporarily pristine snow.*

Cold

A simple solution for hot weather is to just take off more and more. Keeping warm, though, is theoretically more expensive. It is most efficient to dress in layers. To control comfort and to save weight, let different layers do double duty. Add and subtract as the thermometer falls and rises. If the temperature continues to drop, you need to pay more attention. Carry a set of silk longjohns in your luggage wherever you go. They are perfect for emergencies or sudden changes in temperature. They do not add bulk. You can wear them under anything. They are very comfortable indoors and out. You can substitute modern polypropylene, which is nearly as light and comfortable and comes in several different thicknesses.

When it gets really cold, there is only one word: *fleece*. It is an amazing textile that has revolutionized outerwear. It keeps you warmer than any natural fiber, does not itch, and, at the same time, wicks perspiration away from your body, keeping you drier when you are exerting yourself. Sweat is very insidious, because it carries internal body heat away from you and makes you feel colder. Fleece "breathes" and dries quickly.

In extremely cold weather, you must cover all exposed skin: your feet, or the cold will creep up your legs; your head, because you lose 60 to 70% of your body heat there, and especially your hands. A photographer is worthless without the use of his or her hands.

Several expedition companies have made enormous innovations in boots that are guaranteed to stay dry in the most hostile weather; they are even able to withstand artic conditions. Underneath the shoes, layering socks that are made of the same plastics that you wear against your body will protect your feet as well as anything.

World Bobsleigh Championships team, Lake Placid, New York. *It was below zero at the top of this mountain. We had press credentials, but we used a 600mm f/4 lens to get so close. With experience I knew that some of the best action was right at the start house. We wore several layers of high-tech clothing and kept two pairs of gloves on all the time, even while loading of film.*

For photographers, in cold weather, unlike most other professions, your hands and fingers are the second most crucial body part, after your eyes. They control all the mechanical functions having to do with your equipment. Unfortunately most advice about keeping your hands warm is unreliable. Your hands, like your feet, are extremities and susceptible to loss of blood flow. Gloves are the only barrier against the elements. Choosing the right glove is a real science. Once you lose feeling in your fingers, you are finished for the day. A well-fitting pair of leather gloves imitates the feel of skin better than cloth, fur, or synthetics. Leather gloves give warmth and protection and do not become as slippery as other materials when wet. They give you the sensitivity necessary for delicate shutter manipulation, focusing, and film or memory card reloading. If you need more protection, you can put on extra pairs made from any material underneath. If you never remove that first layer when working in the cold, wearing them becomes second nature.

Wet

In photography, water complicates everything. Professional cameras are made to withstand weather far beyond what humans can endure but when it is raining it is essential to increase protection. The cameras will not melt, even though you might.

A good raincoat or trench coat and hat will suffice in a normal rainstorm. If your rainwear has a hood, even better. If you are out for extended lengths of time in driving rain or snow, you might consider a slicker or an old-fashioned poncho. It will cover you, your camera bag, and your equipment from head to toe. You can also work underneath it, like in a tent.

Snow and water are not that harmful to a camera exterior but are devastating to its interior. Moisture will wreak havoc on film and camera electronics. Learn to be extra careful when loading film in inclement weather. You can wipe off the outsides of lenses with whatever is available but you have to keep the insides dry.

In a pinch you can use a large plastic garbage bag as a raincoat. Cut a hole in the bottom for your head and two in the sides for your arms. It may not be very pretty but it offers excellent protection in a pinch. If you store several in your camera bag at all times, you will never be without.

Regardless of their stylishness and couture, the clothes you wear will not improve your photography one iota, but just about any piece can make your photography more difficult. If something you are wearing is uncomfortable, ill fitting, or cumbersome, your attention will be elsewhere. Materials that make noises or shoes that squeak will reveal your movements in quiet situations. Accessories that are out of place will make you the center of attention. If you are too warm or too cold, survival may be more on your mind than aesthetics. Taking pictures can be a Zen-like experience. For you to be perfectly attuned to the sights and sounds and smells of a new environment, it is almost necessary for the stars to be in alignment. Photography that transcends the ordinary requires enormous concentration. So be uncompromising about such frivolous distractions as untied shoelaces and chaffing shirt collars. The desire to always be wearing the correct garment at the appropriate time can have conscientious travelers second-guessing themselves all the time. A wardrobe that is suitable for the majority of social situations you might encounter undergoes constant refinement. Even so, no matter how hard you try you may find yourself dressed in formal wear at a nudist camp. Just be sure the photographs are in focus.

Olympics Even when the photographer is piled high with fleece and polypropylene and sporting a fortune in down and wool, taking pictures in cold weather can be daunting. I have stood for hours at several Winter Olympics to catch a glimpse of the skiers as they flash by. On one of these long vigils we discovered by accident that any kind of insulating material placed between the snow and our boots (e.g., Styrofoam, blankets, cardboard, wood) allows our feet and legs to go much longer without getting cold. Now I can stand all day in below-zero climates. Don't ask me why, but it works.

Ski jump at Winter Olympics, Nagano, Japan. *Extremes in temperature take a toll on the body and on equipment. My assistant and I trained like the athletes for at least six months to withstand the rigors of climbing up ski slopes with all the equipment necessary to take this eye-level picture of ski jumpers. Standing for hours, covered by a military-issue poncho, in the falling snow after carrying a 600mm and other large telephoto lenses and tripods up the hill is physical labor. We studied for years how to keep our hands, as well as, our batteries warm and working at peak levels.*

Waikiki Beach, Honolulu, Hawaii. *Aerials are an unusual way of seeing anything. In this picture, we get a real sense of the concentration of people at the beach, and the long shadows caused by the setting sun are the primary elements rather than the bodies casting them. Changing the perspective is a very photographic method of managing composition.*

> **"It seems to me that composition represents a personally ordered, culturally influenced, and aesthetically driven way of seeing."**
> —DENNIS KEELEY

Chapter Five: COMPOSITION

Different cultures have different ideas about what is aesthetically pleasing; that is, we do not all see the same things the same way—and even these ideas change with the times. Because so much of photography is trying to capture a world that is constantly in flux and the art form itself is so fluid, it is difficult to define composition. For want of a better definition, **composition** is the visual management of subject matter or elements, colors, contrast, and imagination, or any combination of the aforementioned. Attention to good composition will improve appreciation of your work, even if the viewer has no conscious understanding of why.

Different from painting or drawing, you are making hundreds or thousands of decisions each time you press the shutter release. Lens, space, colors, distance, film, direction, time, movement, ethics, and temperature are all parts of your final opus. And you are combining them within say, 1/125th of a second. With experience, most of these decisions become unconscious but they all come under your control.

Before all the rules, the most important element of composition is content. If the image is not worth looking at, it does not matter how beautifully it is arranged. What is the picture about?

Simply grabbing up everything visible in front of you will not make a very compelling reason for anyone to view it later. Getting caught up in the moment is no excuse for abdicating your responsibility. If too many elements in an image demand equal attention, the viewer will become confused. Make sure there is a point to every piece of film you expose. Perfecting the ability to highlight things that interest you is a first step toward identifying content that also holds the attention of others. Never be timid. Move the audience closer. Put them inside the experience with you. Make the scene as urgent as you feel it to be. Pointing your camera toward people or things you are passionate about is an excellent way to begin improving your compositions.

Try to visualize each picture. Randomly shooting events in front of you is not good photography. Anticipate the way a scene will unfold. As the shadows or weather or actions change, the composition might improve. Be patient. Act quickly.

As an artist you have all manner of ways to control composition. Two of the easiest are **point of view** and **perspective**. Moving above or below eye level with your camera alters the normal point of view. Shooting from high or low can make your subject appear smaller or larger than it actually is. Putting your camera right at the point of interest makes the picture more intimate. Bend your knees. Relate to small children down at their level, or climb up higher for exaggeration. Look at the world from various angles. Vantage point can have a strong influence.

The relative distance of objects from the lens and from each other creates the illusion of a third dimension in a two-dimensional picture. This is called perspective. The closer something is to the lens, the larger

Old Courthouse, St. Louis, Missouri. *I only had one day to define the city. I was told the Old Courthouse was a very important building. I was so excited when I looked up. The sun was perfect. I laid down on my back in the middle of the floor and shot straight up to abstract this domed ceiling. Shooting up is just as effective an approach to composition as shooting down. The curving lines and pastel colors provided my camera with lots to look at.*

it appears. Things in focus look closer than things out of focus. You can manipulate how a person receives information merely by altering the perspective of the scene. Move in. Back up. Shoot from above. Shoot below. By doing so, the meaning of what is being seen is also altered.

The type of camera that is used contributes greatly to the final product. Using medium format or a square image shape has a tremendous effect. SLRs are designed to be horizontal or vertical. Typically, vertical orientation is associated with portraits. In this case, it is intended to isolate the subject from its environment on either side. Conversely, landscapes are horizontal. Using an SLR with its 3:2 ratio horizontally tends to integrate and include the surroundings with the main subject. It is easier to shoot horizontal because that is how cameras are ergonomically built, but books and magazines use mostly verticals.

The choice of lens also manipulates composition. Because wide-angle lenses have greater depth-of-field and include more surroundings, they also can be seen as integrating tools. They complement. In contrast, long lenses have a greater tendency to throw foregrounds and backgrounds out of focus and isolate the main subject. They contrast.

Normal people view photography on two levels: objectively or subconsciously. Every great photograph has to work on an obvious level, but many also work due to certain psychological attributes. A line or curve may direct our eyes into or out of a picture. A bright or dark area may draw the viewer's attention. A superimposition may imply something not immediately obvious. Colors have various emotional implications. The subtle manipulation of design elements can have a profound effect on any composition, and we as photographers have the fun of putting them to good use.

> ## "If your pictures aren't good enough, you aren't close enough."
> —ROBERT CAPA

Changing the viewpoint changes the point of view.

Seven Mile Bridge, Marathon, Florida Keys. *I hired a four-seater plane and pilot for aerial coverage of the Florida Keys. I wanted to get up high to see most of the famous Seven-Mile Bridge. Sometimes you have to wait for almost crystal clear weather to make aerials worthwhile.*

Conversely, the absence of things is also significant. The areas around and behind the main subjects, the "empty" areas, are called **negative spaces**. They are determined by the shape of the positive space; they are the holes between forms or within a form. They are the depths into which everything is inserted. They are the spaces through which everything has movement. They are the flip side of the coin. For the accomplished artist, nothing is wasted.

The simplest design element is a **point**. The next is a **line**. Horizontal lines have overtones of stability and tranquility. Vertical lines symbolize stature, strength, power. Diagonals conjure up speed and motion. Curved lines imply grace, sensuality, beauty, and slowness. Converging lines draw the viewer's eyes to a focal point. All of these things can work together to make a composition either symmetrical or off-balance. The brain is more attracted to asymmetry than symmetry.

Multiple lines, curves, or shapes create **patterns**. Patterns are great design elements for photography, and they are everywhere. They infer some form of repetition in arrangement and are made by color or structure. The repetitive "echoes" can be rhythmic and invoke harmony and unity or be random and chaotic. They can reveal order, lead your eye in a specific direction, make a point, or add counterpoint.

Lincoln Memorial, Washington Monument, and Nation's Capitol, Washington, D.C. *"Dutch angle" is a method of canting the camera to psychologically force the viewer's attention to a certain part of the photograph. Here the vertical lines of the columns carry your eyes to a very small spot in the distance.*

"The color red is invincible.
It is the color not only of the blood—
it is the color of creation.
It is the only lifegiving color in nature
filling the sprouting plant with life and
giving warmth to everything in creation."
—FRANK LLOYD WRIGHT

Wooden spiral staircase. *There are so many disconcerting elements in this photograph that it is almost purely abstraction. You are looking straight up at the underside of an old-fashioned wooden spiral staircase. The unusual perspective and the curved lines are totally out of context.*

Old Town Square, Prague, Czechoslovakia. *This perspective of the often-photographed plaza in Czechoslovakia's capital incorporates an intentional diagonal to strengthen the composition.*

Big-wheel race at the Iowa State Fair, Des Moines, Iowa. *The converging lines lead our eyes right into the humorous children's competition. This is a case where negative space is as important as the subject matter.*

"I believe that the vertical axis
 symbolizes the movement toward God,
a historic, timeless movement.
In contrast, the horizontal axis is
 the axis of a story,
a fundamentally temporal axis."
—BORIS MIHAILOV

Carnival Ferris wheel, Santa Fe, New Mexico. *Neon tubes make lines that create patterns. Even though we are showing only a small segment of the wheel, the cropping gives our brains enough to know exactly what is going on.*

Signage on Nathan Road, Hong Kong. *Sometimes when you are just walking around trying to take some pictures you turn the corner and can't believe your eyes. When I came upon this, it was sensory overload. The patterns just filled the frame.*

Composition is making sense of the natural chaos.

What we do is termed **still photography**. Fast shutter speeds can freeze almost anything we perceive and make it sharp as a tack. But the world in which we live is moving and we may want to illustrate that fact. No written rule says everything must be static. An effective way to emphasize motion is to allow the movements of the subject to blur. The blur makes us think of action, power, speed, dexterity, or rhythm. By using a slower shutter speed you can freeze the background and let the subject blur, thereby abstracting the picture, or you can **pan,** keeping the moving subject sharp and blurring the background. There are so many variables involved that both techniques require a good bit of practice and luck. Shutter speed and direction influence the exact amount of panning. Essentially, motion contributes the fourth dimension of *time* to three-dimensional space.

You may not be able to cure the world of war, pestilence, or crime using your camera. It may not be possible to solve even one problem or to sway an election or to quell a riot. You may never influence one person or change one mind. But, you have absolute dominance over the 3/4" × 1/2" part of the world seen through your viewfinder. You control that much real estate. It is your responsibility to make sure it is perfect.

Equestrian event at the Summer Olympics, Los Angeles, California. *The tele-photo lens was prefocused and panned with the horse's forward movements. The picture was taken at the height of the jump. A slow shutter speed enabled the horse and rider to remain somewhat realistic while the background was completely blurred. You should learn to use your ears to hear how long the shutter is open. You can judge from the sound approximately how far the subject travels.*

Tibidabo and Carnival Ferris Wheel, Barcelona, Spain. *Dozens of creative decisions combined to make this photograph. Shooting at dusk to emphasize the artificial colors of the lights on the church and the neon on the carnival ride, using a very wide-angle lens, and waiting for the wheel to be in motion are just a few. The drastic cropping of both subjects is another. One of the unique aspects of photography is that it can create real design out of things we could never imagine.*

FRAMING

When we first start to take pictures, we place the subject right in the center of the viewfinder. It is a safe technique but a bad habit. **Framing** is the arbitrary arrangement of elements in your final picture. Framing is the line you draw around what you see: What you want people to know you include inside the frame, and what you do not want them to see you make invisible. Start with the entire scene, then discard those parts you find distracting. Use the entire camera frame. Cram information into every corner of it. Consider the borders. If there is nothing there, be sure it is intentional. When we frame an object we arbitrarily define the negative space.

Where something is placed in the frame has to do with *weight* and *wait*. Where you place things and what you choose to emphasize give it weight. The more important it is, the more weight it should be given. Different colors have different weights. Visually, dark is heavier than light. Objects at the edge of the picture have more weight than in the center. If things are in motion or evolving in the frame, when you opt to release the shutter and finalize that work-in-progress is a matter of waiting. If the shot seems incomplete, wait for something interesting to come into frame. Wait for the light. Waiting will change the weight. The wait can be nanoseconds, or years. It is a judgment call. What is included and what is left out is entirely the photographer's prerogative.

> "There is no edge more important
> than the snapshot's edge
> where so often
> the event occurs and
> the events are frequently
> fleeing the frame, or have
> already fled
> leaving behind only wisps
> of time."
> —MARK POWER

63

Some of my dance photographs were included in a gallery exhibition. I had taken pictures of the local ballet company and considered myself fortunate to have gotten the assignment and to be in such august surroundings. At the exhibition, one of the members of the corps of ballet came up behind me and expressed his displeasure in all of the artists' pictures. I was surprised because I thought the work was amazing, but his comments were illuminating. He informed me that dance was movement and motion. Performed to music. Never static. To attempt to freeze it with still photography was out of context. I realized he was right. And I have been trying to solve the problem ever since.

A common teaching tenet is the **Rule of Thirds**, which is closely related to Pythagoras' ancient *golden mean* or *golden ratio*. The rectangle of a picture can be divided into three equal parts, both vertically and horizontally. The most attention can be directed at elements placed at or near the intersections of the invisible lines. This rule of thumb forces the weight off-center. This sets up interesting, off-balance relationships inside the frame. The Rule of Thirds should be used as a guideline and does not have to be rigidly adhered to. There are no hard and fast rules. You can employ many other techniques to manage composition as you become more and more experienced. Lighting, motion, tone, and color can also emphasize and weigh every idea you conceive. Gestures, negative space, and vibration are examples of more subtle elements you should be conscious of. Let the subject create its own composition.

With 35mm photography, you have the ability and flexibility to take several versions of a scene, to make many exposures. It is like sketching. You can try different framings, perspectives, lenses, etc. You can take lots of pictures and throw the bad ones away.

"Beauty is truth, truth beauty, that is all
Ye know on earth, and all ye need to know."
—KEATS, ODE ON A GRECIAN URN

THE VALLEY
OF
THE KINGS
(three tombs)

Rule of thirds. *In this unusual use of the rule of thirds, I put the woman with watermelons in the left third and her daughter in the right third, leaving the middle segment empty. This negative space combined with the fact that you can't see the vendors face is intentionally unsettling.*

"Rules are fatal to the progress of art."
—MARCEL DECHAMP

BACKGROUNDS

Despite the fact that our eyes and brain can focus on something surrounded by confusion, the camera puts an equal emphasis on everything; therefore, backgrounds are almost as important as the subject matter. Be constantly aware of them. They are so important that a good background can become the emphasis. Contrasting or dark backgrounds isolate the subject, making shape the dominant feature, and they are often used for portraiture. Light backgrounds surround and tend to enlarge the subject. Move around to obscure a busy background or shift closer or use a wider aperture to throw it out of focus, but include the background when it contributes. It adds scale, context, and environment. Sunsets and sunrises are the ultimate backdrop and electrify almost any scenario.

Consider what happens in front of the subject, too. Filling the foreground or putting an object closer to the lens gives a greater feeling of scale. You can shield unwanted sections by covering them with a strategically placed foreground. Shooting though trees or through a doorway or window, even through other people, arbitrarily frames what you want to emphasize. It is an imaginative device that focuses the attention of your viewer. You have the height and width of a picture to fill, and selectively concentrating on foreground, background, and subject gives you three different layers that can masterfully simulate depth. Scout any new location to find what you need.

Traffic on the Gran Via in front of Plaza de Cibeles taken through Puerta de Alcala, Madrid, Spain. *I walked miles to find this vantage point. Shooting through the opening in the monument frames the building and the traffic activity on this famous street. This was an advertising campaign for a European airline.*

Pedestrian and bullet holes, Esteli, Nicaragua. *During the conflicts in Nicaragua, I waited for an hour in the midday sun for something to happen in front of the bullet-hole-pocked wall. This is a case of the background being as important as anything else.*

Masjid Asy-Syaririn and Petronas Towers, Kuala Lumpur, Malaysia. *The focus of my attention was the Petronas Towers, at one time, the tallest buildings in the world. To get a unique view of these magnificent structures, I walked in concentric circles around them until I found this mosque. I returned early the next morning just before I had to leave for the plane ride home. I used the traditional place of worship as the foreground to the contemporary buildings, putting the skyscrapers in context with the surrounding neighborhood.*

Waikiki Beach, Honolulu, Hawaii. *With credentials from the Tourist Bureau, I traveled with my elderly mother, who had always wanted to go to Hawaii. I asked the hotel manager to let me up on the roof of the hotel, which was the tallest building on the island. I knew the high elevation would give me an advantage. I got lots of photographs of the skyline along one of the most famous beaches in the world. It was idyllic. The weather cooperated, and I was satisfied that I had gotten good pictures. On the elevator back down, I said to my skeptical mother, "See, that's what I do for a living." She retorted incredulously, "They pay you for that?" You can't even get respect from your family.*

"Travel photography is a topographic map of the world with all the borders, flags, races, and terrains illuminated. The camera is the only passport, visa, or language you need. Every detail, longitude, or philosophy is annotated. Your imagination is a road that takes you away and back again. An insatiable desire to see is the only necessary motivation. Fads are fraught with peril."

Chapter Six: WHAT TO PHOTOGRAPH

In travel photography, the world is yours for the taking. Anything you can think of, any place you can get to can be photographed. Some destinations are just around the corner; some much harder to ferret out. Traveling is one of the most educational, enriching experiences you can undertake—second only to taking pictures, of course. And the camera is the perfect tool for taking notes.

You can document your encounters in many different ways. It is fun to be spontaneous and sporadic, but if you want to be comprehensive or are doing an assignment for a publication it is necessary to approach the undertaking systematically. Even without a client, your quest should be adequate coverage in trying to narrate the story of your visit. Of course you should shoot anything that piques your interest. Follow your muse. But, you also need to establish priorities and touch all the bases. Make it an exercise to photograph not only what you see but also what you smell, taste, hear, and touch. The greatest thrill of travel photography lies in the emotional stimulus you receive by pointing a camera at a face or at an object that you have only imagined and are now confronting. The effect can and should be such that your psyche is shaken to its roots. Your viewpoint and mores may be irrelevant but you are communicating that viewpoint.

The cardinal rule is to always be "armed." In new surroundings, the excuse of "if I only had a camera" is anathema to serious photographers. Get used to the occasional inconvenience of toting along your camera. You encounter the best pictures when you least expect to. But, what *is* good coverage?

PLACE

No matter where you go you end up someplace, and you want to produce images that give you and the viewer a sense of that place. After all, the allure of travel is that you will be somewhere different and something drew you there. Your job is to make everyone want to be there, too. If the destination is rural, the local flora and fauna may be the natural attractions. Perhaps the vegetation is unusual or the indigenous animals are ready to be spotlighted.

For various reasons, many photographers specialize in **landscapes**. When done right, this time-honored subject can evoke the grandeur dreamed of by your imagination, but landscapes are difficult to photograph. The arresting emotions we feel when we arrive at a vast new vista are impossible to put into words and nearly as difficult to capture on film.

For decades, practitioners have used large-format cameras to impress us with the intricate detail they provide, but creatively focusing on other factors can be just as intriguing.

For example, flat light does not translate well when you are trying to overwhelm. Wait for the right light or change your position. Rain or moody skies can augment the visual drama. Incorporate foreground and distant objects to show scale. Never hesitate to include people relating to the landscape to add further interest and point of comparison.

Simplify the composition so the viewer does not get confused. Vistas often have too much to look at. Exhaust the possibilities. Move around. Put different lenses on your camera. A wide-angle panorama may be suitable, but a long lens detail may be a better companion shot.

Maroon Bells, Colorado. *A group of us got up before dawn to scout this famous landscape. It is difficult to contribute much that has not been done before, but I focused on the rock in the water and liked the cool monochrome exposure of the light before dawn.*

No two eyes see the same world.

Hot air balloon, Cappadocia, Turkey. *Making exciting landscapes look the way they do to your naked eye takes real skill. Waiting for the light and proper opportunities can take a long time. This land formation was unique to Turkey but it was not until the hot air balloon interrupted the sky did the whole thing work.*

71

If you visit an urban environment, however, you need to capture the man-made atmosphere and what makes it unique. Sometimes it is the **architecture**, especially famous buildings or landmarks. Through architecture mankind builds monuments to itself. Although only brick and mortar, buildings are physical links to our collective past, filled with ghosts and gossip. Life inhabits and permeates them. How people interact with their edifices can be dynamic. Architecture often requires large-format cameras to straighten out the distortion of converging perspective lines, but small format has its own flavor. Get in close with wide lenses and accentuate the height of a skyscraper or back up and use a long lens to emphasize classic configurations. Approach architecture like landscapes. Wait for the light. Ask locals and come back when the light might be better, if necessary. Take extra advantage of your surroundings. Alter perspectives. Add height. Try scaling a neighboring building. Not only is it an unusual way to see but it also integrates structures with pedestrian and vehicular traffic.

Saint Vitus's Cathedral, Prague, Czechoslovakia. *Sometimes structures are so large and magnificent that it is nearly impossible to capture their grandeur. Inside this church, the interplay of light and shadow made it difficult to see everything. As photographers, we have to find ways to illustrate that. Step back, use your imagination, and don't be afraid to break all the conventional rules. Approach the task with fresh eyes as often as you can. The outcome doesn't have to look like anything you have ever seen before.*

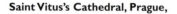

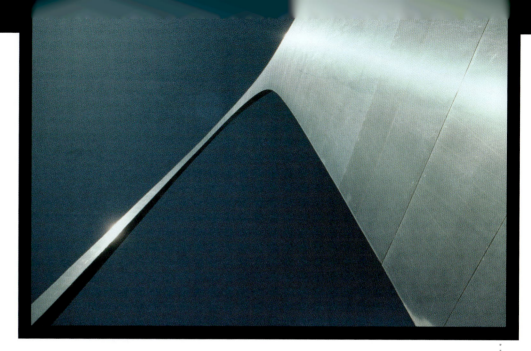

Gateway Arch, St. Louis, Missouri. *Every photograph of St. Louis has the Arch in it. The region is very proud of its monument. After taking all the typical shots of overly photographed places, work on finding your own viewpoint. It stretches your creativity and makes your pictures more valuable.*

Hasedera Temple, Kamakura, Japan. *The weather was so foul that a picture of the entire temple would have been too dull and colorless, so I narrowed my focus. The patterns of the roofs were so provocative that I moved around and shot a number of angles. The monochromatic details made a clear statement.*

73

Skylines or cityscapes are probably the most salable images of a city. Scout beforehand. There may be a famous view that everybody goes to see. Famous places, locations, or landmarks are a must. Unfortunately, most have been overphotographed. For a different perspective, consider juxtaposing the landmark with other objects or find a special vantage point.

Once you go inside, all bets are off. Interiors usually require lots of permissions and lighting. Many museums, churches, and celebrated residences refuse to let you employ tripods or flash. The freedom you experienced shooting exteriors may be restricted when you go inside and you may have to arrange additional artificial lighting. But never give up. The authorities may be delighted to allow you to come in after hours or you can just gravitate to the small amounts of light that are available. Lean against a wall, hold your breath, and make abstract studies. The most amazing feats of design are found in public spaces, where man's genius is on display: craftsmanship, ingenuity, excess, simplicity. Flying buttresses, for example, are perfect subjects. Paying strategic attention to the most important design elements of a celebrated architect will result in great pictures.

Modes of transportation (e.g., cars, boats, trains, bicycles, rickshaws) ensure well-rounded coverage. Get onboard and take a ride. Participation enhances the experience. Mass transportation or personal vehicles show locations on the move.

If there is a principal industry, make an effort to include how it has molded the local region. Photographing work in factories, on assembly lines, or in the fields are more rare and takes planning. Seek out the raw materials or check how the products have enervated the society. Specialty businesses or native crafts can be closely associated with the geography. Storefronts and street vending are often focal points of street life and can be very colorful.

A sense of place is often created with an *establishing shot*. As suggested earlier, get up high. Aerials are great for this. Hire local pilots or take sightseeing flights. Make sure you can open the windows on the aircraft, though. In lieu of helicopters or small planes, seek a hill from which to overlook a city or valley. Also, you should ask permission to get onto the roof of a tall building or skyscraper even if it is just your hotel. It is unbelievable what you can see up there. Climb up on a truck or a fence. Borrow a ladder. Anything.

Many travel photographers employ local postcards as quick reference. It is a form of research that helps you identify the most significant tourist attractions in the area. This trick helps with all sorts of sightseeing. Pick up your own set of postcards at the airport, while you are waiting for your luggage. A good hotel will have a selection, too.

> "The moment an emotion or fact is transformed into a photograph it is no longer a fact but an opinion. There is no such thing as inaccuracy in a photograph. All photographs are accurate. None of them is the truth."
> —RICHARD AVEDON

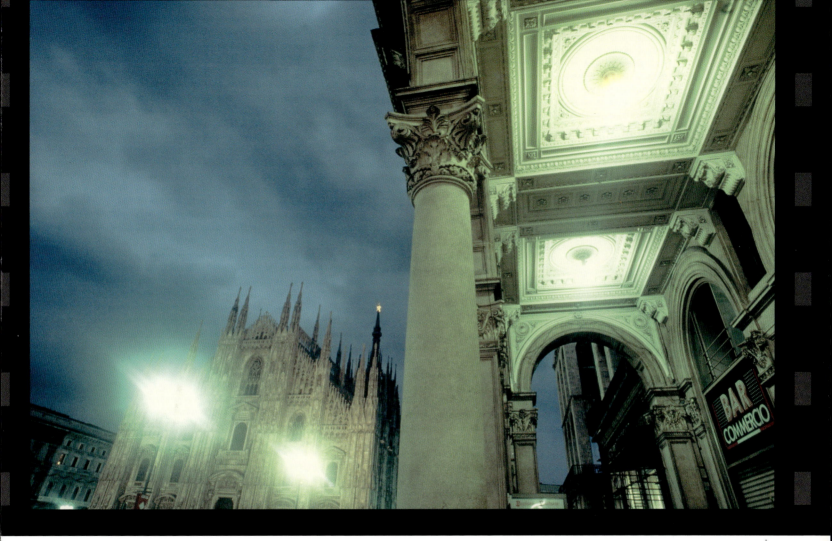

Il Duomo, Milan, Italy. *Even with limited time I was able to return to this famous landmark more than once. Despite the weather, I tried to frame the edifice with the building across the street. Because it was raining I hid under the overhang; my wide-angle lens was pointed up, and I needed to keep it dry. The unfiltered fluorescent light turned out to be a blessing in disguise.*

Agriculture is about the land and is important to rural communities. The local produce may have made an area famous—flowers, unique foods, or innovative methods of farming them. Harvesting crops, the farmhands themselves, or unusual land formations can be quite compelling subjects.

Water is the mirror of the earth. Photographing the interface between land and sea can be well worth the journey. Communities that are at the edge of water have unusual characteristics. Their oceans, lakes, or rivers are essential to their labors and recreation. Beaches are popular vacation spots where an often eclectic mix of locals and tourist can have fun. Hitch a ride on a boat. Fishermen, their vessels, and whatever they bring up out of the water can be fodder for your camera.

Hong Kong harbor. *Hong Kong revolves around its harbor. Because land is so scarce, a part of the population rarely sets foot on land. Their life is spent almost entirely onboard their houseboats, which weave their way in and around the huge commercial ships. This photograph contrasts the personal, human aspect against the impersonal, corporate element.*

76

Pulling in fishing nets, Acapulco, Mexico. *Work is hard. It is also hard to photograph. You may have to get dirty to do so.*

"The photographer is ==supertourist==, an extension of the ==anthropologist==, visiting natives and bringing back news of their ==exotic== doings and ==strange gear. The photographer is always trying to colonize new experiences.=="

—SUSAN SONTAG, *ON PHOTOGRAPHY*

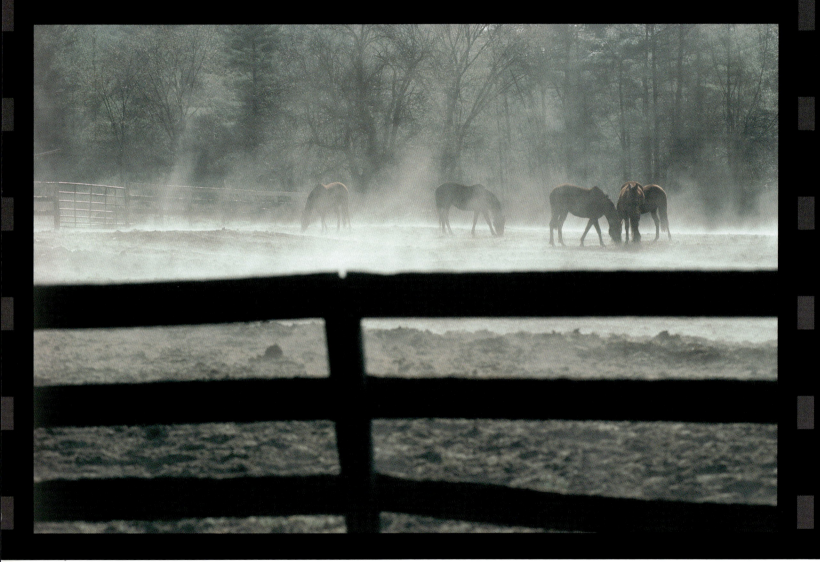

Horse farm in the Berkshires, Lee, Massachusetts. *Sometimes you just have to be receptive to the simplest elements briefly coming together. I drove around the Berkshires at dawn and saw how the mist obscured the bleak background. I let the silhouetted fence act as a strong unifying component that obscured the unattractive foreground. The horses added the romance.*

Certain colors or textures become metaphors in some cultures, and they are steeped in history. Seek them out and make a picture where they are the predominant features. Inclement weather is a potential element, too. It has power. It colors the world in its own way. Anybody can shoot when the sun is shining. There is not much sun high up on the globe or deep into the calendar. Research the time of year. Many spots on the map are better known for a specific season. Spring or fall shows how quickly the seasons change. Seasons in transition produce dynamic colorful variations, animal migrations, and changes in activity. Summer and winter make more aggressive statements. If an area is always rainy or foggy, that is a distinguishing characteristic that should be emphasized.

Fall foliage on the Boston Common, Boston, Massachusetts. *New England is famous for the changing leaves in autumn. Schedule your photography for peak color times if you want to illustrate this spectacular annual event.*

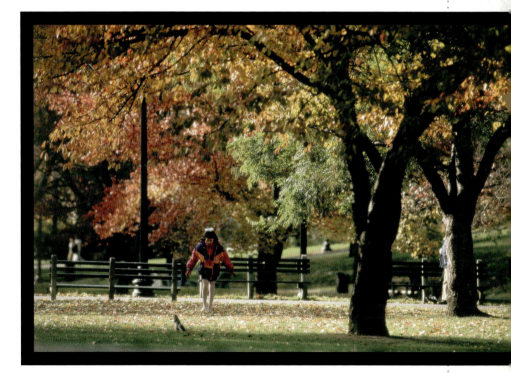

PEOPLE

For most new photographers, shooting **people** is the most daunting challenge in their new hobby. They feel too shy to confront people they have never met. But, with a little practice much of that anxiety can be overcome. The aura you exude probably matters the most when first developing trust with your new subjects, both individually and in crowds. No matter how polite you are, though, sometimes the graven image is forbidden and you should respect that. Do not take this caveat lightly. For example, in Islamic countries Moslem women are a loaded subject. Photographing military installations, airports, even bridges can get you into real trouble. Some people expect you to ask permission before taking a picture of them or their property. This limits the spontaneity of any interaction, but then many photographers like to talk anyway. Each person grants permission in his or her own way—some verbally, some just ignore your presence. It is your job to figure out what is being granted in a matter of seconds. No one owes you a picture, and in some cases the act of taking a picture can be considered a sin against cultural mores or an insult.

There are a lot of variables and mechanics to incorporate, but success in taking candid shots of people is largely a matter of attitude. Move slowly but emphatically. Furtive movements cause strangers to think you are trying

Migrant worker camp, Sigma, Turkey. *If you are uneasy about approaching people to take their picture, start by engaging children first. They are a lot more trusting and are often intrigued by a stranger in their midst. Establish a rapport with them and transfer their curiosity to the adults.*

to be sneaky. You are invading people's privacy, but with practice you can adopt an air that convinces people you are genuinely interested and that you mean them no harm. Develop a rapport. It is extremely difficult to maintain continuity or tell the whole story without involving the human element. Solving this problem is your *raison d'etre*. Everything can be seen in the face of a country. Humanity is universal.

It is important to remember to control the situation, even when you don't. Wait until you feel comfortable and the object of your desire gets used to you. As a preamble, start involving children. Their natural curiosity allows them to warm up to you quicker. Be open when taking their picture. Gain their confidence. Prove your good intentions and allow their trust to transfer to the adults. Spend time with your subjects. You may have to follow them to remote locations or undergo perilous situations. But that is exactly the point. Be a diplomat.

You may have to capture an entire society with a single picture. People expressing emotion reveals the soul of a culture. Festivals and ceremonies are especially rich in picture opportunities. They are often overwhelming, though. The pageantry and movement are *too* good. Throw yourself into the fray, but strive to simplify the confusion. Become part of the show. If there is a parade, learn to walk backwards so you can shoot directly into the faces of the revelers. Never be shy. Include music or any local customs, such as dancing or processions. Avoid the festivals staged strictly for tourists unless it is absolutely necessary. Do not forget the performing arts, such as opera, theater, symphony, or ballet, especially if performances are held outside. This is where quiet, manual rangefinder cameras are so useful. They are less likely to disturb the performers or the audience.

Invent lyrical pictures. Traditional costumes or dress are worn at many of these activities. Hundreds of years of history are reflected in the public displays of religion. Seek out the principal churches, temples, or mosques and put the practitioners into context while they worship. Again, it is important to understand the proper protocol so as not to disrupt the proceedings.

Shoot daily life in the marketplaces: browsing, haggling, and cafes: Etiquette, conversations, companionship; and places where groups gather. As you gain more experience, you will become more selective. Once you have seen it and photographed it, you tend not to repeat yourself. You will learn that your pictures can be improved by adding an additional element, such as light, another person, a more conspicuous background, etc. Stalk your shots. Return again and again to a place if it really interests you. Picture taking requires patience.

Carnival participant, Rio de Janeiro, Brazil. *Festivals are always good photo ops. The revelers drop their inhibitions and invite photographers to take their pictures. The events can be overcrowded and overwhelming, but, if you have the personality necessary to mingle amidst the confusion, there is no better resource.*

Official gardener, Kyoto, Japan. *There is a lot of protocol in Japanese culture. We were doing a story about Kyoto's sister city in the United States, and we needed environmental portraits of the gardeners in each city. We posed this wonderful man in the shadow of an overhang and lit him with strobe light. His garden was in the background. We also photographed his counterpart back in Boston.*

The only thing that differentiates various kinds of **por-traits** is that some are candid, while for others there is some form of tacit agreement with your subjects that they will pose for you. In travel photography, a beautiful portrait can represent all the hopes and dreams of a nation and many of the aspirations of the artist. A compelling face is a cultural metaphor. There is no greater feeling than to represent an entire country with an intimate portrait using someone you just happen upon. Because such portraits are so important, try to control every aspect. Study the pose, foreground, and background, if you have any options in that regard. There is no law against using models. Pose friends, ask strangers, contact local modeling agencies. Your guide or translator is a native and can double as your model. The pictures can be formal or quirky. Let your subjects participate. If you shoot digital, the models can share in the experience by seeing themselves on the LCD. You may gain further cooperation in this way.

The **environmental portrait** is where you incorporate a location that is significant to the narrative. The person is positioned as an element that helps tell a bigger story. Abstract portraits need not always include the face. Eyes, hands, shadows, or other body parts can stand in for the totality.

Add a few people, and you have a group portrait. The dynamics of posing and making everyone look good increase exponentially with each new body, but never just line them up like a school picture. The classical painters always liked odd numbers of people in their compositions. Test that theory.

Bullfighter, Lisbon, Portugal. *Portraits are one of the most important aspects of photography, but they do not always have to be of the face. We hired this famous bullfighter to pose for us in the bullring. His costume was so elaborate that I concentrated on a ritualistic gesture and the craftsmanship contained in a piece of clothing that almost everyone knows the origins of.*

THINGS

In addition to people and places, certain **things** can be called upon to illuminate and flavor the overall story. Some photographers have perfected a style that concentrates on details and objects. Rather than documenting the obvious, they are interested in the nuances. Interpreting the world through inanimate objects is an art, not a science. Intuitive. Things can be photographed in a myriad of abstract, inventive ways. Salvage fragments unnoticed by the average onlooker. You can be either blatant or subtle. Experiment, but avoid preconceived notions. Make your own rules. You are solely responsible for helping the audience see anew.

Antique and new signs graphically spell out the local language. Flags often include the predominant colors of the culture. Graffiti and posters share insight into the political situation and popular culture. Architectural fragments shed light onto the past. The luxury is that these objects rarely move or interact so you do not have to overcome your shyness. You usually get into less trouble with objects, and they spice up an otherwise incomplete story.

You can make patterns, shapes, and colors dominate your compositions. Cropping pictures to include all or only part of your ideas is a decision just as significant as content, when everything around you is alien. Assign unexpected importance to things. Words may be necessary to explain what the viewer is seeing but you have captured their attention.

Origami cranes at Hiroshima Peace Memorial, Hiroshima, Japan. *Having only a short time before meeting with my client, I had a taxi take me to the Memorial, which was right next door to my meeting. I was lucky enough to encounter schoolchildren who had made thousands of peace cranes to lay on the monument. It was such a somber moment that I reduced the event to a colorful detail.*

Japanese umbrellas. *This detail has been used several times for covers of magazines and calendars. The colors are saturated because they are backlit. I cropped the image to show only parts of the silk accessories, which are symbolic of an entire culture.*

License plate, Havana, Cuba. *I was down on my knees photographing some-
thing else when I looked over my shoulder and staring me in the face was this beautiful
automobile grill. It epitomized the dichotomy of the United States' relations with Cuba.*

T-shirt, Kaolack, Senegal, West Africa. *Fear is the emotion that prevents us from doing many of the things we probably should. The group surrounding this young man looked hostile, but the desire for this picture overcame my trepidation. I waded into the middle and asked permission. I am sure that the man wearing the torn t-shirt had no idea I was only photographing his chest. It was a seminal photograph for me in that it broke the boundaries as far as seeing things differently and being more aggressive.*

STYLE

Many have gone before you. As a consequence, you can learn a lot about photography and its history by studying the works of other artists. Learn from their efforts. Look at books and magazines to understand what works and what fails. You can make great strides forward by trying to emulate them and copying their solutions to visual problems. It is then acceptable to go through life honing your craft by making yeomanlike images that document, inform, and educate. Eventually, however, you will want people to know how *you* see the world. You will want people to recognize that you interpreted the scene and did not just accidentally click the shutter. For that, you have to slowly develop your own personal style. Master the intricacies of your own particular vision. This involves penetrating the fog of aesthetics and exploiting the attitudes and emotions that are yours. The mark you leave on your photography can change and grow as you do. You may have an affinity for a particular subject matter or project and choose to concentrate on that. You can introduce an oblique way of seeing or executing the final product. But make it your own.

In business and scientific arenas, you are rewarded for definitive answers. Photojournalism holds a mirror up to society. Documentary is its conscience. Artists ask more than they answer. Art's ambiguity poses the questions and is encouraged for that. With practice you will find out how to balance art and commerce. Imagination and experience will merge. It takes a lifetime.

> "Style is knowing who you are, what you want to say, and not giving a damn."
>
> —GORE VIDAL

Chinese festival at Kiew Lee Tong Temple, Singapore. *I arrived before dawn to find men sleeping on the steps of this temple. I had no way of knowing if I was at the right place because I did not speak the language. They very kindly shared their meager breakfast with me and as the day progressed I was allowed to photograph right up on the altar area while the most solemn ceremonies were being performed. The whole adventure was a result of very careful research. I spent days reading local newspapers to find religious ceremonies that were happening in the area and verified all the details*

"Accentuate the positive.
Eliminate the negative.
Latch onto the affirmative.
Don't mess with Mister In-Between."

—JOHNNY MERCER AND HAROLD ARLEN,

ACCENTUATE THE POSITIVE

Chapter Seven: RESEARCH AND BEYOND

Where photographers tread they tend to scorch the earth, leaving a trail of confused, offended, exploited people behind. Their present-day image is as an aggressive, insensitive caricature. The days of the loud, fedora-wearing, cigar-smoking, flashbulb-popping newspaper reporter are gone. We have to learn to respect what we do not know. We have a responsibility to understand what we are looking at. The more informed we are, the better our pictures and the more truthful our stories will be.

Once the decision has been made as to where your next trip will take you, you need to begin the journey with research. You cannot overly prepare before dropping into a new environment. Photographers are dependent on their eyes, but the more information you possess the more visually acute you will be. Your ability to discriminate what is important and what is frivolous will increase exponentially. Do your homework. Begin by talking to everybody you know (friends, relatives, or anybody else) who has been there. They will give you insight and gossip that the travel brochures ignore. Their feedback is immediate, too.

89

Wailing Wall, Old Jerusalem, Israel. *Friends told me it would be impossible to take pictures at this religious site. I was even warned by my guides not to stray from them and they told me they would ask to see if photographing it would be all right. I was so compelled by how awesome the whole thing was, though, that I made my own way toward the worshippers and spent lots of time immersing myself in the ceremony. When I took my cameras out, there was not a ripple of anxiety.*

Magazine articles are best.[1] Not only do they have information about tourist destinations but they also publish photographs that give you an image of what to expect. The old adage that "a picture is worth a thousand words" is never so correct as in travel research. Take a trip to the library. Find old articles archived in the stacks. Photocopy them for future reference. Read them while you are on the plane. Such publications often include useful lists and charts.

The major national newspapers also have excellent travel sections. You can access their files in a variety of ways. They do not usually have as many illustrations to look at, but some features disseminate a great deal of information. The articles can be about very specific localities or subjects, but they can be used to begin to build a patchwork of the mental image you will work from when on location. Sunday newspaper supplements are also excellent sources of inspiration. Unique story ideas can be cut out and filed away for months or even years—until you actually get around to taking the trip.

Continue your research when you have arrived at your destination. Local papers are a rich source of helpful information. Newspapers in various languages are published in most big cities, and they report the most up-to-date activities. Be wary though. Many articles are just public relations or rewards for advertising in the publication.

[1] *Travel & Leisure,* Condé Nast *Traveler, Travel & Holiday,* and *National Geographic* are a few examples.

Protocol: Color Green is bad luck in England, good luck in Ireland, and sacred in Islam.

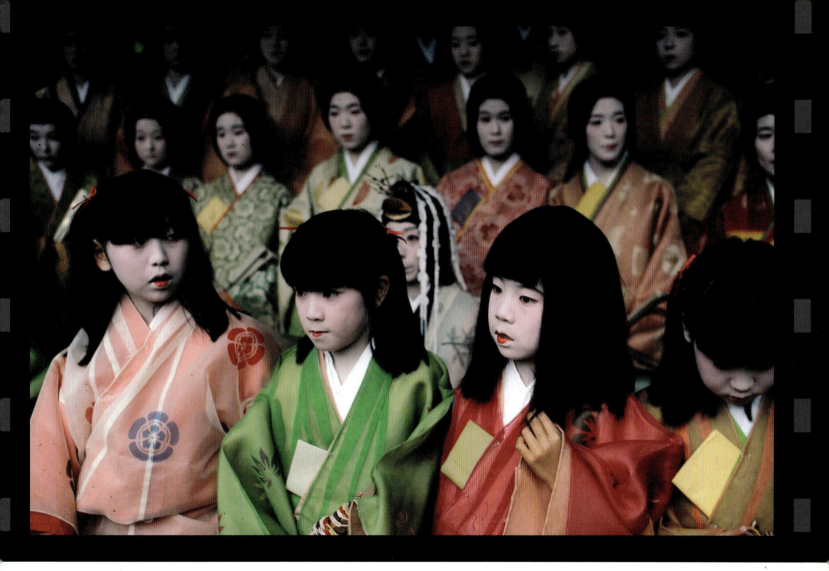

Aoi Matsuri ceremony during Golden Week, Kamigamo Shrine, Kyoto, Japan. *I have returned to Japan over and over. I maintain huge manila file folders on every aspect of the culture. I copy articles from magazines and note dates of events that might be of interest. I cut out pictures of places I might want to go, and I read up on Japanese etiquette. I have file cabinets full of potential projects I would someday like to photograph.*

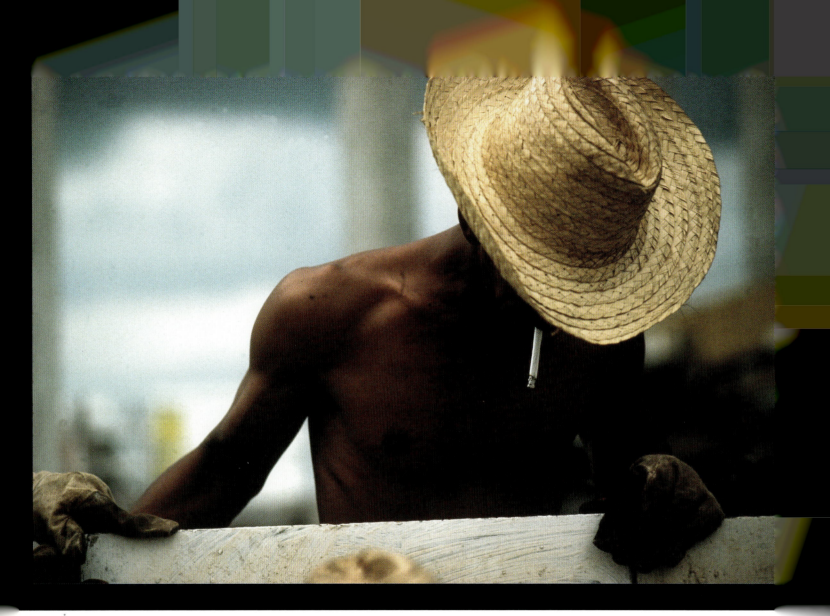

Construction worker, Alaman, Cuba. *Periodically, over the long history of the U.S. embargo against Cuba, the U.S. Department of Treasury has granted restricted entry to Cuba. On my first trip, we had to get all kinds of clearances, and applying for our visas took several months. Knowing how to maneuver around the minefields of international politics is all part of being a road warrior.*

Embassies and consulates can be helpful when you are trying to run the gauntlet of a country's bureaucracy. Seek their advice and knowledge, even for festivals, traditions, events, etc. They are proud of their heritage and eager to share it. Tourism is a major source of income to most nations. The State Department has reports on every location you can think of. They, by necessity, tend to be very conservative, even alarmist, but that disposition may match your own if you are the cautious type. The U.S. State Department can give advice on health issues, visas, political uprisings, special laws, or biases.

The big bookstore chains have unlimited treasures. You can buy books that pertain to your destination or simply look through them at the store and make notes. But be sure to browse the coffee-table picture books. It stands to reason that the largest selection and the best ones can be found in the bookstores in country. Take time out to fine-tune your research with a visit to a good bookstore when you arrive. It does not matter if you cannot read them. Just look at the pictures.

Useful books can be either fiction or nonfiction. Having some sense of the history and flavor of the destination is helpful. This additional background can be translated into memorable imagery. With enough time, many travelers immerse themselves in the romance of travelogues written by expert authors. [2] Several famous travel writers specialize in whetting your appetite for adventure. The same can be said for fiction writers. Inquire with smaller specialty bookstore owners who can suggest beautiful novels for you to read.

[2] A short list of such authors would include Mark Twain, Jack Kerouac, P.J. O'Rourke, T.E. Lawrence, V.S. Naipaul, Ernest Hemingway, Paul Theroux, and Isak Dinesen.

Books. *All forms of libraries are your best method of research. History books, novels, travelogues, and coffee-table photography books can all spark an idea or enhance our knowledge about the background of a new place we will be visiting. The best examples are usually found in the bookstores in country.*

Protocol: Chopsticks On assignment in Kyoto, Japan, I set up a business dinner with an important landscape architect to strategize the next day's shoot. Before the trip I had instructed my long-time assistant that he had to eat **everything** placed before him and he had to learn to use chopsticks before we left the United States. Sitting in the diminutive sushi restaurant we were at the mercy of my host and the restaurant owner who were plying us with specialties of the house. Suddenly, my host leaned across me with a new set of chopsticks (**hashi** in Japanese) bound together with a wad of paper and a rubber band he had gotten from the chef behind the counter. He told my assistant that maybe he should use the "children's chopsticks" so he would not have to struggle with them anymore. My host was disgusted with my assistant's bad table manners, my assistant was humiliated, and negotiations went downhill from there.

Do not forget to include maps in the equation. They are an essential part of research literature. You can use them to familiarize yourself with names, distances, and directions. Country and local street maps put everything in context. Let tour buses or friends chauffeur you on excursions around the city. Mark places of interest on the map so you can retrace your steps later. Save your maps and refer back to them when you caption your photographs back home.

Because tourism is such a huge industry, a multitude of services is available to help both first-time and seasoned travelers. Phone, fax, or e-mail them and request the most arcane information. If you require special care or consideration with regard to diet, hotels, guides, or translations, you can find what you need. Networking is your best tool. One phone call leads to another and piles of new possibilities.

Technology has changed our lives forever. It has erased much of the onus of research. Anyone with a computer and a modem can look up any subject on the Internet ... for free. Learn to use effective search engines and simple Boolean logic to speed up your inquiries. Online guidebooks and electronic bulletin boards have proliferated and created databases around every minute interest, no matter how esoteric or obscure.

The New York Times
The Wall Street Journal
The Washington Post
CULTURGRAMS: www.culturegram.com
Brigham Young University, 755 East
 Technology Avenue, Building F, Orem, UT
 84097-6204; (800) 528 6279

Virtually every spot on Earth has a website. Navigate the information superhighway. In cyberspace you can find maps and charts; make airline, hotel, and car reservations; and buy equipment.[3] Many newspapers keep their archives on the Internet. You can compile prodigious amounts of information in short order. One URL will spawn dozens more. Internet surfing is probably your best device for researching a subject and cannot be beat for time and money saved. The down side is that much of the information is repetitive and spurious. In the beginning, it may seem difficult to decipher what is useful information and what is misinformation. As you become a more seasoned traveler, you will learn to ask better questions and weed out the chaff. Verify anything that seems suspicious with the multiple sources you uncover.

[3] Some examples of such websites include www.travelocity.com, www.fodors.com, www.lonelyplanet.com, www.leisureplanet.com, www.travel.discovery.com, and www.hotelleisure.com.

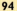

When evaluating cultural differences, the only thing wrong is the certainty that your way is right.

PROTOCOL

The importance of conducting research into *who*, *what*, *when*, and *where* to photograph cannot be overemphasized, but the *how* is too often overlooked. Methods for infiltrating new civilizations come under the general heading of **protocol**. Considered by many to be simply red tape, protocol, for the photographer, is not a hurdle to be overcome but a life-style. Like time zones and exchange rates, global etiquette is a fact of life. Protocol is all behavior associated with any human interactions, from personal encounters to business transactions. It sets the tone and style and, consequently, determines the success of negotiations and exchanges with each and every country, region, or individual with whom you meet. Your knowledge of protocol affects the image you project.

It is hubris to assume that all other societies act as we do. Other cultures move to very different rhythms and perceive things in different ways. Respecting another culture's protocol is the art of understanding and coordinating your efforts with their tempos. Tourists, in general, tend to be very selfish, and photographers are especially goal oriented, but no passport, no visa, no Berlitz lessons can substitute for knowledge of the local customs.

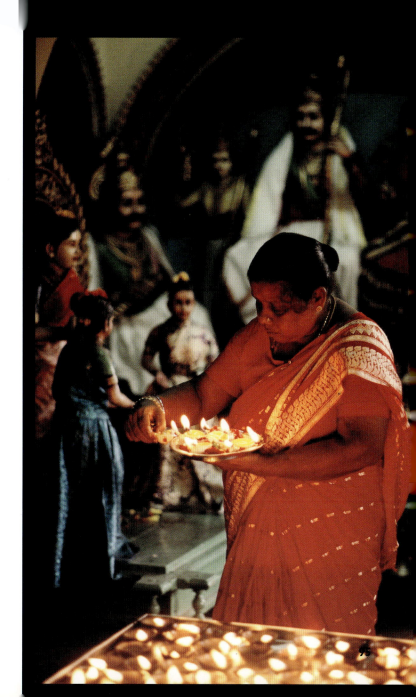

Hindu worship at Mariamman Temple, Chinatown, Singapore. *When I caught a glimpse of activity happening in the back, I carefully entered this open-air temple and did not raise my cameras until I had made my way all the way into the inner sanctum. No one paid any attention to me. I photographed preparations and ritual, priests and participants. As the ceremony moved out into the main area, tourists started to flock in from the outside. They were all escorted out. I could not figure out why they allowed me to stay until I noticed that I had left my shoes at the front entrance and everyone they were ushering out had not bothered to do so. Noticing the little details of cultural protocol may allow you to get better photographs.*

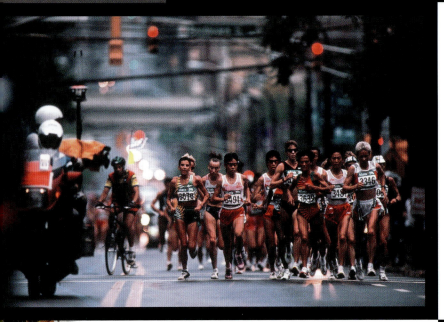

Women's marathon at Summer Olympics, Atlanta, Georgia. *Because my client was not willing to send me there beforehand, months before the Olympics I pulled up the race route on the Olympic website, matched it to a large map of Atlanta, figured out where the sun would be at the start times, and plotted exactly the corner where my crew and I needed to set up our tripods to be able to shoot directly into the faces of the runners. We scouted the entire event on computer.*

VLA radio telescope, Plains of San Augustin, New Mexico. *In photography, you use absolutely everything you learn. Because of my background in science, I had heard about this very large array (VLA) telescope hidden away in remote New Mexico. When I was given a story that covered the state I was able to retrieve my vague recollections about the installation. We drove for hours twice to document this amazing man-made achievement in the proper light. I did a lot of research on what to expect beforehand.*

Computers, television, telephones, and air travel have shrunk the globe. We can see anything, go anywhere, with little effort. As world citizens, travel photographers have a huge obligation to interpret what they see correctly, and to do that they must be as sophisticated as possible.

The details of international etiquette are infinite. You can never learn all the "do's and don'ts." Any caveat amounts to a generalization. Just as every country is different, every individual is different. While one associate might forgive you for using the wrong fork, another at the table might consider your manners barbaric.

When you read sensational stories about diplomats being accused of egregious errors in protocol that might be considered normal behavior or minor mistakes back home, you can begin to fathom the far-reaching effects of such misunderstandings. Acts that some people find insulting—such as using your left hand, showing the bottoms of your feet, patting children on the head, gratuitous backslapping of acquaintances, or eating the last helping at a meal—can change the tenor of a meeting. Before business dealings, you may have to slow down and socialize. Engage in polite conversation. Have a ritualistic cup of coffee. Be a good guest. And, when it is your turn, reciprocate. Just be tactful and firm to evade long, drawn-out ceremonies if they will drastically hamper your photography schedule or compromise your health.

Much has been published about the peculiarities of cross-cultural contact. [4] Handbooks and guides on the subject are available for each country and region. Make an effort to read something even if it is just the tip of the iceberg. Know before you go.

Etiquette is the human artifice that attempts to codify polite behavior. The rules of etiquette certainly are not universal. Most of the potential landmines fall within the few simple categories of dress code (see CLOTHING), sense of time and punctuality, eating and food (see HEALTH), language (see LANGUAGE), gift-giving, taboos, gestures (see GESTURES), and customs. Research and master all that you can about the rules of etiquette for your destination. Recognize that their culture is hundreds or thousands of years old and has functioned well long before you came along.

You are not there to inflict your attitudes on them. In this world, one-third of the citizens use a knife and fork, one-third use chopsticks, one-third use fingers…and they are all civilized. Don't expect to fix what ain't broke. Most importantly, become an observer and absorb as much as possible about human nature. Throw in a little diplomacy and tact and you should never be afraid or intimidated by protocol. Just be willing to practice it. 🔅

Protocol: Business Cards One artifact from a more genteel time that retains real significance in many dealings is the business card. An absolute necessity in certain parts of the world, it is ignored by many Western travelers. I carry several with me every day, when overseas and at home. Not only are they important in business, but they are also a freelance photographer's simplest, most immediate form of promotion. They should not be garish or oversized or too precious. Standard-sized cards with a clean design will be appropriate for all social interactions. If you are ambitious, have them translated into the language of the country you are visiting.

> **"Traveling abroad, the first things you learn are about yourself."**
> —CATHERINE DIMECHKIE

[4] *Complete Idiot's Guide to Cultural Etiquette* (Carol Turkington, Alpha Books); *Behave Yourself!: The Essential Guide to International Etiquette* (Michael Powell, Globe Pequot Press); and *Traveling Smart: The Know-Before-You-Go Guide to International Travel* (Carolyn Uber, Dragonfly Press) are good examples.

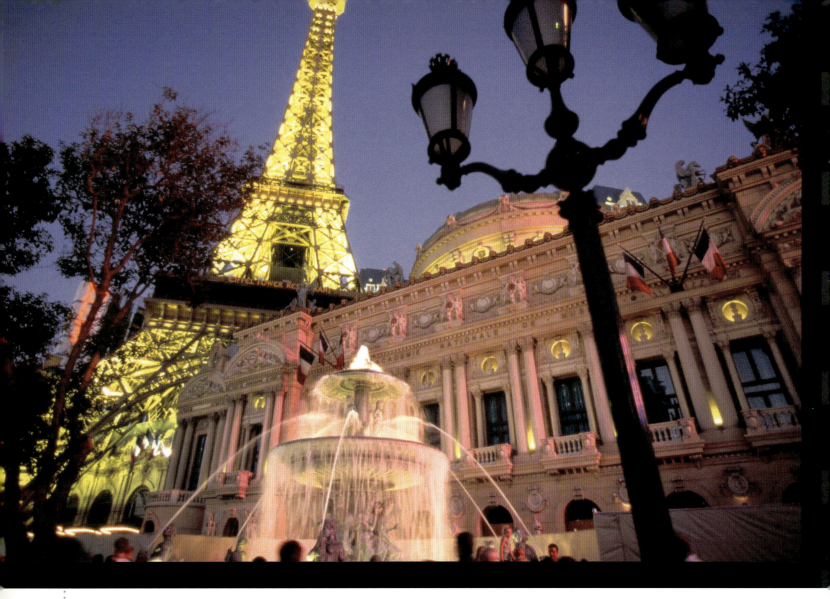

Paris Casino/Hotel, Las Vegas, Nevada. *Is this Paris, France, or a mirage? Should this be filed under Las Vegas or casino or both? When was it taken? Who has the slide and how are they intending to use it? There should be no ambiguity. The better the paper trail that you can create with each transaction the more often editors will come back to you for more illustrations. Also, you know you will get your images back in due order.*

> **"Edit more, don't bore."**
> —JACK REZNICKI

Chapter Eight: EDITING

O kay. You arrive home safely and you have all these pictures. What are you supposed to do with them? You could stuff them back into their boxes, put them in the closet, or show them to friends during nostalgic moments. But, if you want to profit from them, just looking at them will not do.

Photographs can educate, entertain, or make money. You have a unique, visual document of places you have been. In order to put them to further use, you must organize them. You may be gifted with a photographic memory and remember each detail about every frame you take, but no one else will know what or where anything is unless you take the time to edit and caption each one. Also, you probably do remember everything today, but years from now you may not still possess total recall.

The more information you can attach to any given image, the more valuable it is in the long run. If an editor or art director wants to publish the picture and you can supply pertinent data, there is greater chance for sale. Also, as time passes, the image increases in value as it becomes an historical record. We all have snapshots from the old family album without names or dates on them. The images are vague ghosts that grow fainter with time. Never relegate your artistic output to that fate.

Archiving. *As you stockpile images from your travels their value increases with the amount and accuracy of the information you can attach to them. Collating, captioning, and cross-referencing are your primary responsibilities. Whether you use a lightbox or software to view your output, take great care to use archival-quality methods of storage and preservation.*

Cataloguing all the photographs in your library begins with meticulous note-taking. However you do it, make those notes as soon after taking the pictures as possible. You can carry a traditional journalist's notebook in your pocket or camera bag, or you can use high-tech equipment such as a voice-recorder or personal digital assistant (PDA) and record details directly into your computer. Do not wait until you return from a trip. Collecting data is easiest done on the spot. Be sure to get the correct spellings of towns or buildings while you are still in the vicinity. You can ask questions of locals to clarify dates, gather brochures with histories, or buy maps onsite. Immediacy is the best technique for reliable information. Guidebooks are helpful later, but one's memory is a very bad reference tool.

Photographers tend to be their own worst editors. They retain badly exposed, badly cropped images just because they are sentimentally attached to their creation. If you cannot be objective about your own work, it may be more efficient to let someone else handle the process. It is painful, but you must be brutally honest. We have all suffered through those interminably long, boring slide shows where friends make excuses but still show every single picture from their vacations. A usable image has to have good color, good content, and a distinct point of view. If it does not meet those criteria, it should be discarded.

If you are viewing small transparencies or contact sheets, you need the proper tools on hand to make your selections. A good loupe is essential. The optics are important so as not to distort the image, and the magnification should be at least 4x. In that this may be the only way you see the quality of a picture before you commit to printing or publishing, buy the best loupe you can afford. It is not unusual to have 6x or 8x on hand. These are critical instruments for judging focus and composition. With digital, quality control is a little more expensive, as you need the appropriate computer and software to critically view your files. If you are ambitious, you can edit on your laptop while still on location. Using downtime to peruse the day's take is the most economical use of your fresh mind. Just be sure to **back up** everything you plan to keep.

Holding slides up to the window light is not a good work practice. A color-balanced lightbox is another essential tool for examining your pictures. In order to evaluate color, the standard is a lightbox that has a 6500 K source. This is the only way to be sure of the final result. The comparable lingo in the digital world is **color management**. Maintaining consistent results from camera to storage device to picture output is turning out to be a complex proposition. Take the time to match your computer monitor and your output devices.

When you arrive back home and have processed the film or stored your data, you should develop the habit of handling the images as few times as possible. Captioning is a tedious task, so the more streamlined you can make it, the more likely you are to do it well. Put captions right on the individual pictures, if you can. If your medium is transparency, write on the slide mounts. If you have digital files, code information into the data area. Have rubber stamps made before you leave with the names of the most significant destinations: countries, cities, events, etc. It will speed up the repetitive labeling process. If you make prints, adhere a label to the back of each one. With contact sheets, you can do the same thing, with information about individual frames clearly delineated. Develop general categories, such as **A**nimals, **B**uildings, **C**ountries, or **D**ar es-salaam.

AUSTRALIA

hungary

singapore

singapore

west germany KOREA ISRAEL

Kuala Lumpur

Czechoslovakia GREECE BRAZIL

CANADA

spain

Malaysia

NORWAY GREAT BRITAIN ENGLAND Malaysia

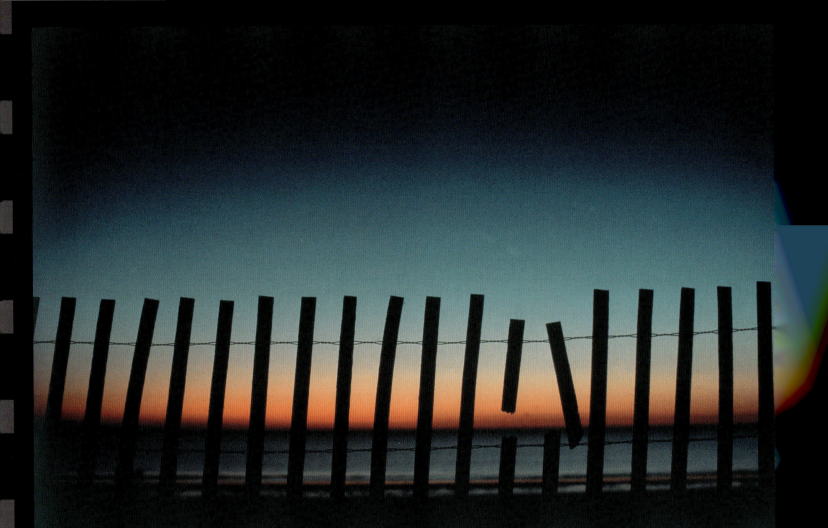

Snow fence at dawn, Duxbury Beach, Massachusetts. *The use of abstract concepts is very difficult to predict. How someone might use this image is anyone's guess. Although the location and date are fully noted on this image, it was irrelevant to the editor who requested it for an airline travel advertisement illustrating uniqueness. No matter how extensive the cross-referencing and keywording, your system has to remain open to conceptual thinking.*

If you are systematic about cataloguing, you will learn that the whole process is a very meticulous ordeal, but your reputation depends as much on the details you can provide as on the quality of your photography. Not only do you have to be careful about the accuracy of your information, but the methods and materials you use to affix that information to the images must also be worked out. Real craftsmen will spend time investigating and employing the most up-to-date, **archival** techniques. You can write on cardboard slide mounts with ballpoint pens or markers, but doing the same to the backs of photographic papers can be risky. Only certain archival inks or adhesives will last any length of time and not ruin the prints. Many inks that claim to be permanent are not. It is very expensive to be perfectly archival, but a great deal of consideration should be given to preserving your legacy for as long as is practical. The labels and fixatives you use are potentially harmful to the life expectancy of a slide or negative, and anything that comes into contact with the print can also have a deleterious effect. Papers, plastics, books, and cabinets all have to be properly administered to ensure the longevity of your photographs. Use top-rated CDs. They have a shelf life, too, and should be updated periodically.

Civil War reenactment at Cedar Creek Battlefield, Middleton, Virginia. *We have a fascination with history. Photography is an excellent way to record history as it happens. Often, photographs are the only artifacts that remain from which we can glean details about the past. From photographs history can repeat itself.*

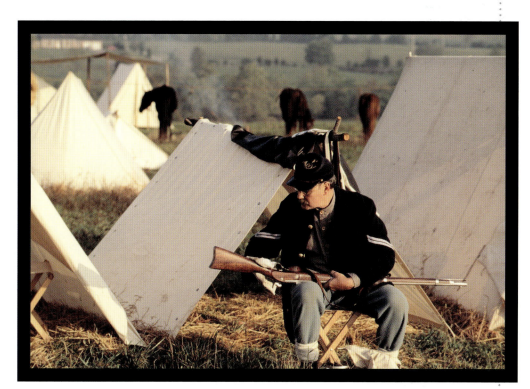

When you think of the labor and money you have put into your collection, preservation eventually becomes your biggest concern. The climate, storage boxes, and envelopes that surround your precious property all can have an effect, and the normal rules apply. Photographic dyes are fugitive and remain living, evolving substrates; therefore, they decay. Your two biggest enemies are temperature and humidity. Keep slides, negatives, prints, and electronic media in a cool, dark, dry place. The greater their exposure to the elements, the faster they will fade.

The science of archival storage continuously changes and updates get more complicated all the time. Even if you buy albums and boxes at photography stores, it does not mean they are good. Most papers contain acids that will leach into negatives eventually. A pH balance between 8.5 and 10 is considered the norm.[1] Only certain clear plastic filing sheets that hold individual slides or negatives are safe. Avoid those made of PVC (polyvinyl chloride). Seek the advice of professional photographers or museum/gallery curators whose business and livelihood are affected by the knowledge.

[1] See *Storage and Care of KODAK Photographic Materials,* Kodak Publication E-30 (http://www.kodak.com/global/en/consumer/products/techInfo/e30/e30Contents.shtml).

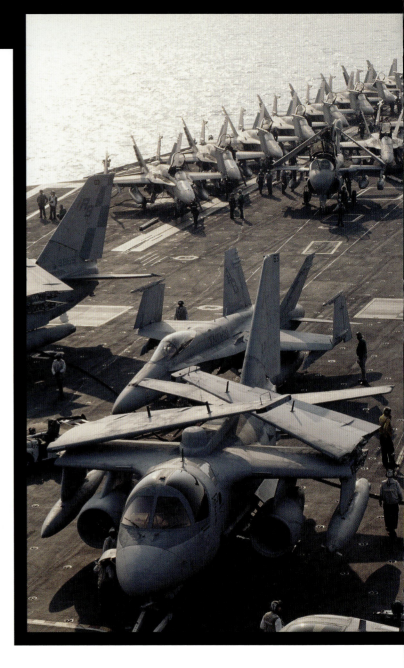

Flight deck of aircraft carrier, U.S.S. George Washington. *Landing and launching from aircraft carriers are physically rigorous enough for photographers. At the same time, though, we are expected to keep notes on everything we see and experience. I carry a notebook with me every day of my life. I know details about the tonnage, crew size, and power plant of this carrier; for example, the planes in the foreground are S3s and those in the back are F18s.*

Digital editing has a totally different definition. The manipulation, retouching, and compositing of images are ubiquitous in the computer age. The ethical question becomes one of intent. Is expediency, greed, or laziness dictating the use of software to stretch reality? Is the photograph meant to deceive? Photoediting can be a marvelous creative tool or it can be abused. With the technology available today we can make any fantasy reality. As time goes on, each person has to answer that for themselves.

Photographs, with age, take on the reality that they once merely recorded. After sufficient time, they, being the only thing left, become more valuable than the original scene.

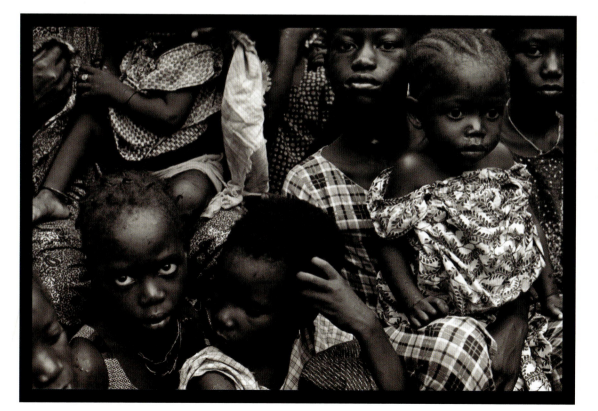

Village party, Fass, Senegal, West Africa. *Not only do we have to keep track of every digital file, every slide, and every negative we value, but we also have to archive every print we have made. Eventually, this can become an enormous task and expensive. Each medium requires its own separate space and care.*

DUPLICATES

If you are using traditional, silver film, your original transparencies are precious, irreplaceable commodities. Clients demand originals. Although good clients are usually trustworthy, sending your work off to strangers puts it at risk. Concerned photographers ensure the safety of their best images by making duplicates. Excellent reproduction-quality dupes can be made with today's films and methods. You can increase their acceptability by duping special images up to 70mm or 4" × 5" films. Many photographers are committing their archives to digital storage by scanning and burning CDs that allow computers to be the vehicle for transmitting images.

There have been tremendous advances in the technology for cataloguing slides and negatives. Computers have made that task easier. Software is available that can cross-reference, label, number, track, and invoice every picture. The programs are time and labor intensive but well worth the investment. As your library grows, it will become increasingly difficult for researchers to access the files efficiently without mechanical help. With these software programs, other people have debugged the sequencing, numbering, and keywording. Coding all your useful slides for filing and retrieval is nearly as essential as captioning. Some systems even use Universal Product Code (UPC) bar coding for logging, tracking, and retrieving film or digital files. Librarians and programmers have been wrestling with archiving problems for decades. If you are so inclined, you can customize your own database but there may be little gained by reinventing the wheel.

At first it may be difficult to determine what information is important to include with any given image. Because journalists, researchers, and editors claim to look for the essential facts, most archival systems ask similar questions: *Who? What? When? Where? Why?*

Location

Where in the world is this? Country, city, region, and neighborhood top the information hierarchy. In some cases, this may seem obvious information, but as the picture is handled and the farther it travels away from you, the more important where the picture was taken becomes. Proper spelling is essential.

Activity

What is going on in the slide? It may appear obvious to you, but the activity can easily appear alien out of context. This is the most important piece of information you can provide. It may not be as necessary if it is a generic building or landscape, but if it shows a function that is unique, it has more value. The more detail, the better for sales.

Identification

Who is in the picture? Identify the individuals, whether they are famous or not. Naming the group, tribe, or team helps immensely. Also, identifying objects in the picture (e.g., mountain range, name of implement, scientific names of plants or animals) increases salability.

Dates

When did this happen? When an event took place is an important factor, especially as a picture gets older and becomes an historical document. If it is a significant holiday or time of year, that information should be included. At the very least, you should record the year; however, dates are controversial in the stock business because some editors feel that some material quickly becomes outdated. So, you will have to work this out with your agent. Some artists mark the date in Roman numerals in an attempt to disguise it and increase the longevity of the picture. Others use a code. Of course, these approaches only work sometimes but may be worth investigating.

Details

What else should we know? No system is perfect, so you should include any other miscellaneous details that will enhance a viewer's knowledge when they see the picture (within reason). If you have the famous architect's name or know the period of the antique, religion of the festival, breed of the herd, chemical being researched, etc., it should be included.

Armed with all these facts, each slide becomes a little novel or encyclopedic. If you adequately cross-reference in your filing system or utilize enough keywords in your software, you can easily call up images that will direct you to ancillary categories. Your archive becomes a living thing and a real source of income.

Clarity is supremely important. Abbreviations and shorthand are confusing. Be consistent with the kind and amount of information provided in your captions. Never lose sight of the fact that mechanical selection of a print is moot. No matter how many of the criteria your filing system may fulfill, editors will choose the image that they like every time. Despite all the keywords that match, visual approval is the ultimate thing that sells a photograph.

COPYRIGHT

To be a good photographer you have to become a part-time lawyer. Basically, you can take a picture of anything you want. If you get away with it, the photograph belongs to you. According to international agreements such as the **Berne Convention**, you are the owner of every photograph you make starting at the moment the picture is developed or saved to a disk, but there are specific rules about how you can use it. Ownership and usage are two different legal issues.

The biggest complaint about photographers that editors, art directors, and contest officials have is that they do not thoroughly identify themselves when submitting pictures. Your name and address should appear on every picture you distribute. Some photographers also include their website address or URL. It is not necessary to put your name or indicate **copyright** on your materials in order to receive protection from the law, but it is a good practice to do so. The recommended format is: © Year Your name (e.g., © 2006 Lou Jones). Copyright is an asset that gives the author or creator a legal right to control the reproduction and use of intellectual property, such as a photograph, a book, painting, music, or software. According to the Copyright Act of 1976, as soon as you develop an image on film or save it in a digital medium, you own the copyright. It should be noted that ideas are *not* copyrightable. The idea must be fixed in some tangible form or expression. A concept cannot be protected.

Although not required, there are good reasons for registering your copyright. Besides the probability of being awarded statutory damages of up to $150,000 per infringement, a favorable judgment will also include attorney's fees. You cannot collect either statutory damages or attorney's fees unless you have registered your works with the U.S. Copyright Office in Washington, D.C. before the infringement or within three months after first publication of the work (see www.copyright.gov/register/visual.html). Because it is expensive to prosecute offenders, registering your copyright is often the only way to recoup any losses from misuse. The procedure is a simple one, and under some circumstances you can register an unlimited number of images at one time for the same fee.

WORK FOR HIRE

A concept that is closely attached to the topic of copyright is **work for hire**. Under work-for-hire agreements, the client is the creator/owner of the intellectual property. If you are an employee, work-for-hire status exists automatically. An organization pays your salary, assists you in your efforts, and consequently benefits from the fruits of your labor. Alternatively, they can transfer copyright only for the commissioned work with a signed agreement between both parties. A client cannot force you to transfer the copyright retroactively.

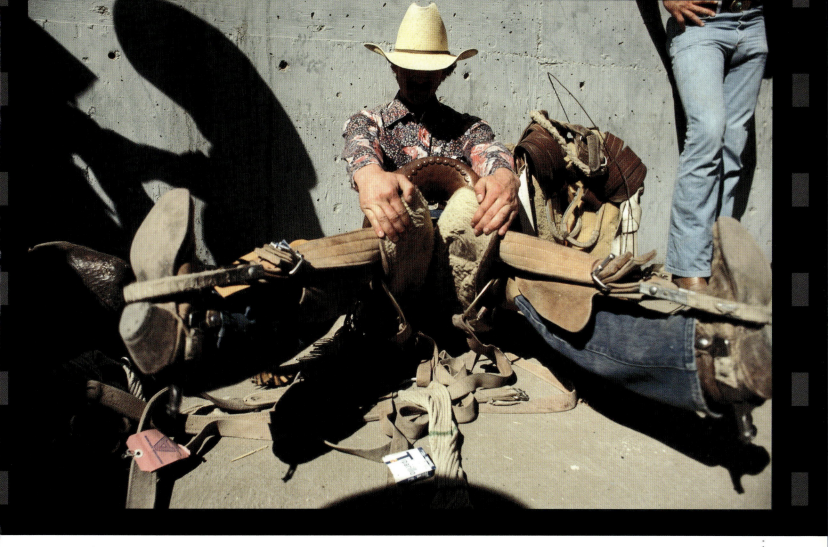

Warming up for saddle bronc riding at the Pendleton Roundup, Pendleton, Oregon. *At the moment I captured this image on film it belonged to me; therefore, no one can use it without my permission. Photographers have had to become artists, salesmen, and lawyers in order to create, market, and protect their intellectual property.*

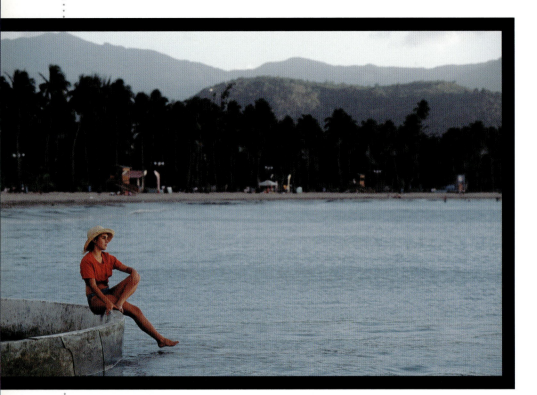

Public beach, Luquillo, Puerto Rico. *I got a model release for this image, and that information is attached to the file. The model is underage, so we had to get her parent to sign for her.*

MODEL RELEASES

As long as no one objects, you can take a picture of anything you want. In the United States, you can be forced to exit private property, and security laws prevent you from photographing strategic installations, but, if you are on public property then you can generally photograph to your heart's content. That goes for taking pictures of people, too. The laws vary greatly country to country. Overseas, if you are approached by the military, law enforcement, or just an irate merchant, do not press the point. The law may or may not be on your side, but they outnumber you. Real restrictions are basically about usage. A subject's right to privacy means that you cannot use their likeness for certain things without permission. If the photograph is for publication in news or editorial instruments, permission is not necessary and a photographer is protected under the law. The law also applies to some educational applications. A photograph is not protected when it is intended for advertising or trade purposes or when the subject can be construed as endorsing a product, issue, or concept. For this, you need a model release; therefore, not having a model release can significantly limit the market for your pictures.

A model release can be simple or complicated depending on who or what has to be protected. There are general adult releases and minor's releases and property releases. All of them can be amended to give additional consideration for either the photographer or the subject. All of the professional trade organizations[2] publish their versions of standard model releases.

You can compose and individualize your own. Although it is a legal contract, no amount of legalese will protect you if you misuse the image. If your subject feels that he or she has been maligned, misrepresented, held up to ridicule, or put in an unflattering light, you can still be sued.

[2] Examples of such organizations include the American Society of Media Photographers (ASMP), Advertising Photographers of America (APA), and Professional Photographers of America (PPofA).

As the years pass, the photographs stack up. Experiences you haven't attached much importance to become big events. The places you have been become memories. The memories you have recorded become history. The history becomes your legacy. Be careful to preserve it all along the way.

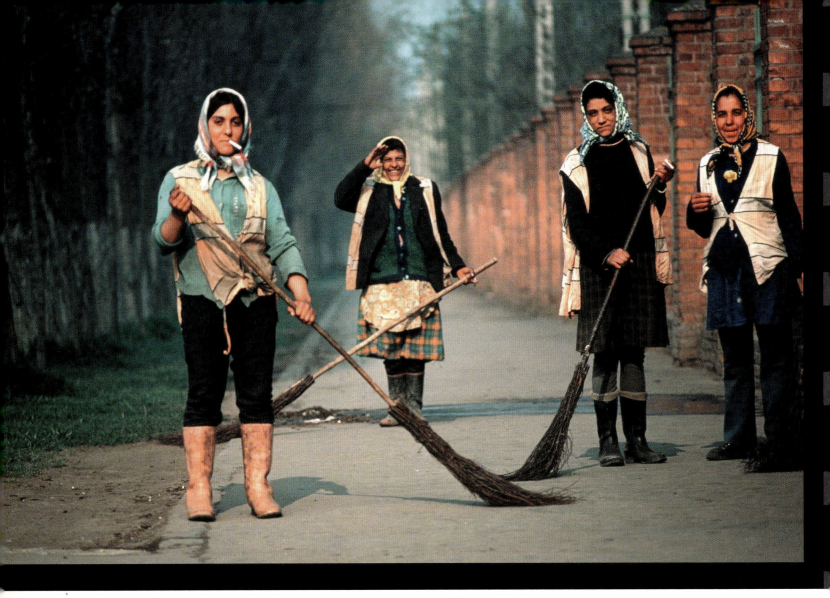

Gypsy sweepers, Brasov, Romania (Transylvania). *Busted in Bucharest. It was my first overseas assignment, and I was being detained by the Romanian police. I was being interrogated in a communist country all because of a time-consuming apparatus: the light meter. At dawn, it took me so long to take it out, calibrate, and make a reading, that a security guard noticed I was in a forbidden zone. Although I was inno-cently trying to photograph these gypsy sweepers, I was too near a manufacturing plant. The delay landed me in jail. The Romanian constabulary had no sense of humor.*

Chapter Nine: SECURITY

As the saying goes, "The world is your oyster." It is a romantic notion, but the minute you step outside your own domicile you are at risk. If you can afford to leave familiar surroundings, you are also at risk for all manner of danger. When carrying cameras, what is slung over your shoulder is often worth more than what some people you are likely to encounter will earn in a lifetime. Whether it is political or redistribution of wealth or just an indigent trying to fund his next meal, photographers and their equipment are major targets for crime. Photography equipment is small, portable, and valuable. It is easily fenced, so it is high on the underworld's "most wanted" list.

You should be ever vigilant. It is imperative to never get so distracted that you find yourself in situations you cannot handle. Know your limits. When moving around uncharted territory, keep your equipment concealed until you need it. Although we like to have the fanciest, up-to-date gear, cameras that show wear and tear are less enticing to thieves. Some professionals tape over the brand names on their equipment. It camouflages the more recognizable brands.

To some, it may seem an obvious precaution, but there is never a good time to leave your camera bag in your car ... not even the trunk. *Never*. The litany of stories told by photographers, both amateur and professional, about stolen equipment is endless and pitiful. It is far more tempting for a thief to break a car window than to assault someone.

Helplessness is an invitation. Looking around as if you are lost or stopping to read a map on the street can invite scrutiny from strangers. Enter a hotel lobby or some less exposed area to retrench. Taking a picture while staying aware of what is going on around you is a form of multitasking. Develop personal radar. Absorb your environment. Over time, grow eyes in the back of your head. Street smarts come with experience.

Tourists are gullible. They are susceptible to all sorts of scams, cons, and ruses, and thieves may not be obvious. They come dressed in stolen Armani and Gucci. They prey on the most vulnerable, when they are the most harried. Pickpockets run in packs and employ decoys and distractions. Con artists target places of transition: malls, transportation stations, subways, special events. Protect your valuables. Keep your wallet in a hard-to-reach place or sling your purse strap over your head. Master the basics.

No matter where you go, you will be identified as different when you are outside your immediate neighborhood. Things you do without thinking will emphasize the fact that you are a stranger. Wearing unfamiliar clothing or hanging an expensive piece of shiny hardware around your neck is just advertising for trouble. Disappearing into one's surroundings is really the result of your state of mind. Exude confidence, but avoid drawing attention to yourself. Dress inconspicuously. The more obvious you make yourself, the more difficult it becomes to take the pictures you want. At the same time, never be afraid to make a spectacle of yourself if it is necessary to get the picture. Timidity is not an asset in good photography but neither is temerity (see PROTOCOL).

Do not wear clothing with identifying labels. This is both a political and economic precaution. Logos announce your nationality as well as your affluence. Give the locals some credit. They can always pick you out. T-shirts, jeans, hats, or jackets with trademarks brand you, and the person watching may have a problem with your place of origin. Women are noticed, especially when they are alone. Women might never be able to blend in totally, but they can dress with care to affect a little ambiguity as to their origins.

Sometimes saving money can be expensive. Staying in bargain-basement hotels may seem frugal but it could possibly compromise your personal safety in addition to that of your valuable property. If the doors and locks are insufficient and the staff only makes minimum wage, you should assume your safety is not their priority. Make reservations at the most expensive accommodations within your budget.

Outside the hotel, do not carry more money than you can afford to lose. Divide the cash or traveler's checks or credit cards so you are never carrying all your valuables in the same place. Put some money in your wallet, keep what you expect to spend in your pocket, and put the majority in a money belt, your sock, or similar concealed device. Never access this hidden place while standing in line or in any other public place.

You have not reached the ultimate in travel until you can willingly put yourself on a conveyance and not know the destination or when you will arrive. The thing that keeps one from traveling is a fear of the unknown.

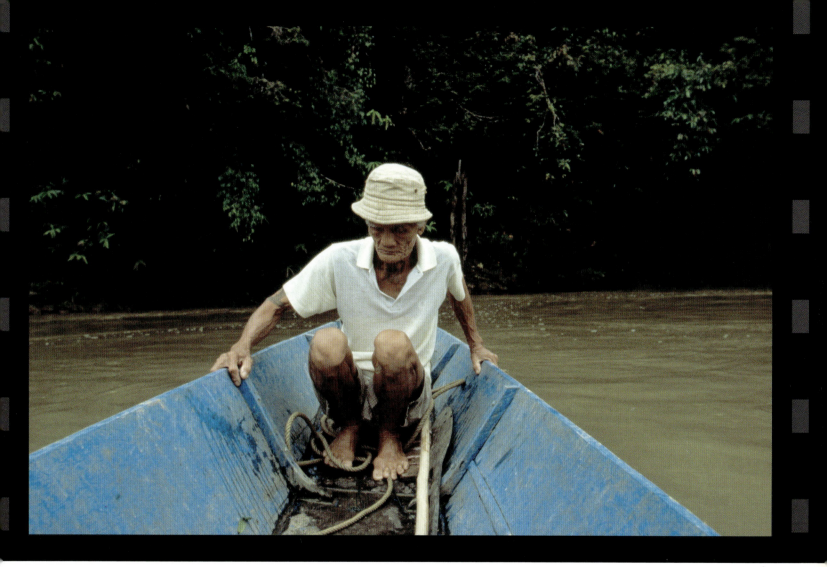

Longboat on the Lemanak River, Sarawak, Borneo, Malaysia. *Life in the rainforest of Borneo has changed little over the last few generations, although not long ago headhunting was outlawed in Malaysia. This member of the Iban tribe was transporting us upriver to stay in his village. It was a form of ecotourism, and I was excited by the uncertainty about what lay ahead.*

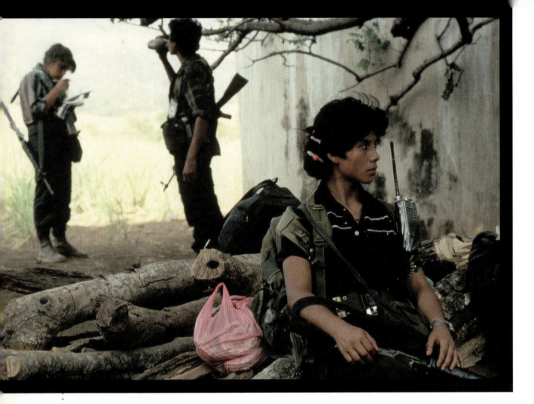

Guerrilla encampment, Buenos Aires, El Salvador. *After much planning, I intentionally allowed myself to be captured by a guerrilla group. My companions and I were stripped of all our belongings and placed in the stockade. The entire camp was surrounded by small arms and mortar fire, as the combatants were being held down by the military. Eventually, we were able to convince the commander of the group to let me take pictures. It was a calculated risk to get provocative pictures.*

When you are out taking pictures, leave your expensive watch and jewelry in your hotel room or, better yet, at home. Record the serial numbers of all credit cards and traveler's checks or make a photocopy of the actual contents of your wallet. Conceal one copy in your luggage and leave copies with someone back home whom you can contact in case of emergency. If you include copies of your Social Security numbers and birth certificate, you can make it easier for that second party to help you in all kinds of emergencies.

Most travel precautions are things you should be practicing in your daily life. Never assume that just because you are in an upscale neighborhood you are safe. Whether you travel to first-world or third-world countries, get in the habit of following the same precautions. Be careful around ATM machines. They may be located near banks and respectable retail sites, but thieves target unsuspecting tourists. Even careful people make the mistake of writing PINs on their debit cards so they do not forget them. Do not make it easy for pickpockets to access your secret codes. Be sure no one can see the PIN you are entering at an ATM or the numbers you are dialing on a telephone in public places. Be aware that thieves have been known to use binoculars or videotape to intercept dialing patterns.

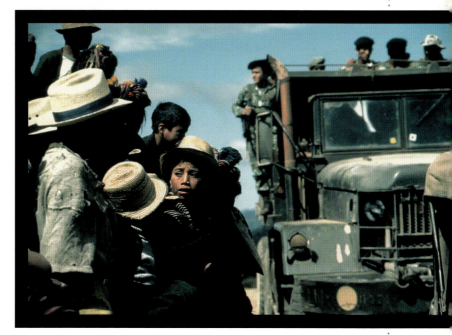

Even in the best hotels you and your property are vulnerable. Leave the radio or television on in your room when you are out, and never use the doorknob signs that request room cleaning. It announces your absence. Employ the hotel safe deposit boxes for everything you feel uncomfortable leaving in the room. If this is too inconvenient or slow, at least split up your camera equipment. Distribute various pieces between different drawers, and place larger items in the back of closets or under the bed. Attach a security wire to your laptop computer and secure it to an immovable object. These tricks do not foil career criminals, but they slow them down from making a big score in a hurry and wiping you out. Also, remember to get into the routine of retracing your steps so you do not leave anything behind.

Do not open your door to strangers. This goes double for women. If the person knocking on your door has not called up to the room or you are not expecting a visitor, call down to the front desk to verify any unsolicited staff personnel. Engage the secondary lock when you are in your room. Keys can be duplicated. Once thieves have breached the security barriers of your hotel and obtained access to the different floors, they can do a lot of damage with sophisticated scams.

Refugee children, Ac'txumbal, Guatemala. *The Guatemalan military helicoptered us to this refugee camp in the mountains to investigate accusations of genocide. The country was in a tense state of siege at the time. I wore a bulletproof vest during the entire trip.*

PASSPORTS

With a passport and credit card, mortals can be lethal. In our overheated century, yesterday's miracle is today's standard issue. In less than 24 hours you can travel to the upside-down part of the world. Consequently, the most important document you possess when traveling outside your native land is your passport, and it is also valuable to others. Nearly 80% of Americans do not possess a passport. If you lose it, for whatever reason, you will discover that it is worth more than its weight in gold. Make at least two photocopies of the first two pages: one copy to carry with you separately from the original and one to store safely at home. Do this for any visas, too. It will prove tremendously easier to replace a document at an embassy or consulate if you have replicas. Carry your passport on your person at all times. It is a legal document, can identify you in all sorts of transactions, and, in some inhospitable countries, may be the only thing between you and detainment. Carry spare passport photographs with you, too. Keep a couple extra in your passport. They can be used when applying for last-minute visas and for identification badges.

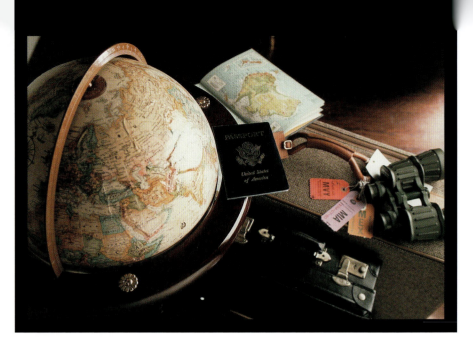

Your passport. *When you are traveling, your passport is your most important document. In it you should keep documentation about visas, inoculations, carnets, equipment registrations, taxes, etc., and then protect it with all due diligence. You should make several photocopies that you keep in safe places so you can apply for replacement or renewal if necessary. It becomes more beautiful as it fills up with entry/exit stamps and dates and is a great souvenir of your exploits.*

If you look like your passport picture, you probably need the trip.

INSURANCE

No matter how much attention you pay to details, inevitably things will go wrong, and you will want to have financial protection against such contingencies. There are several forms of insurance for travelers. Be aware, though, that most homeowner's policies are not valid abroad or in select parts of the world. Check your policy. You can acquire additional protection from companies that specialize in travel and offer a variety of services. Do some comparison shopping for both coverage and price before you venture very far. Also, make sure that any extra insurance that you buy does not duplicate what you already have.

When investigating insurance, be sure the policy fits your type of trip and covers the kind of risks you are likely to encounter. Be especially cognizant of the deductibles and establish what preexisting conditions are excluded. Photographers often have specialized needs. Travel policies can be tailored to also cover trip cancellation, ticket replacement, medical evacuation, equipment, and theft. If you purchase your airline ticket with a gold or platinum credit card, the credit card company will cover lost or damaged luggage. It is a good idea to pay for all large purchases of transportation, equipment, or services with credit cards. If problems, disputes, or cancellations arise, applying for a refund is much easier than if you had used cash. While credit cards offer valuable consumer protection, you should not rely on them to cover everything; when local laws do not require refunds, there may be nothing that will protect you. If you rent cars using your credit card, the credit card company will absorb certain parts of the liability and comprehensive insurance.

Credit cards help protect you against unauthorized usage and misrepresentation, but you need documentation as to exactly what you purchased. If your credit cards are stolen, contact the pertinent companies and leading credit check agencies.[1] Informing them immediately of improper charges on your account will help avoid long-term credit problems and may help thwart the thief.

Insurance A friend came over to accompany me on an annual report shoot in Italy and Austria. She arrived. Her luggage didn't. Justifiably she was angry. Because I had bought her ticket using a platinum credit card I have just for this purpose, I marched her into several nice Italian boutiques and bought a wardrobe to get her through the remainder of the trip—all courtesy of the credit card company. They reimbursed me for the entire amount. Her luggage arrived the last day but we hardly missed a beat.

[1] Equifax, 800-525-6285; Esperian (formerly TRW), 888-397-3742; Trans Union, 800-680-7289; Social Security Administration fraud line, 800-269-0271.

On my second trip to Haiti, I got caught up in a huge, animated political rally. I didn't know what was going on but I waded in to get pictures. The crowd surrounded me and hoisted me up onto the podium near the speakers so I could get better pictures. I could not understand what they were asking but they were adamant about my taking photographs of the proceedings. Later, I realized I was wearing a prized T-shirt, a gift from my sister, who worked for **The Washington Post.** They thought I was representing the newspaper. I was lucky they wanted me there instead of the other way around. I have never worn an identifiable piece of clothing since.

Prevailing wisdom has it that the premiums for most of the commercially available travel policies are very high when compared to the amount of compensation offered. Realistically evaluate your exposure and do not assume that just because you have purchased additional insurance you are well protected. In addition to the initial impact of bodily injury or stolen equipment, the resulting aggravation and waste of time can detract from your assigned mission. In today's unpredictable times, be sure to get a travel insurance policy that lets you cancel for no reason any time prior to your departure with little or no penalty fee. As you become more experienced with comprehending alien environments, you will venture out more and more and realize the ease with which an informed, knowledgeable person can float around the world.

In the unfortunate circumstance that you are actually held up, do not be a hero. Let the perpetrators have your valuables. You can always get new cameras. Try to keep your shot film separate from everything else, as you cannot recreate that. But nothing material is worth your life or serious injury.

TERRORISM

Statistically there is very little chance you will ever encounter any type of terrorist act, but we do live in a "brave new world." The possibility cannot be ignored. As stated before, avoid national or corporate logos on your person or on your luggage. This goes double for military insignias, veteran's badges, or war paraphernalia. Never carry or deliver anything for anyone you do not know. Report abandoned packages or briefcases. If the situation seems suspicious, leave the scene. Make it a habit to stay away from political discussions while in public. It is boorish and your conversations can be overheard. Do some homework.[2] If you are a hostage, never make eye contact with your captors or speak unless spoken to, especially at the beginning of the ordeal. Remember that you are more valuable to a kidnapper or terrorist alive than dead.

Safety is paramount. You can never be too careful; however, travel photographers must accept a certain amount of risk. Exploration attracts the adventurous spirit. When you get into a leaking, dugout canoe with someone you have never met before and set out on snake-infested waters to get the ultimate picture of an as-yet-undiscovered tribe, you have to expect uncertainty. Eventually you come to rely on your instincts to let you know how far

[2] U.S. State Department website, www.travel.state.gov; Australia website, www.dfat.gov.au/travel; United Kingdom website, www.fco.gov.uk.

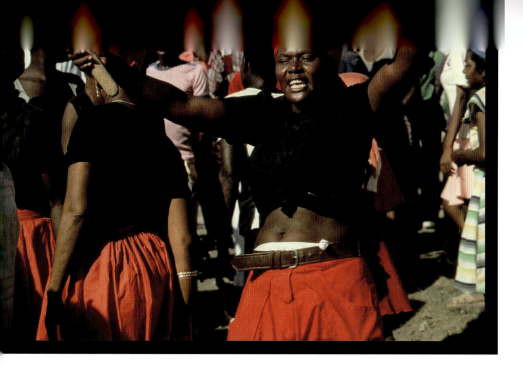

Ra-Ra ceremony, Jacmel, Haiti. *Sometimes you can get in over your head. I stumbled upon this voodoo ceremony in the middle of Haiti. Before I knew it, I was surrounded by the revelers. I do not think they ever meant me any real harm, but I found out soon enough I was not welcome. Fortunately, I was able to retreat with some dignity.*

Terrorism I have had several assignments cancelled because of terrorism. Anwar Sadat was assassinated in Egypt, and they closed the borders. When the Gulf War began, the company I was working for stopped their project in Turkey. The Palestinian conflict prevented a trip to Israel. Internal troubles have never deterred me from flying or traveling into a territory in crisis. In fact, it attracts me. I have photographed in war-torn countries. That is where you find the pictures. But, if you are nervous about an assignment, you have to weigh the pros and cons of the adventure.

you can follow each new experience. The corporate world calls it *risk management*: assessing the danger level and taking necessary precautions.

More to the point, good photography is like high-level risk management. Aesthetically, on every picture you should risk a little more than you can afford to lose, frame by frame and photoessay by photoessay; otherwise, you are just repeating the same, safe images. You will grow bigger travel muscles with time and learn to overcome your fears and preconceived notions.

There is a growing appreciation of extreme photography, where the practitioners perform very dangerous stunts to get improbable pictures. Others live in alien environments for extended periods of time in order to bring back documented proof that they were there. Photography is going places no one has gone before. This is how human knowledge expands. How civilization advances. Photography is at the vanguard and is a preferred tool of discovery. But evaluate just how far you care to go—the main objective is to return.

Medicines. *Carry an ample supply of all the medications you may need for the duration of your trip. If they are available, over-the-counter drugs may not be named the same. Prescription names may not translate well. You do not want a trip cut short because of an avoidable detail. Once again, this text has no medical standing so be sure to check with your doctor before deciding what medication you should take.*

Chapter Ten: HEALTH

Once upon a time, travel meant encountering hostile native attacks, life-threatening ailments, uncertain weather extremes, and wild animals. But, today, with a little advance planning and a lot of vigilance, we can expect a safe, healthy visit to just about any spot on Earth. First of all, you should know your own limitations. In the heat of the moment, you are capable of overextending yourself or trying to cram too much into too little. Travel is all about adrenalin. It is an addictive drug. Combined with your emotions, this hormone can keep you performing well beyond your normal levels for a long time. It tastes bitter. Soldiers and explorers and athletes thrive on adrenalin's effects for weeks, months. With the increased stimuli of an exciting new place, you are likely to find yourself more perceptive and your senses more acute, but you cannot live on adrenalin forever. Pace yourself.

Medical records. *Be especially diligent to manage your medical issues before you leave home. Relying on health care in foreign countries is usually complicated. Access, communication, and insurance issues can make the experience unpleasant, on top of the fact that you are already sick. Methods of diagnosis, medical equipment, and medicines may not be the same as you are used to. Try to assemble the most complete medical records you can for the particular circumstances.*

One of the most petrifying experiences on the road is a visit to the doctor. The best way of handling emergencies is to avoid them. Research the climate, altitude, and living conditions of your destinations. The location or schedule may suggest extra precautions or inoculations or preventive medicines. There are two kinds of immunizations. Recommended vaccinations are suggested for your protection. Required vaccines are given to prevent transmission of disease between countries. The **World Health Organization** maintains daily updated requirements for each country. Regulations change frequently, and many family physicians are not up on which countries demand proof of shots. Another agency that has current information is the **Centers for Disease Control and Prevention** (www.cdc.gov/travel).

Cholera, tetanus, influenza, diphtheria, hepatitis A, and typhoid are critical vaccinations. More optional ones include yellow fever, hepatitis B, and rabies. In reality, infectious diseases cause only 1% of the deaths among international travelers, but be aware of high-risk zones. **(N.B. This text has no medical standing. Be sure to check with your doctor before deciding on which vaccines to get.)**

If you have allergies or existing medical conditions, stock ample supplies of your medications to last the duration of your trip, whether they are over-the-counter or prescription drugs. Do not rely on restocking in a foreign place. Wear your allergy tag if appropriate. Keep all medicines in their original packaging; otherwise, customs officials might suspect you of trafficking in controlled substances. If you routinely treat cancer, hypertension, heart disease, or a variety of other conditions, ask your doctor how the various vaccines might react with your current prescriptions. High elevations can play havoc with people who have pulmonary conditions, and anyone with heart disease is susceptible to dehydration in excessively hot climates.

Any assortment of minor ailments can greatly limit your ability to perform, but if you develop healthy habits you can reduce or eliminate the likelihood they will hinder you.

Before anything else, sit down and write your medical history. It takes just a few minutes. Then keep this piece of paper in the safe place where you carry your passport. Include:

- Current medications—name, dose, prescription number, and pharmacy
- Surgeries—type, place, date
- Chronic illnesses (anything you take medication for)
- Doctors' names and phone numbers
- Insurance phone number and policy numbers
- Personal contacts and next of kin

Travel is very educational.

I can now say "Kaopectate" in seven different languages.

Cataract operation at Higash Jujyo hospital, Tokyo, Japan. *Health and medicine can be the object of your photography. My client helped me gain access to this hospital in Japan, and we were able to light and filter for all the different medical procedures we saw. My assistant and I photographed a brain operation and this eye procedure. We had to dress in sterilized scrubs just like the doctors and nurses.*

Sleep Futurist and global thinker, Buckminster Fuller, noting the inefficiency of sleeping a third of your life away, made a habit of resting 15 minutes every 4 hours. He did this all of his life, round the clock. On the road, I often endure long waking hours due to traveling and shooting; therefore, any sleep I get is haphazard. Taking a page from Bucky Fuller, I have taught myself to grab short naps just about anywhere: in a car, waiting for a plane, etc. I can almost sleep standing up. It is a constant source of amusement for my companions but I have a job to do.

JET LAG

The condition commonly known as jet lag is scientifically termed *circadian dysrhythmia*. By jumping time zones as you fly to distant destinations, you upset your body's natural clock. The 24-hour cycle is established in infancy and affects bodily functions for a lifetime. As a matter of fact, jet lag seems to have a high correlation with age. People over 50 are more susceptible. You get used to eating or sleeping in certain sequences, but, when you step off a plane halfway around the world, your body has difficulty catching up with the altered routines. When that rhythm is interrupted, exhaustion sets in and reactions slow. You often experience lapses in concentration, mental fatigue, anxiousness, and a decrease in libido. The act of flying does not cause jet lag. It is the result of a biological conflict between internal patterns and external cues. A rule of thumb is that it takes one full day to recover for every hour of time difference you experience; that is, if you have traveled across six zones, it will be almost a week before your body is back to normal.

There are countermeasures to jet lag, but they work better for some people than others. If you are forced to take a long flight, try to arrive at your destination late. That way you will not have to work as hard to stay up. You can get to bed and wake up in the local time schedule the next morning. Exercise on the plane to increase blood circulation and prevent fatigue. Stretch in your seat. Walk up and down the aisles.

Consider taking an aspirin before a long flight. There is evidence that it reduces the chances of developing blood clots (pulmonary embolus) in the legs or lungs. People with an allergy to aspirin or history of gastrointestinal bleeding or ulcer should avoid aspirin. Even with the aspirin, still walk up and down the aisles of the airplane to stimulate circulation.

While in the air, imbibe alcoholic beverages in moderation or not at all. The effects of one drink doubles when you are over 30,000 feet. Also avoid caffeine. Do drink lots of fluids, such as water or fruit juice, to prevent dehydration. Carbonated water is said to rehydrate you faster. Be especially careful with antihistamines, tranquilizers, and sleeping pills. Protein-rich foods inhibit sleep and carbohydrates are easier on the digestion. Relax.

There is evidence that sunlight is an agent that controls the biological clock. Learning to harness its effects can provide the energy necessary to put you in sync with a new time zone. Darken your environment when you need that power nap but use the sunlight and fresh air to reinvigorate you.

WATER

If in doubt, the number one rule is not to drink the water. Do not forget that goes for ice, too. In areas without chlorination, buy bottled water or drink soft drinks. Pay close attention to the cap on a bottle. If it is a cork, local tap water may have been substituted. Smell the water. Take extra care to use the original container because glasses rinsed in unsafe water are just as dangerous. Also be careful with fresh juices, as they may have been diluted with tap water. Drinking coffee can be all right, as it is heat processed. Many people make the mistake of believing that drinking tea is safe because the water is boiled; however, rarely is the water boiled for the required 20 minutes. If you do not observe the tea being made yourself, consider it suspect. Brushing your teeth with tap water is also dangerous. Remember that hepatitis is not just inconvenient—it can be deadly. If you need to purify water, it has to be vigorously boiled. Adding a pinch of salt to each quart will improve taste. Filtering is not a real option. If the liquid cannot be boiled, it has to be treated chemically. Chlorine tablets will destroy many pathogens but not all. Iodine is also effective. Read the directions for purifying water carefully.

Sixty percent of the human body is made up of water, and 75% of the Earth's surface is covered with water. *We need it for our life and health and commerce, but it can be harmful. It is essential to learn to manage water consumption when you travel.*

FOOD

Probably the most common health concern among travelers, both novice and experienced, is where and what to eat. Humans are vulnerable to all sorts of maladies when unfamiliar substances are ingested. Nutrition is necessary, of course, but adapting to the complexities of an exotic cuisine is a necessary skill that should be addressed in the early stages of your preparation.

A weak stomach, mental attitude, allergies, and parasites can all ruin an excursion. You gotta eat, but cultural bias, being finicky, and prejudices keep some of us from fully experiencing new tastes and foods. If you are serious about traveling, a reluctance to eat the local cuisine can become a real hindrance. Every culture has interesting foods that are just as significant as the sights and sounds you are seeking. Most distrust of unfamiliar foods is mental. Consistently sampling new dishes helps open new vistas and adds to a well-rounded experience. You practice in order to see better. It stands to reason, then, that you can train yourself to eat more adventurously, too. Without a doubt, some things may just disagree with you, so you do not want to push yourself too far when traveling. Start by experimenting at home.

Food Before the Pompidou Center was erected, I crossed half of Paris to have onion soup in Les Halles. I got up at 3:30 a.m. and walked forever to sample typical food that the restaurant and market suppliers were delivering in the middle of the night. I didn't even like onions, and I had no idea what onion soup was. But, while Paris slept I was anxious to try something new. It was delicious. One of the great food experiences of my life.

Strawberries. *If you know you have a strong constitution, then you can experiment with eating almost anything. Many familiar and unfamiliar foods can look enticing, but fruits and vegetables that do not have a skin or shell or peel should be avoided. Pesticides and fertilizers remain on most produce. And, even if the produce is washed, the water itself may be contaminated with substances that can make you sick. Unless you are sure about the handling of foods, politely decline.*

**Wine and cheese on balcony overlooking Boston Common, Boston,
Massachusetts.** *Not only is the fun of ingesting delicious delicacies essential to the experience of traveling, but photographs of the foods are also part of the story. Keep your eyes open for unique dishes or typical foods that are attractive enough to feature in a still life.*

You already know the foods to which you have allergies: shellfish, peanuts, eggs, spices, etc. It goes without saying to avoid them. But, a much more insidious problem is how to avoid the microbes and parasites against which indigenous cultures have built resistance. Another rule of thumb: If it is cooked, boiled, or peeled, you can eat it. Salads and fruits that do not have a skin to peel are very suspect. Avoid milk, even in your coffee. Also, in developing countries, pass up products bought from street vendors that sit for extended periods of time. Remember, street food is culinary minimalism because the one who has prepared it has little overhead, but there are treasures to be found if you are savvy. One fallback that you can usually rely on is fried foods. They are cooked at temperatures that will kill most anything.

Another excellent practice to adopt is to consider your hands as your enemy. You can easily keep away from food and liquids that are hazardous, but never forget that everything and everybody you touch are potential sources of disease. If you shake hands with someone or pet an animal or turn a public doorknob, you can transfer germs to your mouth or eyes unwittingly. Keep your hands away from your face. Wash your hands frequently if it is convenient; otherwise, make a habit to frequently cleanse your hands with foil-wrapped antibacterial towelettes or instant hand sanitizers that are available in pocket-size bottles from your drugstore. They can also be used to sterilize eating utensils and are small, thus allowing you to be discreet so as not to offend your hosts.

Flatware. *In first-class situations, concerns over what you can eat and how may be moot. But, as you become more adventurous you have to become more vigilant. Besides being careful about what you eat, you should be aware that glasses and utensils are potential carriers of parasites and germs. Make it a habit to carry personal sanitizing packets or liquids for cleaning suspicious utensils. Just be sure to do it discreetly so as not to embarrass your host.*

Tsukiji fish market, Tokyo, Japan. *You should approach trying new cuisines with the same attitude you have toward exploring any unfamiliar country, but certain foods are more suspect than others. You should be careful with seafoods, dairy products, meats, and substances that spoil quickly. Properly prepared, anything that people consume can be a delicacy, but some can also be deadly.*

Food I was on my first of many visits to Japan. I had promised my stock agent there to take her to dinner at any restaurant of her choice. I had made so many egregious mistakes while shooting for a magazine client and she had saved me so many times that I knew I owed her my career. She chose her favorite restaurant in the middle of Tokyo. She asked the owner to prepare her favorite dish for us. He placed what looked like a dog had relieved himself in a bowl in front of me and they would not tell me what it was. It looked awful. It is really bad form to refuse such a gift, and I knew this was a test. It turned out to be squid liver, and it tasted great.

Couple on beach, Edgartown, Martha's Vineyard, Massachusetts. *The sun can be the most important thing in photography, but its health effects can be problematic. As artists, we seek the benefits of all varieties of sunlight, but we have to avoid overexposure to the sun's rays. Wear proper clothing and apply sunblock to prevent the debilitating effects of ultraviolet radiation so you can remain creative.*

SUNBURN

Nearly everyone is drawn to sunny weather. For the photographer, the sun is not only a source of natural light and energy but also our creativity. It contributes to general health and well-being. But excessive exposure to the sun's rays is also a health hazard due to the harmful effects of ultraviolet radiation, which has two components: UVA and UVB. Both can hurt your eyes as well as your skin. Never think that the danger of sunburn is only present when it is hot outside. Sun can also do damage when it is reflected off of snow, sand, or water. Despite the fact that the sun does not feel as potent on cloudy, overcast days, it is just as treacherous.

Sunburn is a major cause of distress for photographers. Cover up by wearing a hat, sunglasses, and a long-sleeved shirt. Also, apply ample amounts of sunscreen to all exposed skin. Although what you might need to apply depends on several factors, such as complexion and length of exposure, a minimum sun protection factor (SPF) of 15+ is necessary. Never allow yourself to get sunburned.

Until you are acclimated, do not do anything too energetic in the hottest part of the day. Heatstroke and sunstroke are other maladies that can sneak up on you even when you are not in direct sunlight. Hydrate often with nonalcoholic beverages.

ALTITUDE SICKNESS

Because the air is thinner at high altitudes (over 2500 meters), less oxygen gets to the brain and tissues. The heart and lungs are called upon to compensate by working harder. If left untreated, altitude sickness can be fatal. Headaches, dizziness, and loss of appetite may result. Severe symptoms include breathlessness, severe headaches, loss of balance, vomiting, and unconsciousness. Rest. Drink extra fluids. Avoid alcohol. If severe symptoms persist, descend immediately.

Ski jumping, Winter Olympics, Lillehammer, Norway. *Some assignments require much prepara-*
tion. I train for photographing the Winter Olympics just as if I was competing in them. The weather and rigors of the
environment are daunting. The best protection against the demands of such extremes is physical conditioning. I exer-
cise for months while testing new clothing and equipment. It is important to duplicate the situations you are likely to
encounter to be sure you and everything else perform as expected.

INSECT BITES

One of the most annoying distractions is idyllic places that are infested with insects, especially flies and mosquitoes. Besides making your job more difficult, they can be dangerous, too. At night, sleep under mosquito netting. The only thing that will give you some protection during the day is insect repellant. Many people concerned about the environment and the hazardous nature of the chemical DEET should also be aware that it is the most effective, scientifically proven insect deterrent. Folk remedies and natural cures such as garlic, bananas, and vitamins are, at best, of limited duration and can be of little value. For convenience, insect repellents come as aerosol or pump sprays, liquids, creams, and lotions. It is safe to combine most sunblock with insect repellent. Apply the suntan lotion first and then the insect repellent. Reapply as necessary.

Tick-borne diseases are found in cooler climates as well as the tropics. If ticks are prevalent, you might consider wearing light-colored clothing so you can spot any on you more easily. Besides bugs, animal bites can lead to serious infections. Give wide berth to wild animals, such as snakes and turtles. Be sure about the safety of even domesticated animals, such as dogs and cats, and beasts of burden, such as horses, camels, and pack mules. Avoid the risk of rabies.

Travel puts a strain on the body as well as the psyche. Remember that the best defense is a good offense. Treat travel with the proper respect. Get in shape so you are prepared for whatever new stresses are thrown your way. While doing all the research and mental preparation, put together a training regime that gets you in top physical and mental form. Start slowly and build up to the levels you anticipate might be necessary. Try to train in conditions that most closely duplicate where you will be. If it is likely to be cold, jog at midnight when the temperature has dropped. Or, use the noonday heat to acclimate yourself to warmer climes. Do not be too ambitious. Just do what you can to avoid injury before you go.

In most countries around the world you will have to pay for medical treatment. Plan for that contingency. If the condition is serious enough, you may want to MedEvac yourself out of the country altogether. In the meantime, however, be aware that some hospitals and clinics will only treat you if they are paid in cash.

A growing number of travelers are carrying their own hypodermic needles while in the field. Fear of catching a bloodborne disease from unsterilized syringes in unknown hospitals and clinics has cautious people adding them to their first-aid kits. Just remember that you cannot have them in your carry-on luggage when you board a plane.

MEDICINE BAG

It is a practical matter to make sure that small, treatable ailments and illnesses do not take you out of commission. You can purchase several types of commercial first-aid kits, or you can put a small, personalized medicine bag together that takes into account your special needs. Following is a list of things to include with all the things you already carry; all of them are available without prescription:

- Acetaminophen (Tylenol®) and/or ibuprofen (Advil®) for headaches, muscle aches, etc.
- Antidiarrheal (Imodium®)
- Diphenhydramine (Benadryl®), an antihistamine for allergic reactions, itching, mild motion sickness
- Cold remedy (Sudafed®, Actifed®)
- Antibiotic ointment (Neosporin®), for cuts and scrapes
- 1% hydrocortisone ointment, for itchy rashes
- Antiseptic solution (Hibiclens®, Betadine®)
- Adhesive bandages (Band Aids®)
- Digital thermometer (some airlines disallow the mercury kind)
- Skin closure strips (Steri-strips™), to avoid stitches
- Roll bandages (Kling®, Kerlix®), for wounds
- Ace bandages, for sprains
- Moleskin, for blisters
- Tweezers
- Small scissors
- Repair kit for glasses ⬤

Medical. *Many cautious travelers carry their own hypodermic needles with them. Because the hospitals of many countries have very unsophisticated medical practices, some people carry instruments that might be scarce. In many countries, you have to pay for each pill or buy every bit of care.*

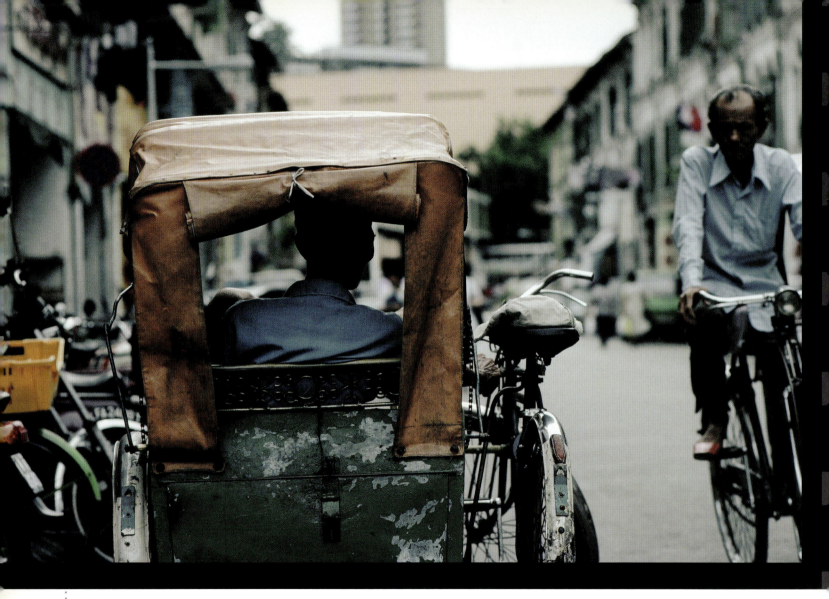

Rickshaw, Chinatown, Singapore. *Acquiring the skills to navigate any crowded city may require help. Getting you and your equipment to specific places may require a form of personal transport. Asking directions, employing drivers, and taking taxis become artforms. Have a knowledgeable person (concierge or friend) estimate the cost or have them negotiate the price before you commit. You are in a less enviable position if you argue over the value of a service at the end of the journey.*

> **"If God had really intended men to fly, he'd make it easier to get to the airport."**
> —GEORGE WINTER

Chapter Eleven: TRANSPORTATION: GETTING THERE AND BACK

It is a lot easier to take pictures if you actually go somewhere. Walk. Swim. Drive. Fly. Anywhere. That is the definition of travel photography. Anybody can get there. It is the ones who come back (with proof) that get to rewrite history. Anyone who has ever lifted a Brownie camera imagines circumnavigating the globe—until he or she actually experiences the rigors. Because the passage is hard, tedious, often boring, and sometimes scary, few thrive for very long. The stress level for photographers is higher than for most travelers. If you have any trepidations, practice first. Go with a group until you gain confidence. Get some experience. Reduce the number of variables as you improve your portfolio and build your travel muscles. The rewards will be substantial.

This planet is a big place full of big dreams. Big dreams translate into big ideas. Big ideas become big miles. To expose film in the more remote places, the first hurdle is to get there. Balloons, sails, and bicycles will serve that purpose, but the most practical modes of transportation today are "planes, trains, and automobiles." If you master locomotion, you can conquer the world.

Airline luggage tags. *As we travel, we gather more and more souvenirs—some tangible, some intangible. Luggage tags, memories, scars, stories, and ultimately friends. But, the most important part of our diary is the photographs we take. They last longer than our memories and tell the stories better. They are proof of where we have been and they let us share the world with anyone who is interested.*

AIRPORTS

Today, most long journeys begin and end at airports. Upside: In an airplane, any individual can be transported halfway around the globe in less than a day. Downside: You have to chase connections over vast expanses of real estate, decipher techno and linguistic gibberish, and ping pong from one gate to another situated at opposite ends of the airport. Everywhere you turn there are lines. Lines to check in. Lines for security. Lines to get food. Mind-numbing lines. Decades of thinking and billions of dollars have been spent trying to turn airports into theme parks and retail outlets and all that has been accomplished is to convert them from hell into purgatory.

Just a few years ago you queued up at an airport and waited until personnel told you what to do. Today, anybody can make a reservation. With a telephone or a computer, photographers can update volatile schedules on very short notice. But without help, you may be at the mercy of insidious forces. The Internet[1] has made it much easier to find flights that suit your timetable and pocketbook. If you do not mind surfing the Net or if your plans are dependent on a tight budget, these sites are a genuine asset. Learn to read the arcane hieroglyphics that pass for information on your tickets and boarding passes. If you only travel intermittently, electronic tickets bought through these websites are efficient and less expensive, but they are resisted by the airlines; consequently, there are many restrictions on online tickets to discourage their use. Do not expect a lot of sympathy when you arrive at the gate if you have used this method.

[1] Online travel websites include Orbitz, www.orbitz.com; Expedia, www.expedia.com; and Travelocity, www.travelocity.com. These all get their information from ITA.

No matter if you're going to heaven or hell, you have to transfer through Hartsfield (Atlanta).

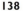

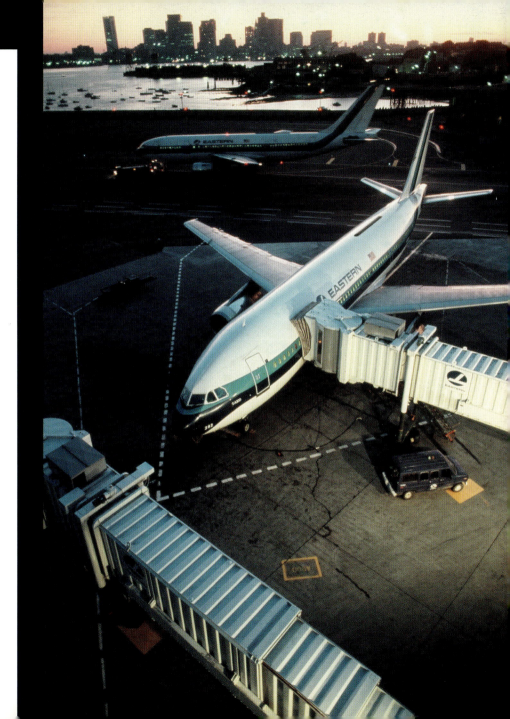

Alternately, if you are a frequent traveler, a **travel agent** can become a direct extension of your operation. Usually it is not in their best interest to search for deals. They make better commissions off expensive tours. It is a quantum leap of faith for them to understand that they are establishing a long-term customer if they go the extra mile. Developing a relationship with someone who comprehends byzantine airline regulations and a photographer's peculiar needs will give you more options. Last-minute changes occur when you are chasing light or weather. Some agencies have a 24-hour emergency service when problems occur. Find an agent who is enthusiastic about the challenges. A travel agent can also apply for visas, manage budgets, arrange car rentals, and make hotel arrangements. As they become more familiar with your habits, they will manipulate your credit cards, maximize your frequent flyer programs, and advise you on professional or temporary discounts. They can learn your preferences in seating and diet.

Airline gate, Boston, Massachusetts. *In many countries, it is forbidden to photograph at airports or train stations. For this photograph, I was hired by the local transportation authority to illustrate how the airport was an integral part of the city. I chose to take the picture at sunset for additional drama.*

With increasing concerns over security, be sure your travel agent is close enough to deliver tickets and documents in a timely fashion. Although it is fast becoming moot, it is best to have a paper ticket in hand rather than rely on E-tickets, especially if you travel with a lot of equipment. At the very least you need a confirmation letter and number or the authorities will not let you onboard.

Juggling airplanes, schedules, and your belongings is a quick way to develop ulcers. The more times in and out of luggage compartments underneath the plane, the greater the chance your equipment will be misrouted. This is especially true if you have to change planes or airlines. You go to one city, and your bags end up in another. Also, if you change planes, there is the additional possibility that some overzealous official will separate you from your carry-ons (e.g., valuable cameras, film, lenses). In fine print on your ticket the airline company makes it clear that it is not responsible for loss of or damage to video, camera, or film equipment. This amounts to a legal contract that exonerates them from anything they do to your property. With few exceptions, they are obliged to care for everything else you pack, so it is your responsibility to ensure the safety of your cameras. Usually trips with stops or layovers cost less. When economics dictate, keep that in mind. It can save you money. But, with layovers, there is a greater chance for delays. Whenever possible try to book direct flights. Pick days of the week with less traffic. Friday afternoons and nights are the worst times to fly. Saturday afternoons and Wednesday mornings are relatively good.

Skycaps can be your best friends (an island of sanity in the chaos that surrounds airports). Most of them are competent. They know the plane schedules better than the counter staff. Their livelihood is dependent on helping you. They can be very lenient about excess or overweight baggage. Tip them well, and they will remember when you come through again.

No amount of precaution is too great since the weak link in the chain occurs after your luggage has left your sight. Pack your equipment to withstand mistreatment. Baggage handlers can destroy anything. Because of random searches you may be required to open all your belongings. Learn how to pack and secure everything with the likelihood of unpacking for security check. It is inadvisable to lock your luggage anymore. You can misplace the keys or waste time looking for them, and most security agents insist on rummaging through your baggage. Always remove shoulder straps from everything. They get caught in the machinery and can destroy or delay your bags.

Regardless of the skycap's trustworthiness, you are taking a chance when traveling with shiny aluminum cases or expensive matched luggage. It is like a red flag advertising stuff to steal. The baggage handlers that you never see can be your worst enemy.

From many destinations there is a departure tax. It can be substantial, and often authorities insist on "coin of the realm," although some airports demand American dollars. Go figure. Inquire before exchanging all of your currency and set some "escape" money aside.

"The easiest pictures to take are war pictures. All you have to do is live."
—DAVID DOUGLAS DUNCAN

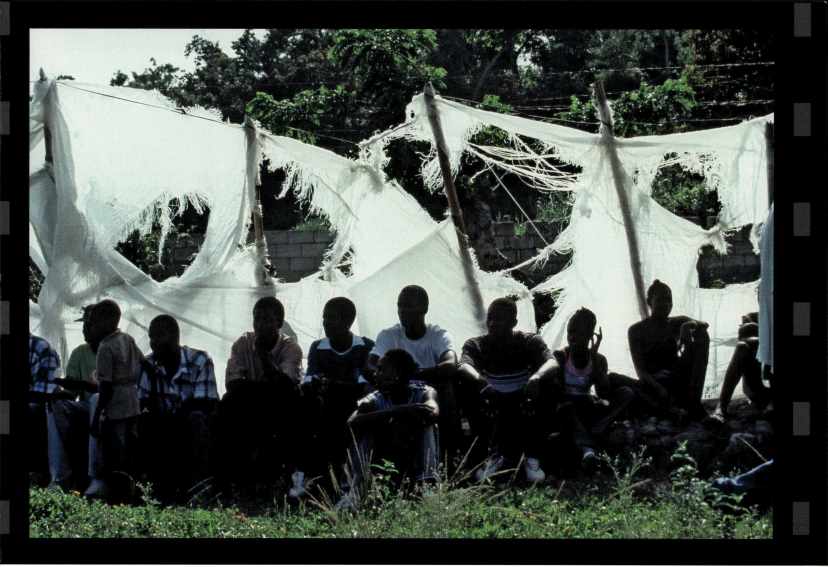

Soccer fans, Morant Bay, Jamaica. *This photograph was accomplished with free airfare. If you plan on traveling a lot, frequent flyer miles should be hoarded diligently. I carry a small laminated card with the frequent flyer numbers for all the airlines I normally utilize. My travel agent has my information also. He can attach the numbers to each ticket he books for me. That way, the more I travel the more I can travel.*

Concierge Incountry, the best addition to your crew might be the concierge, who can help you get anything and get anywhere. The concierge can provide you with directions, dining recommendations and reservations, theater tickets, shopping tips, help with your luggage and tickets, and translations. Usually, the better the hotel, the more influence the concierge has. Of course, the assistance comes with a price.

FREQUENT FLYER MILEAGE

You can subsidize a photography business on frequent flyer miles. If you do any substantial traveling, join all programs that do not charge fees. These frequent flyer perks mount up like interest in the bank. The unique requirements are difficult to juggle but a competent travel agent can help. Carry all your numbers typed on one small card in your wallet or purse. They should be at your fingertips. Beware! The rules change. Some of the programs let your mileage expire. Use them or lose them. The programs are designed to make you feel like you are running in place, but amassing the miles affords you certain perks. Upgrades and advanced boarding will smooth an otherwise bumpy journey.

AIRPORT SECURITY

During these unstable times, you will encounter more and more storm clouds when "flying the friendly skies." These problems are equally annoying to those who make pictures by venturing from their local environs only sporadically and those who might be eligible to take up residence in the firmament. For years the only worry was whether your aircraft would fall out of the sky. Now airplanes are used as political pawns. Exhibit a little decorum when you observe men in uniforms brandishing guns. Security types exhibit no sense of humor (it must be a requisite of the job). Neither rationality nor piques of temper work well with them.

Domestically, whether the security personnel are competent or not, the rules change constantly. How you are treated is purely a matter of random luck. You should update yourself on the debate about x-ray damage to film. If you are still concerned about the possible damage to your film, tell the security agents that you are carrying film that is susceptible to electromagnetic radiation and that x-rays are cumulative. They will insist that the machine is film safe, and it then becomes a matter of wits (see X-RAYS).

Be as compact as possible. Because one person may insist on hand inspecting your camera bag while another tries to irradiate your film, you need to reduce your distractions. Consolidate all metal objects with your laptop computer. If you are chasing your wallet and your coat and a cup of coffee, you are more likely to take your eyes off the prize. Not only do you chance losing track of valuables because of the confusion, but you are also revealing yourself to thieves who could

I have several hundred thousand free miles on one airline that doesn't seem to go anywhere and enough free miles on dozens of others to only upgrade from the left side of the plane to the right.

prey on your purse, watch, etc., when you are not looking. Make sure all your property and all your traveling companions are successfully beyond the x-ray and magnetic machines *before* you go through. (Do not assume you are safe from theft at this juncture, as some teams set up on both sides.) It is difficult to retrieve equipment or help a friend once you have been cleared. Ask for a supervisor and explain your predicament . In the United States, FAA law ensures your right to a hand inspection. Ill-prepared security personnel may not believe you and insisting must remain your last resort. You may have the law on your side, but their revenge is to delay you until you are too late for your departure.

Once you cross borders, all bets are off. There is no standard. Outside your native country, you are at their mercy. Gird yourself for battle. Get to the checkpoint early. Wait until there are smaller crowds and volunteer to do anything to help make their job easier. Try never to be the first or last person to board. This multiplies your chances of being singled out by security. The "electronic stripsearch" is a way of life for the aggressive traveler. Add a camera bag and you become a target for suspicion and abuse.

Areas under a state of siege are the ultimate gauntlet. If you plan on exploring war-torn countries, do so only with experience. It may sound romantic to some, but it is nothing but dangerous. Obviously, if you are actually contemplating going to war zones, nothing is going to deter you. You have to have a firm belief in your own immortality. You can check government travel advisories to see what the current diplomatic status is for various countries. Be aware that your passport may not be legal in some places.

CUSTOMS

Navigating customs, in both directions, is a paradox. The more adventurous you are, the more scrutiny you tend to undergo. Plus the system is draconian. After standing in one interminable line to pass immigration, you find yourself jockeying for position in another line for customs. To make that wait tolerable, analyze every item you are carrying or purchased along the way. Risk transporting only contraband or souvenirs for which you are willing to lose your freedom. Weapons and drugs must be avoided at all costs.

Customs is the ultimate bureaucracy. No matter where you are, you cannot turn around and go home. Even if you are exhausted, be alert. Do not fumble for your documents or words to explain where you have been and why. Uncertainty arouses suspicion. Do not volunteer additional information. If you plan on doing a lot of shopping, be prepared to keep meticulous records and receipts of purchases. You may have to itemize the goods you are bringing back into your country of origin. This includes gifts that friends have given you. If the total exceeds defined quotas you will be asked to pay duty. One myth that continues to circulate is that if you wear newly acquired clothing it is not subject to duty. Not declaring all items is illegal. In addition, you cannot bring certain agricultural products across borders.

Some countries limit the number of cameras and amounts of film you are allowed to bring in. Try to determine that before you are confronted with an untenable choice at the border. Divide your equipment among your companions before you reach an official. It may be expedient to declare yourself only a tourist and deny that you are a professional photographer.

If you are doing a job in which you need to bring in lots of expensive equipment, you may need to purchase a **carnet**. These are documents that guarantee you are bringing out everything you brought in. Customs is trying to guard against your selling goods without paying excise taxes. You put up a

143

certain percentage of the value of your equipment in the form of a certified check or as an insurance bond. It is supposed to expedite entry through customs. Carnets can be expensive. A detailed list of items with numbers must be provided, along with an additional fee. Carry several photocopies. It may be convenient to have your client handle these arrangements, but many are not as conscientious about doing so as they should be.

Airplane. *Most travel photography is about destinations. In this photograph, I concentrated on the marvels of transportation itself. It is a dynamic composition and color—the idea and emotions of travel. Airplanes are symbols of faraway places and the romantic call to go there.*

It is a good idea to register your equipment with the U.S. Customs Service before you leave. They are most concerned that you are acquiring goods outside the United States and trying to avoid import duty. You can find the certificates of registration at all U.S. Customs offices (www.customs.ustreas.gov) or international airports. Fill out the forms. Note all brand names, model designations, and serial numbers. Bring the certificates back with the equipment so officials can inspect and stamp your papers. If you are not near an airport, you can do all this just before you depart. Just be sure to allow enough time for bureaucratic inefficiency. Staple these forms to your passport. You can add new pages as you acquire new equipment.

AIRPLANES

Anthropologists have discovered primitive societies called "cargo cultures." Their entire belief system is based on airplanes. They watch them come and go and attribute divine provenance to the flying machines because they fly closer to heaven. I would hope that most photographers adopt a more enlightened worldview. Nevertheless, air travel possesses mystical properties.

Time at altitude is tedious but you can find solace. You are speeding through time zones. Enjoying new movies in the air. Catching up on your reading. A photographer lives his or her life hundredths of a second at a time. Stringing so many uneventful ones together does not have to be painful. Use the time wisely.

Where you sit in the plane is largely a matter of personal preference. Statistics are inconclusive as to what section is safest. Research has shown that, in case of a crash, fighting over the front or back of the plane is moot. Seating in first class or coach is decided by money. The only other choices you have are if you can sleep then ask for a window seat; if you tend toward claustrophobia, sit on the aisle. If you book early enough, you can reserve bulkhead seats. There is no seat in front of you so you have more legroom, but you will not be able to slide your carry-on under a seat in front of you. It is a trade-off. After more than three

hours suspended inside a tube in midair, it becomes clear that hell is full and the dead are prowling the skies.

Try to board the plane early so you can store your equipment in the overhead bins. This should give you more legroom. You may have to be creative in order to fit all your cameras, big lenses, laptop, etc., into the spaces provided by the airline. Try to fit it all into one piece of luggage. It may be heavy but it has to look unassuming. Ramp personnel will try to wrestle it away from you if it looks like it exceeds weight requirements. Commuter airlines pose the biggest problems—the smaller the plane, the smaller the compartments. Pare down to what you cannot live without (e.g., cameras, computer, medicines). Put everything else in checked luggage. Then protect what you carry with all due diligence.

Boeing 727. *So much time tends to be logged in airplanes that it stands to reason that the experienced traveler gets used to the vagaries of that form of transportation. Make peace with the long hours you spend in airports. Figure out how to use the time wisely or to entertain yourself. Mistakes and delays can frustrate the most meticulous plans. Learn to be flexible. Lower your blood pressure and live longer.*

**Number of passengers on U.S. planes
in 1970: 170 million.
In 2002: 612 million.**

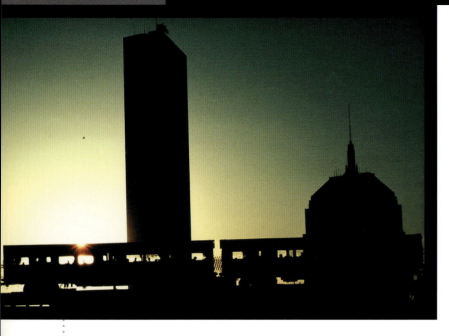

Elevated railway, MBTA, Boston, Massachusetts. *Navigating local transportation systems is often difficult, but in crowded municipalities it can be faster to travel by subway than above ground. If you have the ability to submerge yourself into the culture by moving around on public transportation, you will be rewarded with unpredicted adventures.*

TRAINS

Some parts of the world are accessible only by air or water. Some cities are dependent on automobiles. But the original frontiers were pioneered by the steam engine. Generations of romantic myths are still attached to trains. They remain the most authentic mode of transportation in many regions. Trains cover long distances, and you can pay for unmatched levels of comfort. Technology has improved speed, ingenuity has perfected sleeping berths, and necessity has furnished many with fine dining cars.

On trains, what you often lose in speed you can make up in convenience. Also, the fastest route is not necessarily the most fun. As a photographer, you can tote more equipment than you can load and unload yourself. And, if you are ambivalent about flying, trains are a reasonable substitute. In remote areas, trains may provide the only access. If you are trying to hopscotch around the countryside, frequent stops are feasible, and you can observe the landscape in between, brush up on your research, learn a language, and read magazine articles and guidebooks. Tickets are available for extended travel durations and you are not as much at the mercy of capacity problems as when you fly. In many third-world countries, it is advisable to make reservations in advance. Technical efficiencies have not caught up everywhere, and you can be delayed for days because of bureaucracy.

SUBWAYS AND BUSES

Sometimes the job calls for "going native. It may be necessary to submerge yourself in the local culture. Learning to navigate local public transportation systems can lead to great adventures and pictures. In urban congestion, subways often beat cars. Traffic can be atrocious but subways are almost exempt. Subways, at certain times of the day, tend to be overcrowded. You may have to be aggressive and quick, but you certainly get in touch with the population and learn more about a city. Although some systems

Shinkansen, Tokyo, Japan. *Seeing the countryside from the window of a moving train is a romantic notion and a good way to visit a new place. The Japanese bullet train is one of the fastest modes of ground transportation in the world. This efficient system is often faster than flying when it is necessary to span long distances across the nation.*

Trains In order to complete an assignment in Europe we had to do it almost entirely from a train. Because the schedule was so tight and we had such long distances between locations, my assistant and I endured all-night train rides more than once. We sat up in comfortable seats all night and "pretended" to sleep on one leg and purchased berths in the sleeping car for another part of the trip. After my clients joined us, they did not think that riding the train was the most glamorous way to spend an evening, but they were the ones who had made up the impossible schedule. I thought it was a great solution and a way to point out their lack of understanding with regard to the logistics of international travel.

are archaic, most are designed with the uninitiated in mind. After a little instruction, they begin to make sense.

Buses are above ground, so you can see everything, especially if you are not cradling livestock. No matter where you are, traveling by bus is unpredictable. Whereas deciphering a subway map takes some skill, mastering the bus system is the mark of a veteran traveler. Language and logic are useful but never enough. You may find yourself relying on the kindness of strangers. It is an art. Keep a good map in front of you and mark the route as you go. If you see anything of real interest, note its location

and return later. Despite the often unscheduled stops, buses are a practical way to explore a city or get to really remote rural areas. Rethink that overnight bus excursion, though. Sitting too long on a bus traversing hair-raising back roads in the pitch black can be harrowing.

The real joy of photography is those precious moments capturing new experiences when your mind is overloaded with creative decisions. But you have to spend long hours staring out the window, biding your time, until you get there. It is the dues you pay for priceless opportunities. Just be ready when you step off the bus.

AUTOMOBILES

Climbing behind the wheel of an automobile can be a satisfying way to regain some control of your movements, and driving is a real geography lesson. Regardless of the conveniences that internal-combustion engines bring to transportation, their use can complicate things. Although cars may be the only realistic way to get across town or cross country, they can be distracting and dangerous. They are also your legal responsibility. Just because you know how to drive, the decision to do so should not be taken for granted.

RENTAL CARS

Even though the contracts vary from state to state, inside the United States rental car contracts are fairly regulated. Depending on who is paying the bill, rent the best vehicle you can afford. You should seek the same discounts, coupons, and deals from small rental agencies as the national brands. If you need the option of a network of offices, you may have to stick to the larger companies. They are usually situated closer to the airports, which will be beneficial if you have a lot of stuff or are in a hurry. Many have established satellite connections with the better hotels.

Couple driving, Worcester, Massachusetts. *If you are doing the driving you are controlling your own destiny. You can make you own schedule and stop and take pictures anytime and as often as you like. But hundreds of excellent photographers have met their demise in car accidents. Drive defensively. Attitudes in many countries make driving a competition. In foreign locales, it is almost more important to watch what other drivers are doing than how you are driving yourself.*

In most places, a valid driver's license is sufficient for renting a car, but if you have to deal with the authorities because of a traffic violation or accident the situation gets trickier. A few countries require an **international driving permit**. It is usually just a formality, but some travel agents recommend it. You can arrange for one through an automobile club where you live.

Whether you need a compact, van, or luxury car, resist being ostentatious. As often as you can avoid it, do not park on the street. Keep your car in a hotel garage if possible. *Do not leave anything in the vehicle*, not even in the trunk. All luggage should be out of sight. Although the insurance that is available through the rental agency is expensive and usually a bad value, you should consider buying it unless you have an excellent alternative through your own car insurance policy. (If you use your own insurance company, the paperwork takes forever.) Nothing can ruin an adventure faster than a car accident that you have to pay for.

Not only does your vehicle provide transportation, but it also protects you from the elements. In warm climates, rent cars with air conditioning. That way you control the temperature and humidity to help protect your film and equipment. It may also be your only way to be comfortable.

Get used to wearing your seatbelt. It is inconvenient when jumping in and out of your vehicle with cameras around your neck, but too many great photographers have been lost in automobile accidents all over the world. It is a tragedy that can often be avoided. Unless you are really a veteran, stay off motorcycles and mopeds.

Try to flush out and negotiate all the hidden costs before you sign the contract (e.g., second drivers, drop-off at secondary locations, states or countries restricted from travel). Pay with a credit card in case there is a billing dispute later on.

DRIVERS

You have to be realistic about driving when signs are in a different language or, more importantly, in a different alphabet. Throw in learning to drive on the opposite side of the road and you might not be able to give proper attention to the sights you are there to photograph. Traveling with a friend or an assistant can help divide the labor, but consider hiring a driver. In most situations, you can conduct a job interview on the spot. They are infinitely more familiar with the customs and terrain. Put a lot of emphasis on whether the driver can translate for you. If you choose well, the driver can serve as a model, too. Students and young professionals are educated, eager, and excellent candidates willing to earn extra money. They may even own their own vehicles. It is easy to strike up a friendship, but if one driver does not work out, seek another. If you are asked to handle large productions, you can book your driver well in advance. Drivers become a part of your crew, act as security, and add a helping hand. It may be necessary to hire limousine drivers for pick-up and delivery to and from airports or for transporting excess equipment and personnel. Do this through your travel agent or the hotel concierge.

TAXIS

The abridged version of a limousine is the taxi. They are ubiquitous and come in all shapes and sizes. All of us have undergone the humiliation of standing on a corner trying to flag down a cab. That is the hard way. The easy way is to have any concierge arrange for your transportation, no matter how bizarre the request. They can dispatch a fleet of taxis to pick up clients, props, models, or lunch. Be ever vigilant for cabbies who are dishonest and prey on tourists. The hotel staff can screen people and tell you the route and approximate price of any trip. Ask. Insist that the driver use the meter. In unfamiliar territory, taxis may have no meters. Agree on a fare before you depart. Bartering your way out of a disagreement at the end of your trip can be embarrassing and expensive. When you arrive at your destination, do not pay until you have your luggage out of the trunk. When appropriate, get receipts. Your transportation is tax deductible, and if the receipt does not indicate the taxi number record it right away on the receipt. It may be your only way of recovering lost or forgotten articles. Carry the proper currency and have small bills. Taxis are notorious for never having change. Do not force them to be the bank.

WALKING

There is no substitute for hard work, and photography is no exception. To be a street photographer, you just have to wear holes in your shoes as you walk around in search of the perfect picture. Once you have gained enough confidence, you need nothing more than a comfortable pair of shoes. Luck and instinct will lead you around corners and down side streets to those chance encounters that you cannot predict. Smells and sounds have as much influence as sight. Follow whatever attracts you.

When the culture is completely alien to you consider using a guide. Guides come in all shapes and sizes and can be acquaintances or professionals. They will be knowledgeable about customs, money, and the language. They can teach you history, answer your questions, and react to your whims. You may encounter gatherings of eager "friends" at remote bus and train stations and outside your hotel. Even though they may be annoying and intimidating, occasionally they can be useful. They can act as guides, negotiate better prices, or tell you about local lodgings. They ward off constant pestering by all the rest.

When you have reached the limits of public conveyances, your adventure may be just beginning. If you have to ride pack mules, hang glide, portage, sail, or hike the rest of the way, you are on your own. Forget what is in your wallet and rely on what is in your heart. Every map made more than 500 years ago carried the inscription: "Beyond this place there be dragons." It indicated the limit of man's knowledge. There may be fewer of those places on modern maps, but the travel photographer's quest is to erase them one by one. 📷

Road signs. *Myriad icons suggest travel: posters, advertising, brochures, and tickets, to name a few. In the right hands they are all great metaphors for your photography. Trains, airlines, and cruise ships allow you to cover large distances quickly, and they lend themselves to great images. But, once you are incountry, you will find that simple markers, milestones, and road signs indicate that you have arrived. They speak their own unique language. If you learn to understand it, your world is expanding.*

Magic We were creeping along a pitch-black dirt road trying to avoid the horse-sized craters that were hidden by the darkness. Each hole was big enough to swallow a human whole and not give up their whereabouts until daylight. We were in search of a restaurant someone had recommended. I was traveling with two women who were models for my assignment. It was my first time in Haiti. I was so enthralled with the exotic country that I looked straight up to take in the ambience. To my surprise I realized it was a full moon. A full moon in Haiti. As luck would have it on this sweltering hot night, the clouds were swirling around the moon. It was a film noir moment. A scene straight out of a 1940s horror movie. I was fascinated with the good luck of such irony. One of the clouds seemed to cut a crescent out of a corner of the bright orb, and I realized that a lunar eclipse was occurring during a full moon in Haiti. It was surreal. No amount of money can buy that much magic.

Signage, Luxor, Egypt. *Written language is intended to communicate, but it can be decorative as well as informative. I posed my guide in front of this Arabic graffiti. He was reluctant, but his clothing and demeanor and the background were perfect together.*

Chapter Twelve: LANGUAGE

You can make up a thousand excuses not to travel: everything is foreign, the food tastes funny, "beyond this place there be dragons," you never learned to speak Farsi. It is true that traveling is not easy. If traveling were easy everybody would do it. On top of that, communicating with people who do not share your vocabulary is one of life's most frustrating obstacles. Language is a tool, like your tripod or filters. If you cannot talk to anyone, you cannot do the job as well.

Reading and writing are the fundamental building blocks of literacy. When you calculate how little of the world's population can read, you begin to comprehend how potent a tool you possess. Being literate and having command of just one language gives you privilege and cognitive advantage over many of the people you meet. If you speak more than one language you exponentially increase your potential for communication, problem solving, and wage earning. Being fluent in multiple languages constitutes real power.

Language is more than the sum of words. It is a door to a whole new way of thinking. The character of a society revolves around its languages. How the citizens of a culture relate to each other and how the culture organizes itself, constructs its laws, conducts its business, and raises its children are embedded in its speech. Whether the people are horizontal or vertical, precise or easygoing, colorful or opaque is conjugated in their words. If you fully fathom what that all means,

Political poster, East Berlin, Germany. *This photograph was taken during the fall of the Berlin Wall. This is probably the simplest political poster I have ever encountered. It combines language and humor. It has been used often as a generic political illustration.*

it will be reflected in your photography. The more you translate, the more will be translated through your images. And your pictures will speak volumes.

Once you leave the safety of your neighborhood, never for a second expect your native tongue to take you very far, nor should you anticipate your high-school foreign language elective to be sufficient. At the same time, never let the fact that you have not mastered the *lingua franca* keep you from venturing forth. Language comprehension is essential during critical negotiations, but the spoken word should not prevent you from enjoying foreign adventures anywhere. Many people are immobilized because they do not speak the local dialect. They get flustered under pressure. Loss of language is loss of control. You have to become comfortable with not

knowing exactly what is happening. The stereotypical ugly American is characterized as just talking louder and louder. Hearing is not the problem. The essential key to language is knowing how to listen.

When trying to converse with someone who has only limited facility with your language, *listen* first. Then use simple, declarative, short sentences. Be very careful to eliminate idiom, slang, and jargon. Try different synonyms for the same words to bolster comprehension. You may have to work "toilet," "bathroom," and "WC" into the same sentence before someone takes pity on you.

Language is not a stable structure. It is a vital mode of expression that changes with time, space, and dimension. Words have different connotations according to when and where you learned them. Meaning

is dependent on context, so paraphrase often. Enunciate. Never raise you voice. Tone is important, too. If you are too studied, you come across as condescending. Communicating in this way takes a little practice, but it can become second nature. Even after you become more relaxed with people, approach levity and joke telling carefully. Humor does not travel well. Not only is humor difficult to translate, but the punch line is rarely funny in other cultures and you will find yourself trying to explain the joke to blank stares.

Graffiti, Esteli, Nicaragua. *These little girls saw me photographing them and posed in their cute dresses. A comment on the quality of their lives was painted on the wall next to them and gave a very different spin to the nature of their daily existence. It is the photographer's responsibility to make choices such as these to convey the intended message.*

Even if you have no facility for languages, learn enough to greet people in their vernacular. Besides being simple courtesy, it goes a long way toward spanning the gap of international relations. Learning a little bit of a new language is a goodwill gesture, but it is not sufficient in certain societies. Neophytes have the misconception that natives appreciate any attempt at their tongue. One rarely gets much credit for doing things poorly. The fact that you may be well intentioned does not alleviate the problem. Struggle with what you know rather than confuse a conversation by using improper translations, bad pronunciation, and atrocious grammar. The exception is to learn, at the very least, how to say "thank you." Use it liberally. You can add "yes" and "no" and "excuse me" if you are ambitious.

Not having a common language banishes you from the inner circle of personal interactions. Phrase books and dictionaries are virtually useless during rapid, tense, or confusing encounters. Besides trivializing the idiosyncrasies and nuances of common speech and dialects, texts are too slow. No one uses those archaic words and phrases anyway. But a smile substitutes for words and will go a long way toward proving your sincerity.

Of course, literacy involves the written word too. You may have to write letters or send notes before, during, and after the trip. The same rules apply. Again, use a short, simple sentence structure. Be especially cognizant of using abbreviations, which are another form of slang; for example, "Street" should not be written as "St." Your country or town should not be reduced to two or three letters followed by a period. Your associates may know what you mean but that is not the point. This goes both ways. It often becomes a puzzle to figure out what someone intends with shorthand. This applies to acronyms, too. They are just alphabet soup to most people. Get used to spelling everything out. It may be obvious to the author but colloquialisms are trouble.

Advertising poster, Padua, Italy. *On an assignment about the sister cities of Boston and Padua, I was constantly trying to juxtapose photographs of common objects in each place. This is a provocative example of advertising and how its language confronts the typical citizen. I waited for quite a while until the bicyclist came by.*

Posters, Prague, Czechoslovakia. *Framing this photograph was intended to show the repetitive nature of posters and their colors and typefaces. Without understanding what each advertisement meant, I was able to create an abstract image made up almost entirely of words.*

＊＊
＊＊ このプログラムはお客様と日本語で対話
＊＊ 東京・新大阪間の下り新幹線の検索を行
＊＊

いらっしゃいませ。ようこそODDSシステム

何の御用でしょうか？

》らいげつきょうとまで２りででかけたいので

5月の何日なのかを正確に教えて下さい。

》さいしょのどようびですが。

何時ごろ迄に京都駅に到着すればよろしいので

》ひるごろとうきょう　　たいのですけど。

切符は大人2枚でよろ　　でしょうか？

》いいえ　　ども　　　ます。

　　　　　　　　　ますので、暫くお待

　　　　　　4時53分着の
　　　ょうか？

　　　いのですが■

Get people's names right. No excuses. Use correct spellings and pronunciations—first name and last (in the appropriate order), titles, and salutations. You only get one chance to embarrass and dishonor an important contact. Planning for a trip can take weeks or months. Arrangements may require a lot of correspondence, such as sending letters, faxes, and e-mails back and forth. In the past, you had to rely on professionals to translate incoming and outgoing mail if you wanted a prompt reply. This is very inefficient. Today, there is software available to help you. A number of free websites will also do translations for you. Plug in whole documents and the computer does a very credible job. It is not perfect and cannot be relied upon for formal or critical correspondence, but you get the message and can reply immediately. The software handles the primary European languages that use the Latin alphabet. It is an amazing technology. Even though there is evidence that technology has had an adverse effect on manners, in this case faster communications are probably an improvement.

Confucius is credited with saying, "A picture is worth a thousand words." As a photographer, you are staking your career on that. Carry paper and pen to draw your subject: a diagram, a map. You can play your own version of Pictionary®, if necessary. Show photographs of what you want.

Computer screen at Tokyo Institute of Technology, Tokyo, Japan. *I was doing a book assignment on artificial intelligence that took me to the college. The students were doing research on machine language (i.e., computers translating languages automatically). The beauty of the kanji caught my eye, but I needed something more than just the words on the computer monitor. I was just barely able to reach the screen and still trip the shutter, including my own hand in the photograph.*

BODY LANGUAGE AND GESTURES

Social anthropologists claim that 60% of all communication is nonverbal. You can signal hello or goodbye, ask for directions, acknowledge, beckon someone, or commit a *faux pas* without saying a word. Gestures can be informative and perilous. Over half of the planet's people use their thumb to hitchhike, but it is insulting in Nigeria. Forming a circle with your thumb and forefinger will indicate "okay" in some places but can cause a fight in Brazil. Pointing with your forefinger is not done in Malaysia; instead, use your thumb or extend your whole hand. If you plan on a lot of social interaction during your travels, find books that will teach you country by country how to conduct yourself.[1]

[1] *Gestures: The Do's and Taboos of Body Language Around the World* (Roger E. Axtell, John Wiley & Sons, 1997).

The most widely spoken languages in the world (in order) are
(1) Mandarin,
(2) Hindi,
(3) Spanish, and
(4) English.

Road signs, Milan, Italy. *At the most basic level of any new language you will be constantly confronted with public signs. If you can't read addresses and road signs you are functionally illiterate in that environment. If you cannot master a new alphabet or recognize landmarks, your efforts to move freely in a new place will be hindered. Even though you should never let this dissuade you from beginning an adventure, you will have to develop more sophisticated travel muscles in order to cope with your inadequacy.*

I have watched television ever since it was invented, so whenever I go anywhere I immediately turn on the television in the hotel room and watch dramas, comedies, quiz shows, commercials. But, on my several trips over the years into Japan, I can honestly say I have never had any idea of the gist of the shows; however, the sound and timbre of the language, the nuances of what I am hearing are preparing me for the outside world. I get used to the rhythms and rhymes. You can sense happiness, anger, inquisitiveness, and other emotions through the tone of the voice. Even though I may not fathom what is being said, I have a better idea of mood and temperament and much of body language that the people I meet will throw at me when I am trying to take pictures.

Migrant workers picking cotton, Sigma, Turkey. *I flagged down and jumped on the back of this truck when I saw the migrant workers going off to work early in the morning. I didn't know where they were going or what they were harvesting. I didn't speak Turkish and they spoke no English. I got a ride to the fields and hitchhiked my way back without sharing a word.*

There are over 3000 languages spoken around the world. And speaking another's is a sign of respect. But, if your primary goal is to take pictures, then the spoken word becomes almost irrelevant. Photography is a universal language, and to practice it you can go all day without uttering a word. As you gain experience, language becomes less important. You develop a sixth sense. Real literacy informs you of what should be the logical reaction in certain social situations, and eventually you even become comfortable not knowing what is being said around you. You can feel the rhythms of the dialect and know if people are agitated or amused by your presence.

Eye contact and hand gestures are real flashpoints. While one culture resents being looked at directly, another is nervous about being touched. Proximity while conversing is called *personal space*. Observe the distances maintained between friends, business associates, and families. Try to match it. Body language differs from frontier to frontier. How you sit, stand, leave a room, and greet a person takes on different connotations wherever you travel. Table manners are fraught with peril. Get advice about how to eat and how to use utensils at any table where you sit.

Even if you are conscientious and attempt to learn a little bit of every language, you can never master them all. While you are trying, though, there are habits you can pick up to compensate for your shortcomings. Have the concierge write the address of your destination. You can show it to a cabdriver or a policeman or any passerby if you get into trouble. Pick up a few hotel business cards before you go out. Carry them in case you get lost. It is very easy to get disoriented and confused and forget a name or location, especially under pressure. Have your own business card translated into the local language. Some airlines have a service that prints an ample number if you book flights through them. Bring several sheets of your stationary along on the trip. You can never tell when you will have to write a letter, and your official letterhead may add just the proper cachet.

All modern languages are malleable. *They change with the times and conditions. They incorporate the economics and politics of a culture. An alphabet or pictographic language mirrors the people. These symbols are sensitively reflected in the faces you want to record past and present.*

Early in my career I found myself traveling to Greece. I convinced a friend who was multilingual to accompany me to his native country. He was to lead me all over and translate and tell me what I was seeing. Unbeknownst to me, he met a woman on the plane trip over and disappeared with her as soon as we landed. Because he was to assist me, I had not really done my homework. Language problems caused me to miss a flight over to Crete. They even announced my name over the intercom but I didn't understand. Once there, I had difficulty renting a car and finding a hotel. I was panicked. First thing in the morning I set out to drive around the island, expecting to get lost forever at the first crossroad. But I had an amazing epiphany. I could read Greek. Forced to learn the alphabet by my fraternity, I could decipher the maps and road signs and had a great time navigating the rest of the trip.

Torii, Kyoto, Japan. *I filed away someone else's photograph of this location for years with the intention that, if I ever had the chance, I would visit for myself. After I sent the image to a location scout, he was able to track down the exact spot. These monuments were just like grave markers to honor a loved one, and even though there were hundreds each name carved on the columns was just like an address.*

Why struggle to make yourself understood when you can hire an interpreter to do it for you? He or she can be your intermediary. Hiring an interpreter is expensive and it can be risky, but it may be necessary. Unless you have worked with a translator for a period of time it is hard to know how they are representing you. If your conversation is full of technical terms, the translator could betray your meanings entirely. Even with their help, set up questions along the way that act as "traffic signals" to be sure your audience is keeping up with you. It may be worth it in the end. Never use run-on sentences. Develop a cadence of pauses that allows your translator and your audience to catch up.

In developing countries there are often hangers-on who mill around outside your hotel or tourist destinations. These unemployed "guides" can be a nuisance. They flutter around you asking for handouts and such. Observe how selecting one to show you around may eliminate hassling from all the rest. If you are judicious about whom you pick, you may be able to promote the local economy, employ a cheap translator, and buy yourself a modicum of peace. Be aware, though, that they are streetwise and are as likely to screw you as to help. Often their main objective is to steer you to local merchants who give them a kickback, but they can also be amazing resources.

Even though English is the international default language, ultimately the project you undertake may be important enough to learn a new language. If you are going to spend an extended period of time in a country or if your personality depends on talking to your subjects, the investment is worth it. There are schools that design curricula to teach you quickly. Total submersion techniques are offered at local colleges, by private tutors, or through specialized programs. It is hard and it is expensive, but the gain will outweigh the pain.

Flags Vexillology is the study of flags and related emblems. As you travel internationally, you will become familiar with more and more flags of the places you visit. Just as you can be picked out of a crowd, you can learn to recognize the facial appearance, physical structure, and cultural habits of different races. Spellings of names, accents, and clothing may be dead giveaways for where new associates are from. If you can identify their origins, you have an advantage. Flags are excellent clues. Even just the colors of the flags are enough. Memorizing flags is an excellent exercise for your general knowledge.

Silence has its own volume.

As soon as you cross borders, money takes on almost mystical qualities. *With enough of it you can buy nearly anything. During an overseas photography project I find that the more successful I am the less I spend, but judiciously used it lubricates many social and business dealings.*

> "The Owl and the Pussycat went to sea
> In a beautiful pea green boat,
> They took some honey, and plenty of money,
> Wrapped up in a five-pound note."
> —EDWARD LEAR, *THE OWL AND THE PUSSYCAT*

Chapter Thirteen: MONEY

Eventually you have to dig down in your pocket and pay for your indulgences. What and how much you find when you look into your purse may have very little to do with photography but everything to do with survival. Whether you fund your excursions with food stamps or you happen to be a trust fund baby makes no difference. Luxury accommodations or bargain basement, it comes down to how many zeroes follow the dollar sign. Whether you can afford it or not, your monetary transactions fall into three basic categories: cash, credit, or check. Knowing when to use one over the other can save some aggravation.

CASH

No matter where you are and regardless of the coin of the realm, cash is the most liquid instrument for monetary transactions. There is nothing like the feeling of a roll of bills in your pocket. In contrast, nearly half of this world's citizens live on $2 a day. Almost anyone will take cash. And that is the problem with cash. It is so valuable that everybody wants to take it. From you. Rule one: Avoid carrying large sums of cash around. In every corner of the world, you have to guard against being victimized. Just by carrying cameras around your neck, you are a walking billboard advertising affluence. If you also hoard cash on your person, be aware of the consequences. For all sorts of reasons, you should handle the smallest quantities that still allow you to be comfortable.

> **"Money alone set all the world in motion."**
> —PUBLILIUS SYRUS

Banks and post offices most often give the best exchange rates. *American Express offices are also good places to move large amounts of money. Avoid the ubiquitous tourist bureaus. They are meant for convenience, not expedience.*

Gold coins. *I purchase and bring home the best examples of money when I travel. I use them in still life photographs about the places I visit, and I include them in photographs about more complex ideas such as precious metals or international trade.*

ATM machines have almost replaced traveler's checks. *They are in most urban environments and offer excellent exchange rates. Also, you can use them often so as not to carry much cash around. Pay attention to the fees some systems charge for use, though.*

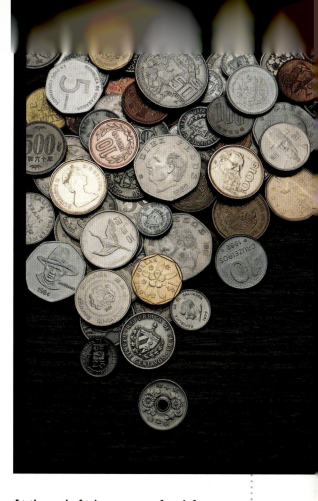

> "A much travelled man knows many things and a man of great experience will talk sound sense.
> Someone who has never had his trials knows little; but the traveled man is master of every situation.
> I have seen many things on my travels, I have understood more than I can put into words."
>
> —*ECCLESIASTICUS 34:9–12*

To move easily from one frontier to another you may have to convert from one money to another. Navigating currency exchanges when you cross borders does not mean you have to return to business school or balance the trade deficit. It can be vexing, but mastering a few simple concepts will give you the appearance of an experienced financier.

The first misunderstanding is that it makes absolutely no difference whether your money buys another at a rate of .7 or 253. At your level, the exchange rate has little bearing on the strength of one currency *versus* another. Buying kopeks and pesos, one for one, can almost never be a fair exchange. Nor should it be. Whichever money is stronger should be left to government experts. In the short term, it is immaterial whether a particular currency is rising or falling *versus* yours.

That being said, you always lose when changing money. Every venue has a service charge; that is how they make their money. Banks usually have the most favorable exchange rates. Hotels are more convenient but you might pay as much as 10 to 20% for every transaction. Automated teller machines (ATMs) give decent rates and they provide a little added security because you can extract small amounts whenever you need cash, usually without incurring sizable fees. But be careful. More and more ATMs are charging conversion fees and transaction fees. Money changing is additive; you are assessed similar fees when you change back.

At the end of trips you are often left with an excess of coins. *Most places will not buy them back. You can send them to Travelex, a company that collects thousands of dollars in coinage sent in by travelers for good causes. (Travelex America, Change for Good for Unicef, JFK Airport Terminal 4 IAT, Jamaica, NY 11430.)*

Tourists are often approached for black-market exchange. The rates can be very attractive and very flexible. You must approach illegal monetary transactions with trepidation. In may seem an easy way to make your wallet fatter but it destabilizes a nation's economy. It can also land you in jail. If you choose to risk it, carefully observe others completing the transactions before you plunge in. Black-market transactions also attract con artists. Some governments tolerate parallel money markets; for example, some stores or businesses will give you a discount if you pay with a stronger currency or a credit card.

Some places are so disrespectful of their own money that they will not allow you to convert your money back—one more reason to carry small amounts of cash. In most countries, you cannot sell back coins. If it is important to you, first buy equivalent paper money with the coins and then exchange.

TIPPING

The ubiquitous gratuity is one of the most hotly debated issues in travel etiquette, and many feel insecure about the practice. Which services insist upon it? Where is it forbidden? How much? The history of tipping is possibly tied up in the French word *pourboire* which means "for drink." A vocal number of experts believe it imposes an artificial master/servant relationship on the participants, but there is no escaping it. Whatever the local rules, they are no longer voluntary. As a matter of fact, some establishments preempt the decision to tip by levying a 10 to 18% service charge right on the bill. If discretionary, a normal tip is between 15 and 20%, excluding taxes. It is a wise practice to pay restaurant staff separately in cash. Often the management deducts the credit card fees right out of the server's share.

Money jigsaw puzzle. *International monetary exchange is a very complicated business. Governments rise and fall on small percentage point differences. At the street level, black-market trading disrupts the local economy. No matter how frequently you see it conducted be careful about your own involvement. Money always attracts a crowd. You could get into trouble or be the victim of a petty scam.*

On all other occasions, deciding who and when you tip—the person who opens the door, the bellman who carries your bags, the maid, the maitre d', the parking valet, *ad infinitum*—becomes an artform, albeit one that confuses both the novice and sophisticated traveler alike. Some countries, such as Japan or Iceland, claim to have little or no tipping. In others, everybody has his or her hand out. If you fail to give an appropriate tip, you are stigmatized. Do the research before you are confronted with an embarrassing dilemma. Guidebooks rarely have valid information. Ask anyone and everyone you know who lives there or has visited recently what the etiquette should be. Learn how much the local currency is worth. Concierges can tell you who gets what. In general, the more posh the establishment or the more cosmopolitan the city, the more you tip. Conversely, in some societies nearly everyone has a hand out, whether deserving of a tip or not. Remember that service people can affect your enjoyment or ability to get work done. If protocol calls for it, be generous. You are an ambassador. And there are long memories in the hospitality industry.

Tipping does not always require money. Well-placed gifts of all kinds can pay for special attention or kindness. Many photographers send photographs back to subjects. Some treasure such a memento. Polaroids are gold because they are immediate and will open up all sorts of opportunities if you cart the instant cameras around. Many people, though, are strictly mercenary and will accept no substitute for cash.

Certain circumstances insist on very visible contributions. If you are taking pictures and a donation is requested or a hat or plate is passed around among participants at a church or public event, people will feel especially exploited if you do not think enough to help out. Be very obvious about it. Let everybody see you donate. Nobody will then object to your taking all the pictures you want.

BRIBERY

To master the art of traveling you need to maintain a mature attitude out in the hinterlands. Much of humanity struggles and lives in the shadows, on the edges. As a photographer, you are expected to inhabit those fringes, too. You meet people in your travels that have something you want or have power over you. A favor or a certain amount of money may be necessary to coax them into performing a public duty or to gain unusual consideration. Whether inconsequential or substantial, this is termed a **bribe**.

Bribery can amount to a few well-intentioned rupees to help smooth the way or clear up a traffic citation, but it is also a rampant form of corruption. From customs agents to police officers, clerks and government workers, merchants and doctors, where bribery is prevalent the compromised individual is rarely subtle. In some cultures, it is considered a way of life or the easiest way to supplement an unstable economy. Economists often claim corruption curbs economic development but in some cases you do not have a choice. Learn to recognize the signs.

171

Called *baksheesh* in the Middle East, *jeito* in Brazil, *la mordida* in Mexico, bribery is often a crime, and you should give great consideration to how to handle the "gratuity." There are a few telltale signs you can spot when bribery is expected: (1) you always have to negotiate price, and (2) police always want to see your passport. There are others.

These situations can make you very uncomfortable if you are not used to them. Sometimes there is a threat attached. If you feel you are in danger, feign confusion. Pretend you do not understand the language or request. Move toward a friend for help or just anyone for assistance. Embarking on a philosophical tirade or being indignant is not a good idea. Criticizing the practice or trying to ignore it is ill advised. If you have a moral objection, do not go there in the first place.

As in tipping, try to elicit as much information as you can beforehand. The right officials may talk about it off the record. Learn from observation, but experience is the best teacher.

CREDIT

Today, it is difficult to function without credit. To venture forth trying to anticipate every contingency and carrying enough money to cover them would be prohibitive. When traveling, get in the habit of utilizing credit cards for major purchases (e.g., airline tickets, car rentals, equipment purchases). If you are employed by several clients and need a detailed record of every expenditure, such an accounting is a real benefit of credit card usage. Each month you receive an itemized record of all your expenditures that you can use when billing your clients. Be sure to maintain a list of your credit card account numbers and have one copy stored safely away.

The exchange rate on credit cards is usually the more favorable bank rate that corporations enjoy. In case of loss or theft, you can avoid liability by promptly reporting the loss to the appropriate authorities. In a few

> "When it comes to the language of money, credit cards are nouns. Dull, concrete, limited by rules and restrictions and creepy fine print, credit cards have all the élan of aluminum foil. Personal checks—the coward's stand-in for cash—are ugly and static pronouns. But a twenty-dollar bill, now, that's a thing of beauty. Nothing static about a twenty. Used correctly, a twenty is all about movement, access, cachet. Forget the other bills. The single won't get you much more than a stiff nod and, these days, the fin is de rigueur. A tenner is a nice thought, but it's a message that you're a Wal-Mart shopper, too cheap for the real deal. A twenty, placed in the right hand at the right moment, makes things happen.... The twenty, you see is a verb."
>
> —TOM CHIARELLA,
> "THE $20 THEORY OF THE UNIVERSE"
> (*ESQUIRE*, MARCH 2003)

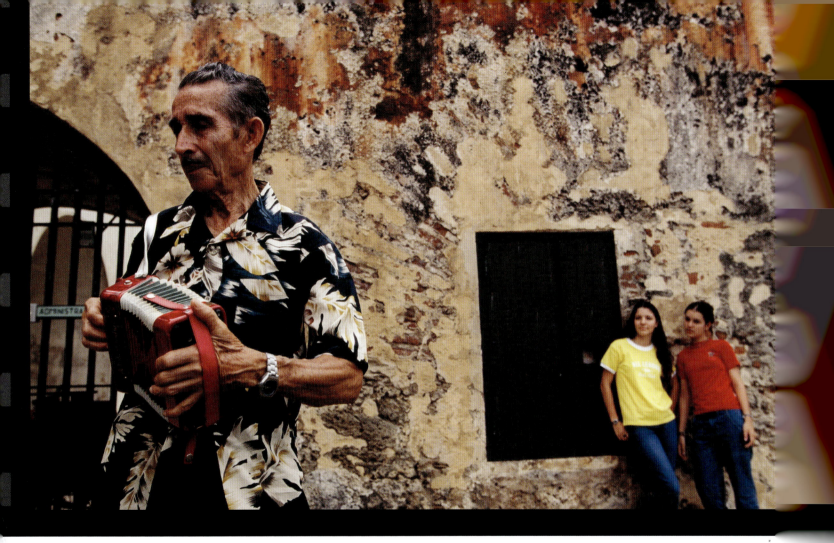

Street musician at Castillo de San Cristobal, Old San Juan, Puerto Rico. *Photoillustration versus photojournalism: I paid this street musician to meet me next to this amazing wall. Paying for models in your photographs is hotly debated. The ultimate intent of the photograph should dictate your decision. The girls were friends.*

situations, you can have a replacement issued so you can continue on your trek. Most of the premium cards offer special services to cardholders. Insurance on airline tickets and automobile rentals are important benefits. You can call international telephone numbers and obtain medical services extending to MedEvac and helicopter retrieval if you are seriously ill or injured.

The major card companies have a network of international offices and, in lieu of that, toll free numbers. You can get cash from ATMs and large advances through service bureaus. Purchase protection is attached automatically, and platinum cards grant you substantial lines of credit. Baggage insurance, hotel reservation assistance, and legal referrals round out just a few of the advantages that today's credit card companies offer in order to make their cards more attractive to consumers. If you expect to run up larger than normal charges on a trip, alert your credit card company beforehand.

CHECKS

If you can find anyone in today's world who will accept a personal check, embrace them. On rare occasions some do, but personal checks have limited application and are not a practical means of exchange when far from home. A staple for decades has been the traveler's check. A few years ago, it would have been unthinkable to go anywhere without them, but today many people feel that ATMs and credit cards have rendered traveler's checks nearly obsolete. They have so permeated the fabric of the world, though, that they are a good alternative where credit cards are not accepted. They may be your only recourse if the computer system is down or the machine does not recognize your PIN. ATMs can be finicky and impossible to fathom in another language. Traveler's checks are easy to convert, and their biggest advantage is that they are

replaceable when lost. The claim is that they are safer than cash. To ensure reimbursement, maintain a record of check numbers and transactions. They can be bought at a rate about 1% over their face value. Stick to the major brands, such as Thomas Cook, Barclay's, or American Express. Do not hesitate to shop around. Your bank may offer free traveler's check purchase with some premium accounts.

TAXES

The value-added tax (VAT) is a form of sales tax that you will often encounter. It is a tax levied on just about everything you buy: food, services, clothes, souvenirs, hotel rooms, etc. It is intended for residents, but tourists also pay it and often ignore it even though travelers are eligible for refunds.

"So far as my coin would stretch; and where it would not, I have used my credit."

—WILLIAM SHAKESPEARE, *KING HENRY THE FOURTH*

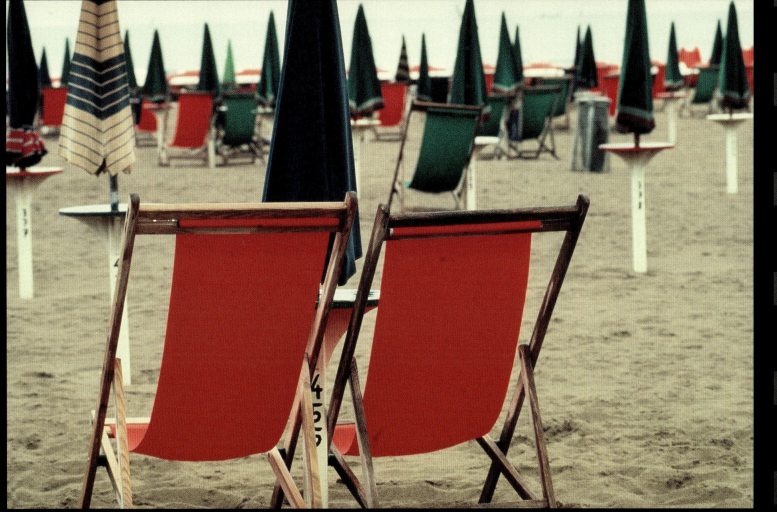

Beach chairs, Lignano, Italy. *When my companion arrived on my assignment in northern Italy, her luggage did not get there with her. Because I had bought her ticket with a platinum credit card, I was able to charge all the necessary items needed to continue her visit. From clothing to toothpaste, all the purchases were honored by the insurance included in the annual fees of the card.*

THE ELEVEN COMMANDMENTS OF TRAVEL PHOTOGRAPHY

1. On the road, *NOTHING* is ever as promised.
2. On another country's turf, they're *RIGHT* and you're *WRONG*.
3. *DON'T* come back without the picture.
4. *DON'T* lose your passport.
5. In awkward situations, *DON'T* say the most obvious or first thing that pops into your head.
6. F/8 and be there.
7. Everything is idiomatic.
8. If you can't make it good, make it big. If you can't make it big, make it red.
9. Keep moving. If the shot is not working, move on.
10. Never wait. When you see it, take the picture.
11. When you are traveling, all truly significant events occur at the last minute.

INDEX